PAINTING FOR THE

Absolute AND *Utter*
BEGINNER

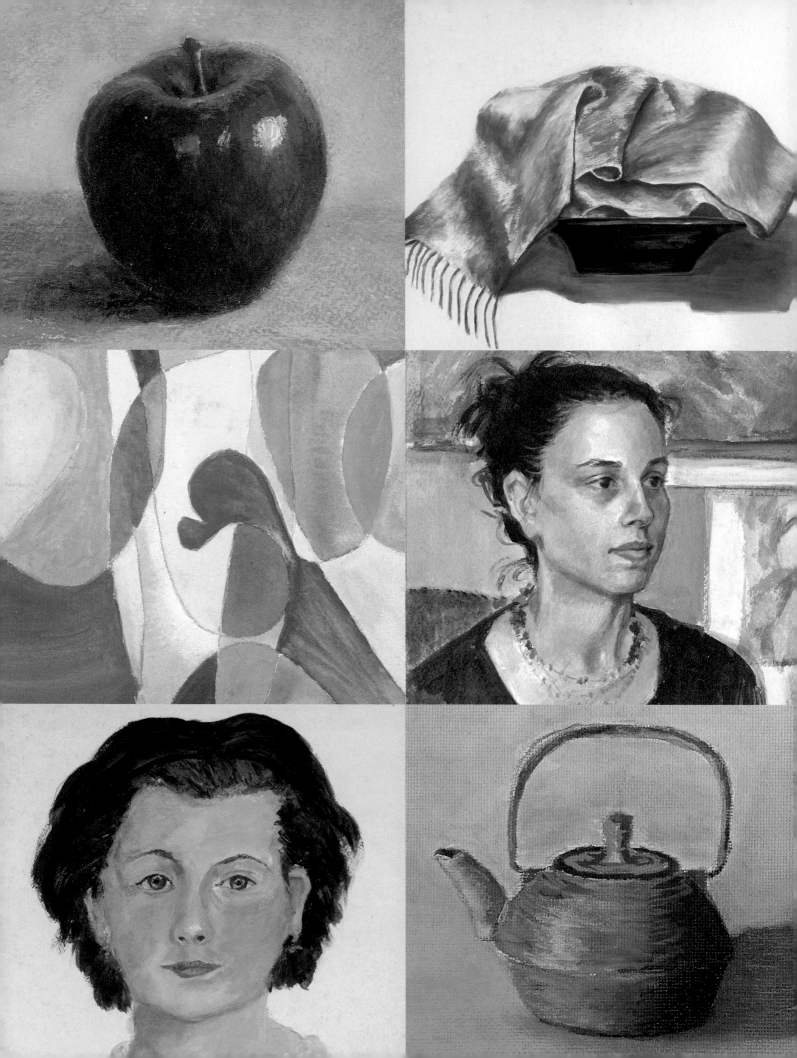

PAINTING FOR THE
Absolute AND *Utter*
BEGINNER

CLAIRE WATSON GARCIA

WATSON–GUPTILL PUBLICATIONS · NEW YORK

Text © 2009 Claire Watson Garcia

Designer: Drew Stevens, www.studiodrew.net

First published in the United States in 2009
by Watson-Guptill Publications,
an imprint of the Crown Publishing Group,
a division of Random House, Inc.,
1745 Broadway, New York, NY 10019
www.crownpublishing.com
www.watsonguptill.com

Watson-Guptill is a registered trademark
and the WG and Horse design
are trademarks of Random House Inc.

Photo credits
Kari Lonning: Steps and supplies
Josh Burkholder, Visual Impact: Artwork

Art credits
Page 1: Renee Hansen Goddu
Page 2–3: Top row from left: Claire Watson Garcia, Donna Faber,
Kathleen Bossert, and Liz Finkelstein. *Middle row from left:* Melinda
Caldwell, and Claire Watson Garcia. *Bottom row from left:* Mary E.
Tangney, Liz Finkelstein, Julie S. Swearingen, and Anne Carr.
Page 4: Julie S. Swearingen
Page 5: Claire Watson Garcia.
Page 6 from top to bottom: Claire Watson Garcia (2nd and 3rd pieces),
and Melinda Caldwell.
Page 7 from top to bottom: Caitlin Gury, Julie S. Swearingen, and Junko
Goto Donovan.

Library of Congress Cataloging-in-Publication Data
Garcia, Claire Watson.
 Painting for the absolute and utter beginner / Claire Watson Garcia.
 p. cm.
 Includes bibliographical references and index.
 ISBN 978-0-8230-9947-4 (alk. paper)
 1. Acrylic painting—Technique. I. Title.
 ND1535.G37 2009
 751.4'26—dc22

 2009006569

First printing, 2009

1 2 3 4 5 6 7 8 / 15 14 13 12 11 10 09 08

To my beautiful, colorful mother,
Jan Watson,
who took me to see the Picassos.

Acknowledgments

This book is the result of the unique contributions of many people, first and foremost the love and encouragement of my husband, Baxter, and daughter Liz; mother, Jan; brother, Win; and late father, Win Watson Jr. At Watson-Guptill, I am grateful to Joy Aquilino, executive editor, for her continued support; to Cathy Hennessy, my editor on this project, for her skilled and steady guidance; and to Jess Morphew, art director, and Alyn Evans, production manager, for availing me of their talents. And a big thank you to Marilyn Allen, my agent extraordinaire.

Many thanks to the staff at Silvermine School of Art, especially Anne Connell, school director. My gratitude goes to Pam Booth, Renee Goddu, Pat Glass, Liz Finkelstein, Kari Lonning, Betsy Halliday, and Dawn Hettrich—friends and artists with "great eyes" who gave me invaluable assistance. Thank you to Visual Impact in Danbury, Connecticut, and especially Josh Burkholder, for his technical expertise and sense of humor. And a special heartfelt thanks to those students at Silvermine who contributed directly to the creation of this book, as well as to many others who have allowed me to teach them and learn from them over the years.

Contents

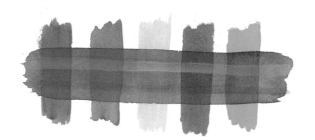

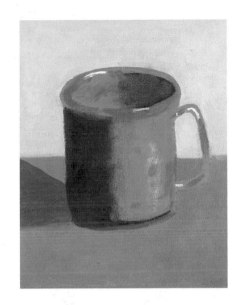

Starting Out

"If you hear a voice within you say 'you cannot paint' then by all means paint and that voice will be silenced."

VINCENT VAN GOGH

DO YOU WANT TO LEARN TO PAINT? Perhaps you have always dreamed of painting and now feel ready to make that dream a reality. Or maybe you love looking at art in museums and imagine that you would enjoy creating paintings of your own. This book is designed for people like you who feel inspired to learn how to paint but have little or no previous training.

"The eye is the most refined of our senses; the one which communicates most directly with our mind, our consciousness."

ROBERT DELAUNEY

Some of us may have had positive painting experiences years ago and want to reclaim that feeling. We were all artists in elementary school; painting is a natural means of expression when we're young. We may watch our children or grandchildren painting now and want to join in the fun. It's exciting for young, old, and in-between to see their brushstrokes recorded in vivid color.

Whatever your individual reasons, it makes sense if you want to learn to paint. The urge to create paintings is a basic drive that has been with us since the beginning of our human history. We derive a majority of our experience from our visual sense. Painting provides us with a language that corresponds directly to our visual experience of the world. It is a universal language, one with a rich

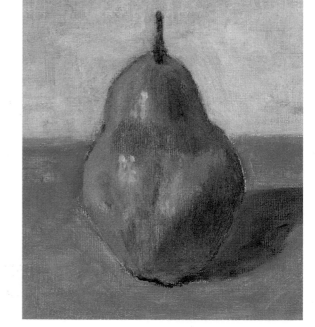

PEAR, *by Nancy Brown Condon, student*
"I've never painted before, so to create something that looked like a pear... I'm amazed. The color chart was also a big help."

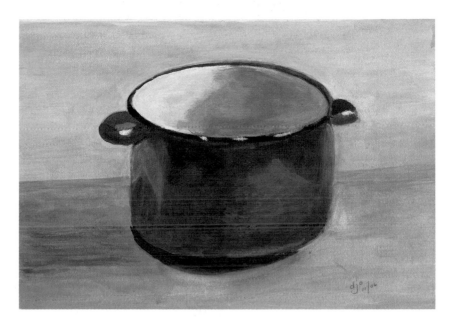

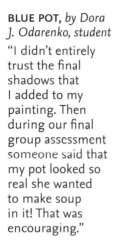

BLUE POT, *by Dora J. Odarenko, student*

"I didn't entirely trust the final shadows that I added to my painting. Then during our final group assessment someone said that my pot looked so real she wanted to make soup in it! That was encouraging."

vocabulary of colors and shapes that allows us to communicate over centuries, across national boundaries, and between generations.

Painting is a learnable skill, accessible to anyone who decides to activate his or her potential. In fact, I believe that in learning to paint you are reclaiming a human birthright. Picking up this book and being receptive to the idea that you can learn to paint are important first steps toward learning to do so.

Now that you're ready to explore the art of painting, the next step is to use a method designed expressly for the total painting novice, such as you'll find in this book. This material was developed during my twenty years of teaching, and has worked for beginning students in my Painting for the Absolute and Utter Beginner classes and workshops. The content of these classes is useful not only for beginners, but also for experienced artists who need to fill in gaps in their painting preparation.

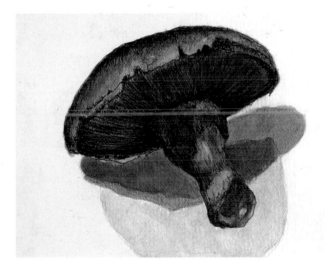

MUSHROOM, *by Julie S. Swearingen, student*

"Painting and cooking are similar. You become immersed in the process of creating your work, whether it's a piece of art or a favorite meal."

"If I could say it in words there would be no reason to paint."

EDWARD HOPPER

How To Use This Book

> "... feeling is the principle, the beginning and the end: craft, objective, technique—all these are in the middle."
>
> PAUL CÉZANNE

Over the years, aspiring painters have come into my studio classroom with the same expectation: to learn how to paint in a representational way. That is, they want to make paintings that resemble the world they see around them, and to receive a basic foundation in the skills and principles of painting that make that creation possible. Representational painting isn't the only way to paint, but it is an effective way to acquire the tools and understanding that will prepare you for any kind of painting you choose to do.

Painting for the Absolute and Utter Beginner starts you at the very beginning of the learn-to-paint process where you don't need to know anything at all about painting. You'll follow an organized learning sequence that teaches you basic skills such as how to handle the brush, dilute the paint, and mix the color you need. Each exercise develops your skills and provides the foundation for lessons to follow. As painting projects grow more challenging—from single object still life to still life composition to portraits and nudes—they remain within the reach of the beginner. My step-by-step demonstrations will show you how each painting project develops; you use them to gain an understanding of the painting process so that you can apply it to the subject matter of your choice. The book is also illustrated with paintings by beginners who learned how to paint from the same material you'll be using. Their comments and helpful hints, along with the words of well-known artists, will inspire and support you.

STUDY OF A QUINCE FROM JUAN SANCHEZ COTAN'S *STILL LIFE WITH QUINCE, CABBAGE, MELON AND CUCUMBER, by Helen Lobrano, student*

Mentor painting involves making studies of great works of art and can be an effective way to learn.

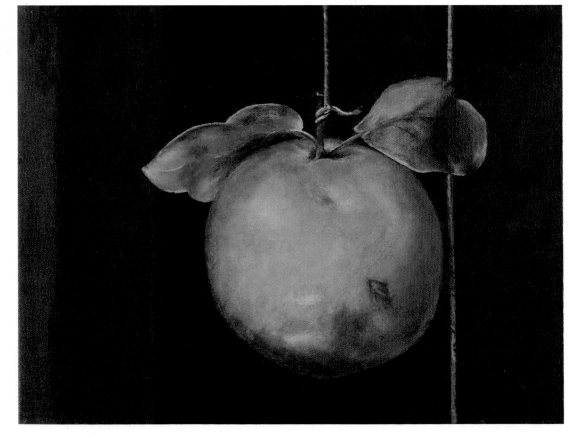

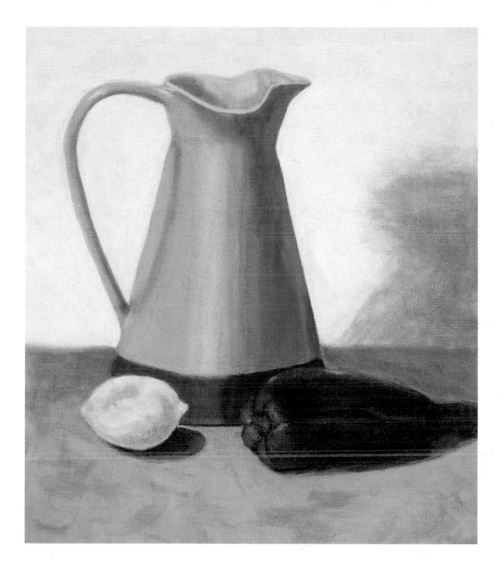

STILL LIFE WITH PITCHER, LEMON, AND RED PEPPER, *by Melinda Caldwell, student*
"I was amazed that it did look like a pitcher, a lemon, and a pepper. Not a masterpiece but not bad for someone who hardly knew which end of a paintbrush was up a few weeks earlier."

No previous drawing skills are assumed for beginners using this book; however, experience in drawing will help make learning how to paint more accessible. Some basic drawing instruction is included in the text, as well as some methods that will allow you to temporarily bypass drawing to continue learning to paint. My companion book, *Drawing for the Absolute and Utter Beginner*, is a resource for those of you who want to strengthen your drawing foundation.

Your innate painting ability lies close to the surface of your conscious awareness and can be activated quickly using the right method. Even if you have never painted or drawn before, in a short period of time you can learn the core painting concepts and techniques needed to create convincing paintings. So what are you waiting for? Everything you need to learn to start painting is here. The time has come for you to follow your dream and start expressing your own unique vision in painting!

"In any human being there is an artist, and whatever his activity, he has an equal chance with any to express the result of his growth and his contact with life."

ROBERT HENRI

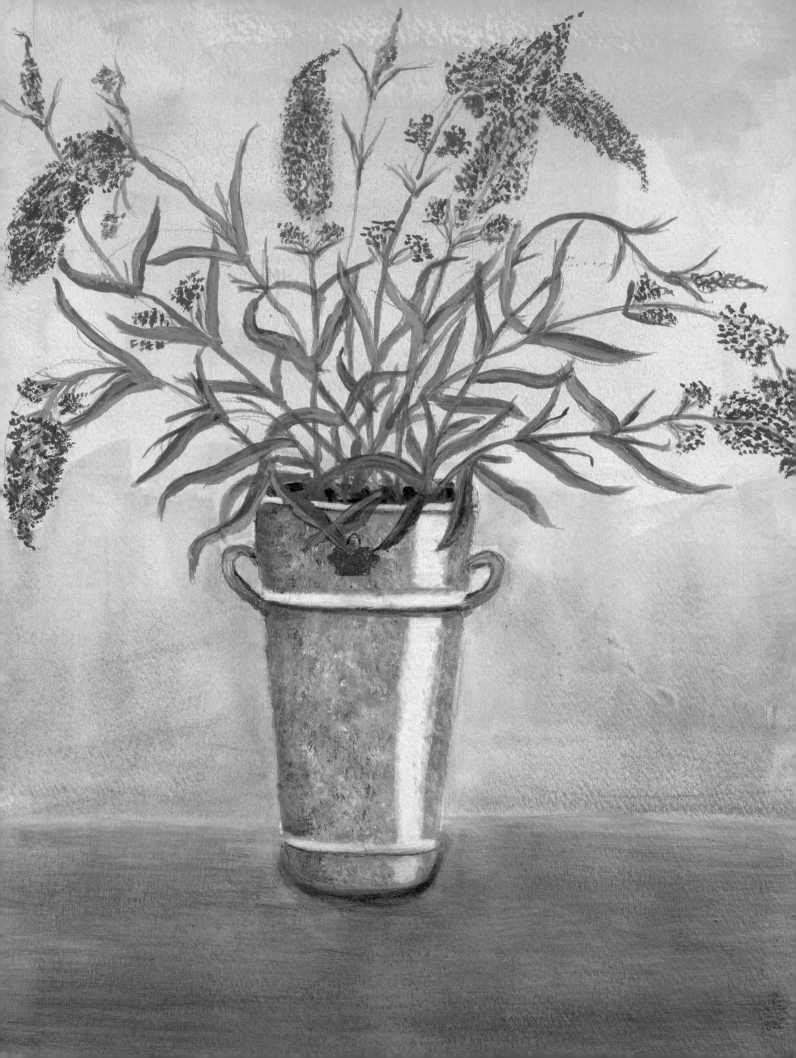

Getting Ready: Paint, Materials, and Setup

*"It's so fine and yet so terrible
to stand in front of a blank canvas."*

PAUL CÉZANNE

You're about to set out on a painting adventure that will take you places you may have only imagined. Preparing well will help make your journey go smoothly, so let's start by assembling all the essential elements you'll need: reliable art supplies to paint with, the right surfaces to paint on, and a place at home where you can paint.

Your tools support your ability to express the creativity within you. The paint you squeeze onto your palette offers you a world of color. Brushes allow you to mix that paint into an infinite number of colors. Each brush in your hand can create a variety of strokes, marks, and applications to help you replicate the shapes and surfaces you see in the world around you. Once you set up a place to work, you can begin learning how to use your tools and materials effectively in order to bring your inner vision into the outside world.

Opposite: **BUTTERFLY BUSH IN A VASE,** *by Pat Glass, student*

Right: **THREE APPLES,** *by Katharine H. Welling, student*

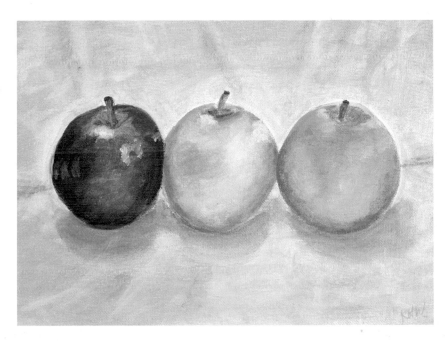

At the Art Store

The supplies that you'll purchase here are recommended for you because they're moderately priced, high quality, and widely available, and have worked well for students in my classes. I work with them myself, and did the step-by-step demonstrations with the same painting materials you'll use.

Your first visit to the art store can be both stimulating and somewhat overwhelming. Bring this book with you to help you find your way: it will be especially useful when it comes to purchasing brushes. Ask the art store staff for help if you need to make substitutions.

The basic list below contains both supplies you'll purchase at the art store and those you'll get from other sources. I'll discuss some of these supplies in detail later in the chapter.

Acrylic Paints

Acrylic paints are used for the painting projects in this book. Their versatile properties make them a good choice for beginners. Acrylics are equally well suited for use on watercolor paper or canvas. Students have the option of using acrylics in wash form in a watercolor technique or in a thicker, more opaque form similar to the way oil paints are used. This gives beginners a taste of what it would be like to work with either of these other paints.

Acrylics are thinned with water for the painting process and cleaned up with water as well, which makes them a good choice for use at home. Acrylics dry quickly, which makes correcting fast and easy for the beginner. This in turn allows beginners to progress quickly through the steps of learning how to create a painting.

Golden's and Liquitex acrylic paint brands are the ones I recommend. Buy them in 2 oz. tubes of "heavy body" paint. This is professional grade paint of a standard consistency. You'll also see "heavy body," "soft body," and "fluid," which refer to variations of the original standard consistency.

Buy titanium white in a 5 oz. tube, since you'll use more of it than other paint colors. A student grade acrylic

The Basic Supplies

FROM THE ART STORE:
__ Six paintbrushes
__ Eleven tubes of acrylic paint and one bottle of gesso
__ Palette
__ Canvas boards
__ Watercolor pad
__ Newsprint pad, 18 × 24 regular or rough surface, *not* smooth
__ Strathmore drawing pad, 6 × 8 (80 lb. weight)
__ Kneaded eraser
__ A package of "soft" vine charcoal
__ White blackboard chalk (also found in stationery stores or drugstores)

__ Black ink pen—waterproof (also found in stationery stores or drugstores)
__ Spray fixative: Krylon Workable Spray Fixative for pastel, charcoal, and pencil

Optional
__ "The Masters" Brush Cleaner and Preserver
__ Goldens Archival Varnish
__ 2B and 2H pencils are useful, although a regular pencil will do

FROM OTHER SOURCES
(stationery, drug, or hardware stores, and from home):

__ Clip-on light with aluminum photo reflector shade and bulb

__ Blue painter's tape of inch width, designed to peel off easily for up to two weeks
__ Box cardboard
__ Old shirt to use as a smock. Acrylic paint does not come out of clothing.
__ Clear glass or plastic jar with wide lip. Medium to large mayo jars are good.
__ Paper towels or cotton rag
__ Scissors

Optional
__ Spray mist bottle

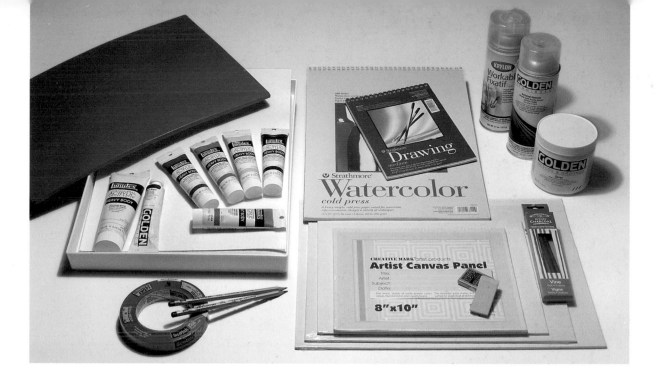

such as Liquitex's "Basics" will be less expensive, but colors will be less vivid and less resistant to fading than the standard professional brand.

Acrylic brands are interchangeable; you can substitute colors from different brands of "heavy body" (standard consistency) paint. An exception to this rule is when acrylics are labeled "open." The "open" acrylics stay wet longer, and can be layered on top of dry applications of standard acrylics but not mixed into them.

Acrylic paints are considered a non-toxic paint. A tube that says "hue" on the label, as is the case of cadmium-based colors, means that the paint color has been reconfigured to reduce or eliminate the toxicity of the color. The original color will have a more intense, truer color than the "hue" version.

Acrylic medium (in gloss or matte) enhance glossiness or matte qualities, depending on the type of medium you choose, and also strengthen the final paint film. It can be used with or instead of water to thin the paint. I find the minuses for beginners outweigh the pluses. The milky color of these mediums, which become clear after drying, makes color mixing more confusing at first.

Gesso is an opaque white paint used for sealing (priming) raw canvas to prepare the surface for painting. Gesso can also be applied to watercolor paper to create a surface more like that of prepared canvas. It's also useful to correct and enhance small areas on paper.

You can create all the colors you need for painting projects in this book by mixing paints from the list below. Learning to mix color is an essential skill, and more cost-effective than buying lots of paint colors you can mix yourself.

Here are some of the basic supplies you'll shop for at the art store.

PAINT SUPPLIES

__ Gesso, 8 oz. bottle

Tube Colors

__ Titanium white
__ Cadmium yellow MEDIUM, not light
__ Yellow oxide or yellow ochre
__ Cadmium red LIGHT, not medium (looks orange)
__ Napthol crimson
__ Phthalo green, blue shade
__ Ultramarine blue
__ Burnt sienna
__ Burnt umber
__ Mars black
__ Dioxazine purple

Optional

__ Phthalo blue, green shade
__ Acrylic Gloss Medium, or Matte Medium

This to-scale photo of brushes from the list below will help you identify the shapes and sizes of brushes you need. Soft-hair brushes in this photo have red handles, and bristles have black handles (note: handle colors vary; this is not always the case). Bristles appear in two different shapes: round shapes in large and small sizes, filbert shapes in medium. The soft-hair rounds with white hairs are synthetic and are less expensive than the soft-hair round brushes next to them, which have a mixture of natural and synthetic hairs.

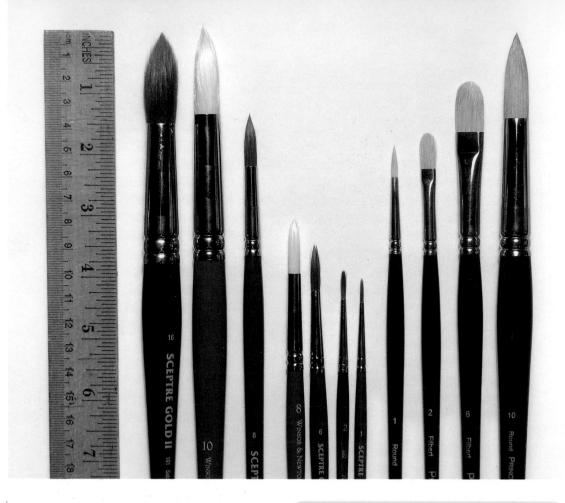

Brushes: Bristles and Soft-Hairs

Look for brushes in two broad categories: *bristle* and *soft-hair*. Bristle brushes have strong, coarse hairs. Soft-hair brushes are basically any brush that isn't a bristle; they have thinner, silkier, more delicate hairs than bristles. They may be natural, synthetic, or a mix of the two. The soft-hair brush is made for use with watercolors and acrylics. If you already have brushes that have been used for oil painting, they can't be used for acrylics. The oily residue left on the brushes will resist the water used with acrylics.

Both bristle and soft-hair brushes have the equivalent of haircuts, which identify them as *filberts*, *rounds*, *brights*, or *flats*. Look for a round that comes to a nice tapered point; otherwise, your accuracy will be affected. Other specialty shapes are also available. Each can make a range of particular marks on the painting surface.

Winsor Newton, or Princeton Brush Company brushes shown here in the photo above, are established brands that make reliable-quality brushes.

Brushes

SOFT-HAIR ROUNDS
(choose one in each size):

1. Large: #10 Winsor Newton University 235 (synthetic), *or* #16 Winsor Newton Sceptre Gold II 101 (sable/synthetic)
2. Medium: #8 Winsor Newton University 235, *or* #8 Winsor Newton Sceptre Gold II
3. Small: #6 Winsor Newton Sceptre 11, *or* University # 2 *or* #1 (either series)

BRISTLE FILBERTS (or Rounds):

1. Large: #10 round Princeton Brush Company 5200R
2. Medium: #6 filbert Princeton Brush Company 5200FB
3. Small: #2 filbert Winsor Newton Rathbone

If you feel like adding a brush, the #10 Princeton Brush Company 4000B bright is popular with students, who get some nice blending effects with it. This is a soft-hair, small/medium size brush with shorter, squared-off hairs.

Manufacturer's name, type of brush, and brush size numbers will appear on the handle of the brush, and/or on the display case next to them. Choose brushes with short handles and synthetic or natural and synthetic hairs to save money. Large art supply stores often have in-house brands that are less expensive.

You'll need a total of at least six brushes—large, medium, and small-sized brushes—in both the bristle and soft-hair categories. There is no industry wide standard for the numbers that designate brush size. If you need to substitute another brand, ask a sales associate for assistance, and use the photo of the brushes to help you. If you can't find a filbert bristle, choose a round-bristle of the same approximate size.

This selection of brushes will allow you to match brush size to the size of the painting job. The three general categories from which you're purchasing correspond to the three stages of building a painting. You'll use the large brushes to block in the overall image, the medium ones to develop and correct, and the small to add the finishing details.

Palettes

You'll squeeze out pure colors from your tubes onto your palette surface, and then mix them to create the specific colors you need for your painting. Your palette for acrylics is a sheet of white, coated paper, usually kept flat on a table. Acrylics need to be kept moist on the palette when you're painting, and also when you aren't painting, to preserve them. Following are a variety of options for your palette.

I highly recommend the Masterson Sta-Wet Premier Palette (red, not blue box). This comes with a sponge and paper palette inserts. Follow instructions inside the palette box, and it will keep paint moist for weeks, allowing you to conserve paint, save money, and recycle (or discard) the palette paper inside as it's

You can make delicate lines with the tip of a soft-hair round brush.

used. Knowing that the paint isn't going to dry too fast also makes beginners feel more confident.

If you don't want to buy or make a palette box, use a pad of heavyweight (35 lb.) palette paper. Acrylics will dry quickly if left out on this palette. Mist the paints while working, and cover the palette with a top when you take a break, to help the paints last longer. You can also use everyday household items as palettes. Here are a few suggestions:

1. Use a white plastic plate for your palette and another one to cover it. If the plates are lightweight, you may want to put something heavy on the top one to keep the palette covered.

2. Containers with lids from take-out food are useful.

3. Use polyvinyl freezer paper (that you can buy at the supermarket) to make a palette. Cut off a piece and tape it down. You can roll out as much of this inexpensive palette paper substitute as you want.

If you'd like to hold your acrylic palette when standing at the easel, one of my students came up with this idea: use large paperclips to secure the palette paper to the back of a canvas board. Then you'll have a palette you can pick up and an extra painting board when you need it!

TIP Here is a way to make a palette box substitute, which is less expensive than buying a ready-made one (but more work).

1. Buy a pad of palette paper first, then find a large shallow plastic food-storage container of the same size that has a lid.

2. Trace the outline of the pad of palette paper on watercolor paper and then cut the paper to size.

3. Moisten the paper, place it in the bottom of the plastic container, cover it with a piece of palette paper. Replenish the water by dripping some into the base of the container. Keep closed when you aren't working.

Supports

For the projects in the book, you'll paint on canvas boards and on watercolor paper. However, as you continue to paint you may find that you enjoy experimenting by painting on different types of surfaces. Just avoid any surface that's oily or waxy. So while you may paint on almost anything, for now let's start with the basics.

Canvas Boards

These are sturdy pieces of cardboard covered with canvas, primed (sealed) with gesso. These provide a fine painting surface for beginners. You'll start on small boards with small projects and then advance to larger ones. Not all projects need to be done on canvas: watercolor paper can be substituted. Prestretched canvases are a step up in quality; you might want to try them out later. As you progress in your painting, learning to stretch and prepare your own canvas in order to create a desired size is another option.

Make sure your canvas boards have been made for acrylic paint, not oil paint alone. Purchase two 8 × 10 inch's to start. Some other size boards you may want to purchase later are 9 × 12 inch, 11 × 14 inch, 12 × 16 inch.

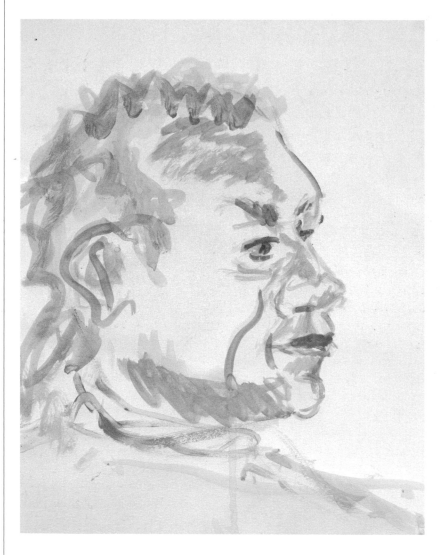

SKETCH OF WENDELL, *by Liz Finkelstein, student*

This spontaneous sketch was "drawn" with a brush and paint.

Watercolor Paper

Cold pressed is the most widely used watercolor paper, and I recommend it for beginners. Buy a 12 × 18 pad of 90 lb. to 140 lb. cold press watercolor paper in loose pages, not in a block. Strathmore is a reliable brand.

Watercolor paper is available in three surfaces: cold press, hot press, and rough. Cold press provides a slightly textured, more user-friendly surface for the beginner. The other two provide interesting surfaces you may want to explore as your painting experience develops.

Watercolor paper tends to ripple more or less depending on the weight of the paper (140 lb. will ripple less than 90 lb.). If some rippling bothers you, I encourage you to tape the edges of your paper to a sheet of cardboard when painting, which reduces this. Purchasing large individual sheets usually results in a waste of paper because beginning projects require cutting the paper down to smaller sizes.

Easels

You can work at a table for the first few chapters while you're getting to know your supplies and basic techniques. However, to continue your development as a painter you'll need an easel, and a chair or stool if you have difficulty standing. Look for collapsible tabletop or simple wooden easels. (I've been using the same one since high school!)

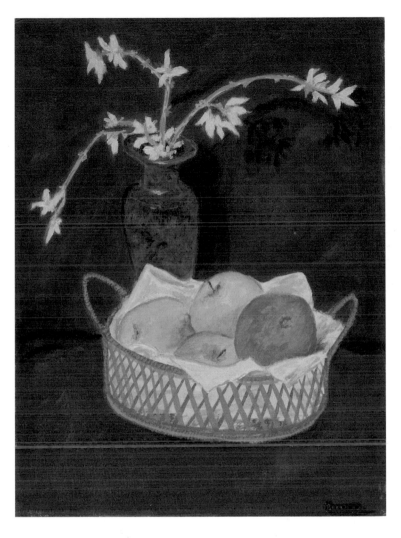

"It's a lot easier to keep standing back and evaluating one's work when you are already at the easel. It's difficult to constantly stop, put the work up, and check it when one works at the table."

Kathleen Bossert, student

WINTER FORSYTHIA,
by Diana Ringelheim, student

Getting Ready to Paint

It's frustrating when you're ready to create but have nothing inspiring to paint. As part of your preparation, start hunting for things now that you might want to paint. Your own shelves at home (and in the attic, if you have one) can be your first source for subject matter. Tag sales, student ceramics sales, thrift shops, and the grocery store are also good sources. Let the subjects you see in this book guide you, and add to your collection as you go along.

> "The artist is a receptacle for emotions that come from all over the place, from the sky, from the earth, from a scrap of paper, from a passing shape, from a spider's web."
>
> PABLO PICASSO

Not everything that you collect has to serve as subject matter. It can simply be something that stimulates your visual sense: postcards of paintings you admire, scraps of color, a feather. Keep them near your painting area.

Your collection represents what you love to look at, but it's also part of a strategy for success in painting. You'll want to find objects that you connect with visually, that have colors and shapes that you respond to strongly in a positive way. In my classes we've come to refer to objects like these, with a mixture of seriousness and humor, as "the beloved." And they will be different for each person. Among the hundreds of items at a tag sale, some of them will "speak" to you, as in "take me home and paint me!".

Your interest in the shape and color of an object will motivate you and keep your connection with your painting strong. There's a relationship between the intense response you have toward your subject and your ability to access your capabilities. You're inspired to reach beyond what you thought you could do.

For your first painting project you'll need a simple, one-color symmetrical container. A basic coffee cup is fine.

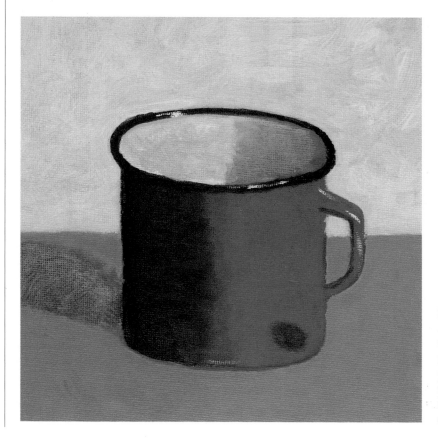

RED TIN CUP, *by Nancy Vukmanovich, student*

For your first project, you will paint a simple, one-color symmetrical container.

When choosing pottery, a low-luster or matte surface will be easier to paint than shiny, heavily glazed pottery. Look for a glass bottle too, especially in olive or yellow green. Colored or clear glasses are good choices. Stay away from those with printed labels or imprints on them.

Setting Up Your Studio

Most beginners don't have studios. At least not yet! So, find a space in the kitchen, basement, or bedroom. You'll need a table to start, and a chair or stool. You don't want to paint hunched over, or reaching up to the surface. You want to be comfortable, just as you want to feel sitting at a desk or in front of the computer. If the area where you'll be working is worth covering, newspaper or a plastic drop cloth can be spread out and left, if possible.

You'll need an artificial light source. Natural light from the sun changes light conditions faster than beginners can paint. You can use a table light, but it's really better to have a strong light source that you can direct toward the subject you're painting. I suggest getting a clip-on light with an aluminum photo reflector shade and a 150 to 200 watt bulb at the hardware store (look for watt limitations inside the shade). Clamp it onto the back of a chair or onto a doorknob. If it doesn't grip well enough, stuff a cloth between the back and the grip.

Beginners who talk about enjoying painting the most seem to be the ones who have set up a permanent place to paint: an area that gives them immediate access to their painting supplies, the project they're working on, and an easel. People tend to wait to do that until they are ready to make a commitment. Sometimes it takes a while to find the right solution. Keep in mind that you can make adaptations to your particular physical needs as well.

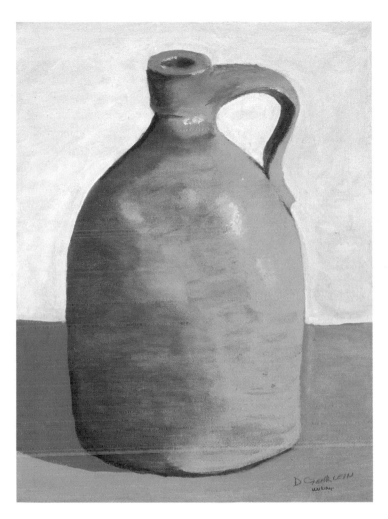

JUG, *by D. Gehrlein, student*
Handmade jugs have a lot of character; their slightly irregular shapes give beginners some wiggle room when it comes to precision.

"My work studio is a space we cleared in the basement. My husband took an old door and made a worktable for me and I have a bar stool to sit or lean on. There's no sink in the basement so I fill a bucket with water and dip my smaller containers into it. I love it!"

Barbara Bosill, student

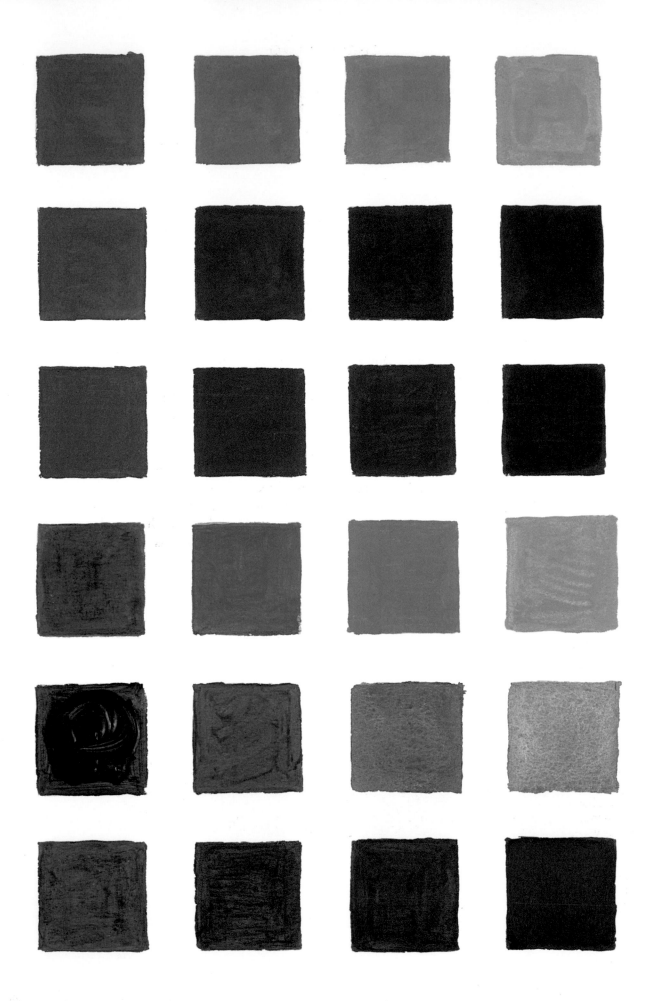

Mixing Paint:
All About Consistency

"Some say they see poetry in my paintings.

I see only science."

GEORGES SEURAT

The first steps in painting are fun, and allow you to experiment with the materials. It's not unusual for beginners at painting workshops to gasp with pleasure when I first squeeze paint onto the palette during my demonstration. And it's not because I'm such a good squeezer! The color and consistency of the paint is very beautiful and exciting in itself.

Acrylic paint is diluted with water for most of the painting process. In general, you're going to use three different paint consistencies in your work: impasto, with little or no water added; medium consistency, with some water added; and wash, with lots of water added. In this chapter you will learn to mix paint with these consistencies.

Opposite: This chart shows the variety of colors that can be created simply by diluting a paint color, or by adding white, black, or the complement of a color.

Right: As you look from right to left, you can see how the consistency changes as water is added: from impasto, to medium consistency, then to wash.

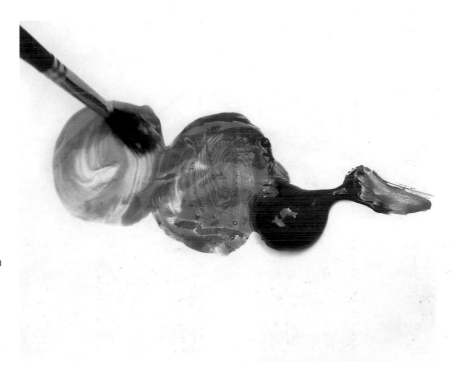

How to Dilute the Consistency of Paint

TIP When you work, put the supplies you'll be using on the same side as your painting hand to avoid dripping paint across your art as you work.

Sometimes beginners believe that a painting surface is supposed to be smooth. This impression may have come from looking at reproductions of paintings, or at those from a particular period of art history. Some painting traditions did value a smooth surface, such as those seen in Dutch artworks before Rembrandt. Then Rembrandt championed the use of thick paint, including touches of impasto, and visible brushstrokes—techniques he adapted from Titian's work—to give spatial impact to his painting.

EXERCISE: IMPASTO

Impasto is a thick consistency of paint, usually straight from the tube with no water added. However, if the paint needs a little water to move it around, you can add it. The name is Italian and it sounds like a nice gelato, which it resembles. When light shines on impasto texture it highlights the peaks, giving a viewer the impression of an active, rippling surface. Read through the following exercise once before you actually begin painting.

1. Squeeze out about a dime-size amount of orange (cadmium red light) paint onto your palette. Use your pencil to make four 1-inch squares in two rows on watercolor paper. You can be casual with the shape of your squares.

2. Use your medium soft-hair round brush. Hold it as you naturally would hold a pencil or pen for writing. Use your brush to scoop some paint from the side, not the middle, of your paint source. Deliver enough paint to the first square to fill it in. Let the paint sit up like whipped cream. Move your brush hairs around in it, leaving visible strokes behind. Impasto is used for highlights and textured areas, so let the peaks stand up (see below).

Paintbrushes

Before you jump in and get your brushes wet, let's learn something more about how to use and care for them. With minimal effort you'll have them around for a long time to help you accomplish your painting goals.

MEET YOUR BRUSHES

Pick up the soft round brush and the bristle and feel the difference in their hairs. One has soft and silky hairs, the other coarse and bristly. While you're at it, touch the surface of your watercolor paper. Feel the bumps? This is called "tooth" and will play an important part in your painting technique. You'll also find tooth on your canvas boards. Your small drawing/painting pad has a smoother surface and lacks tooth.

CARING FOR YOUR BRUSHES

Keep your brush hairs in water while you're working. Don't let paint dry on them. If by chance paint happens to dry on the brush, you can use the brush cleaner mentioned in the basic supply list in chapter one to restore the hairs. Avoid leaving them sitting in water with brush hairs down for extended periods when not in use, or the hairs will become bent.

When you finish your painting session, wash your brushes out thoroughly with water (no soap required) and leave them flat, or standing in a jar, brush hairs up. Make sure you massage out any paint left around the metal collar, or *ferrule,* of the brush.

Notice the texture in the square of impasto.

EXERCISE: STANDARD/MEDIUM CONSISTENCY

I wish this consistency had a lovely name, but this term merely signifies what it means. It may remind you a little of kindergarten poster paint. It's the broad middle of the road where most of your painting work takes place. Acrylic paint will naturally give you a fairly smooth surface in this consistency. Expect that your brushstrokes will leave some imprint on a painting surface when you apply medium-consistency paint.

1. Using the paint already on your brush, dip the paint-filled hairs in water, then to the palette, and mix them together.

2. Add water until the brush slides around on the palette easily. The resulting color should look intense, like the original color from the tube. Too much thick, dry paint on a brush causes it to drag when you try to move it around the painting surface. Your brush should move freely now, with no resistance, gliding over the painting surface like a skater. If it doesn't, add water to increase fluidity. If you got a pale-colored puddle, add more paint. Then fill in your second square with paint (see below).

Medium-consistency paint will have the intensity of its pure source color but not much texture.

NOTE Van Gogh used expressive applications of impasto to give his work its signature style. Once the paint dried, the movement of his brush in paint was frozen in time.

EXERCISE: WASHES

Washes are the basis of watercolor painting. You can simulate a watercolor technique by layering acrylic washes to create new color impressions. Paintings on canvas start with thin wash layers for practical reasons: you get a quick look at the overall painting without applying thick, hard-to-remove paint. And you can paint over wash more easily than thick paint if you need to adjust it.

1. Add more water to what is left on your brush. Mix the results on the palette to homogenize and mix in any thick paint left in the brush. Add enough water to create a small tinted puddle with NO paint blobs or streaks. The color won't be as strong and intense looking as in the two previous consistencies.

2. Fill in the third square. Tilt your paper slightly, resting it against a support, like a roll of tape, and keep it in this position while you fill in the square with horizontal lines of color. Overlap the edge of each previous stroke of color slightly with the new one. (Beginners tend to halt here, and gaze at the first line they put on!)

3. Don't hesitate. Work while it's wet to encourage each line to flow into the next, without giving the edge time to set. Your result will look brushless. If you're producing lines, not flow, try again, applying the paint more rapidly now that you know the process (see swatch at left).

4. Add more water to the wash mixture you already have to make a lighter color. Fill in your fourth square.

TIP You will need your palette, watercolor paper, and a water container for all the exercises in the book.

NOTE Take a look at the four squares you painted to see which has dried fastest. The drying time of your squares will be different. The thicker and wetter the paint, the longer each square takes to dry. Middle consistency dries fastest. Thicker and wetter paint takes longer to dry.

The more diluted wash on the right is lighter and less vibrant than the wash on the left.

Explore the wash techniques on this page. You don't have to get them right the first time! Illustrations are to guide you; they won't reflect your own learning process. Experiment until you feel comfortable with your results.

TIP When you apply wash with the painting surface on a slant, excess wash will gather at the bottom. Blot your brush, and then let it drink up the extra wash, which acts to soften the edge of the wash as well. To erase a wash while it's wet, blot it gently with a paper towel.

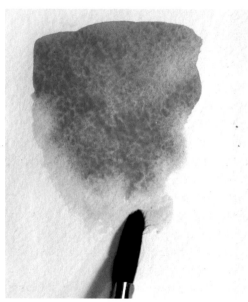

Notice the contrast between the crisp edge and the softened edge, where the wash has been blotted. This technique will come in handy when you create shadows.

To control the flow of color, premoisten the paper before adding your wash.

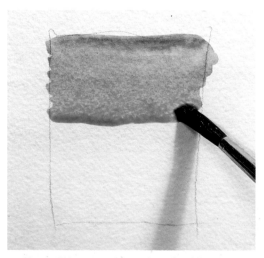

Apply each horizontal stroke of wash, slightly overlapping the bottom edge of the previous one, while both are wet and your paper is tilted to keep the wash moving down the page.

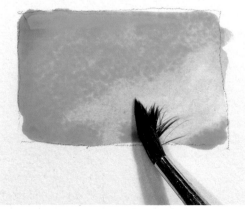

To evenly lift off a layer of color intensity from a wet wash, blot a soft-hair brush, then skim back over the wash surface.

EXERCISE: MORE ON WASHES

When a wash is used over dry paint, whether on top of another wash or opaquely painted area, it's called a glaze. To learn how glazing works, try this simple exercise:

1. Apply a horizontal crimson wash on watercolor paper.

2. Apply vertical colors over it: cadmium red light, napthol crimson, cadmium yellow medium, ultramarine blue, and phthalo green, then horizontal lines of mars black and titanium white.

3. Let each layer dry completely before glazing on top of it.

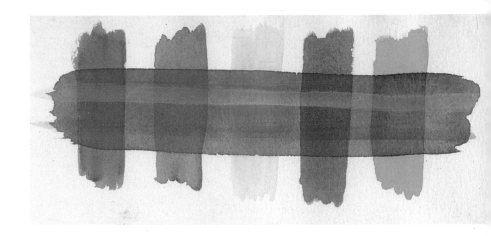

> **TIP** When you're changing colors, press down on the ferrule, flattening brush hair on the palette, to see what is there in order to avoid undesirable color surprises or to incorporate pleasant ones. Get into the habit of pressing the brush to the bottom of the water container in order to release trapped paint when starting a fresh color.

EXERCISE: MAKING CONSISTENCIES WITH A BRISTLE BRUSH

Now that you've experienced some of the effects possible with the soft-hair brush, let's see what the bristle can do.

Create the same four squares that you made in the earlier exercises. This time, give your bristle brush a tryout and use ultramarine blue to fill in the squares.

Now that you have done the exercises with both brushes, do you find that you prefer one to the other? Applying wash is easiest with soft-hair brushes: they hold water better and are less likely to leave brush marks in wash, where a brushless result is usually desirable. Bristles pick up thick paint with more finesse due to their stronger hairs, but both brushes work similarly with medium consistencies.

Soft-hairs and bristles overlap in terms of getting the job done. They're both winners! Even if you forget which brush is which, you'll begin to feel and see the difference in results when you use them. And you'll change when you need to.

> **NOTE** A change in brushes can change art history. Lucien Freud's adoption of bristle brushes after using soft-hair sables in the early part of his career was key to the creation of his signature thickly painted figurative style.

Notice how the crimson wash is changed by each of the seven washes glazed over it.

> **SUPPLIES:**
> pencil, medium-size bristle brush, ultramarine blue

When you dilute blue you'll notice changes from dark to light similar to what you saw in the previous exercise when you diluted orange.

Value Relative to Consistency

You've already created a small *value scale,* simply by gradually changing the consistency of paint. The *value of a color* refers to how dark or light that color is. Sometimes you'll hear this referred to as tone or tonal value. A value scale is a way of representing changes in value in a graduated fashion.

The more diluted the paint, the lighter value it will have. Water has no color; the more water is added to a paint mixture, the fewer the number of paint particles are present, resulting in a lighter version of the color.

Each individual paint color has an overall value. Orange is a lighter value than blue, for example. Each individual color can be turned into a value scale, either by changing consistency as you've already done, or by adding darker or lighter colors to it.

As you can see in the black-and-white versions beneath each value scale, overall value of each color is different.

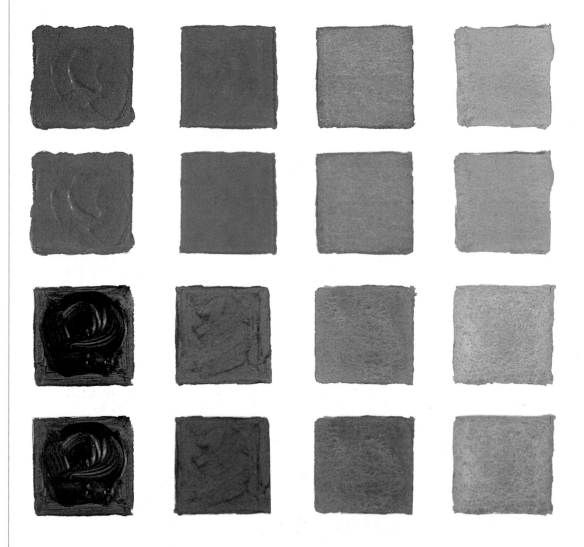

Why Are Values Important?

The values in a painting will give it an overall pattern of lights and darks, or *value structure*. This plays a part in creating a balanced composition, where the visual elements are arranged so that all the parts are in harmony. *Shadow* *values,* a part of the value structure, are key to creating the impression of three-dimensionality, which in turn will give your painting the illusion of "reality." We'll go more into depth about these concepts in Chapter Eight.

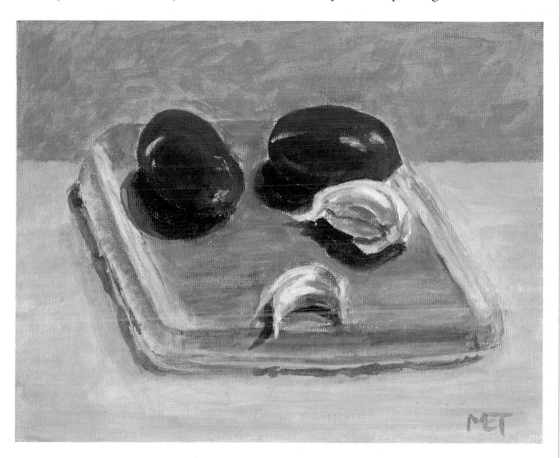

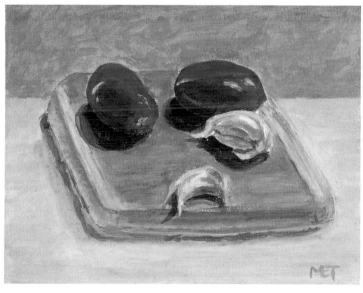

WHAT TO MAKE FOR DINNER, *by Mary E. Tangney, student*

Each color has a corresponding value, as you can see by comparing the original painting in color with the black-and-white version of it.

Opaque vs. Transparent

Adding white to any color you want to lighten, such as ultramarine blue in this case (left), can result in a pastel color (middle) unless you add more of the original color to the mix (right).

When you're painting an object that needs to look solid—such as a piece of fruit, a person, etc.—your paint needs to be opaque. This means you need to apply the paint so we can't see the color or texture of the painting surface through the paint. If the subject you're painting is transparent, like glass, a transparent application of paint is desirable. Medium-consistency paint applied in a single layer, as well as washes, both have transparent qualities. Colors applied in medium consistency usually need a second coat of paint to become opaque.

Colors can be made opaque with the addition of a little white. This is comparable to adding flour to thicken a sauce when you're cooking, which also changes consistency and lightens color,

but which sometimes results in making the flavor bland. The solution: putting another, more intense flavor back into the mix. The same rule applies in painting (and don't get the two confused!). After adding white to create opacity, add more of the original color if your resulting mixture looks washed out; doing so should revive intensity.

Transparent paint allows the color of the painting surface—canvas or paper—to show through. The transparent paint color is illuminated from underneath by the white painting surface, like light through stained glass. If that surface is colored, you'll experience a new color impression, created when you see the underpainting and the wash simultaneously. Any color can be made transparent through the addition of enough water, resulting in a wash. Some of your paint colors are by nature more transparent when right out of the tube, while others are more opaque. Any paint color applied thickly can be made to obscure the support, even if that color is transparent by nature. Impasto is more than opaque; it's sculptural!

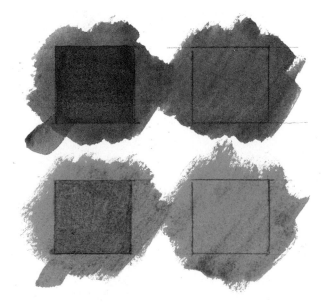

Phthalo green is a transparent color by nature, while burnt sienna is naturally more opaque. However, both can be made transparent (right) in wash form. After second coats (left) the colors look more opaque, as well as darker, with fewer brushstrokes visible. This exercise is worth trying yourself. Let layers dry between applications.

Consistency Problems and Solutions

Problem: "The thickness of the paint and graininess of the canvas board were a problem. I kept getting white showing though."
—Mary E. Tangney, student

Thick paint that's too dry, literally called "dry paint" in some texts, will tug at your brush, resisting application, and leave the canvas surface showing. When this happens it indicates paint has reached only the top bumps of the painting surface, leaving the bottom layer uncovered in places. Recognize this resistance, add water, and mix well to get more fluidity. "Dry paint" isn't always a bad thing: it will depend on your needs at the time.

Solution: To fix a painting with undesired white showing through after the paint has dried, apply wash in a matching color over the problem area, which will tint all the white areas.

Problem: "I have a real problem with getting the right paint consistency: it globs and I keep adding more water and have this glob on my brush I don't know how to get off!"
—Melinda Caldwell, student

You're mixing too much thick paint that hasn't been diluted enough, and probably using too small a brush for the amount you're taking on.

Solution: For beginner-size projects your medium-size brush will do the job and large amounts of paint aren't required. Use a bristle if the paint is on the thick side. Pull paint away from the sides of a pure paint source to mix in a new area. Avoid crowding your mixing—if you need more space, use more palette paper. Wipe excess paint from your brush with another brush onto the palette if you want to save it. Wipe the rest off your brush with a paper towel.

NOTE Paul Cézanne chose not to cover all the white surface of paper or canvas. This was a daring step away from traditional representational technique. Learn "the rules," then break them your own way!

BLUE BOTTLE, *Mary E. Tangney, student*
Notice how this artist has "filled in the holes" in the "after" image by applying a matching wash.

Before

After

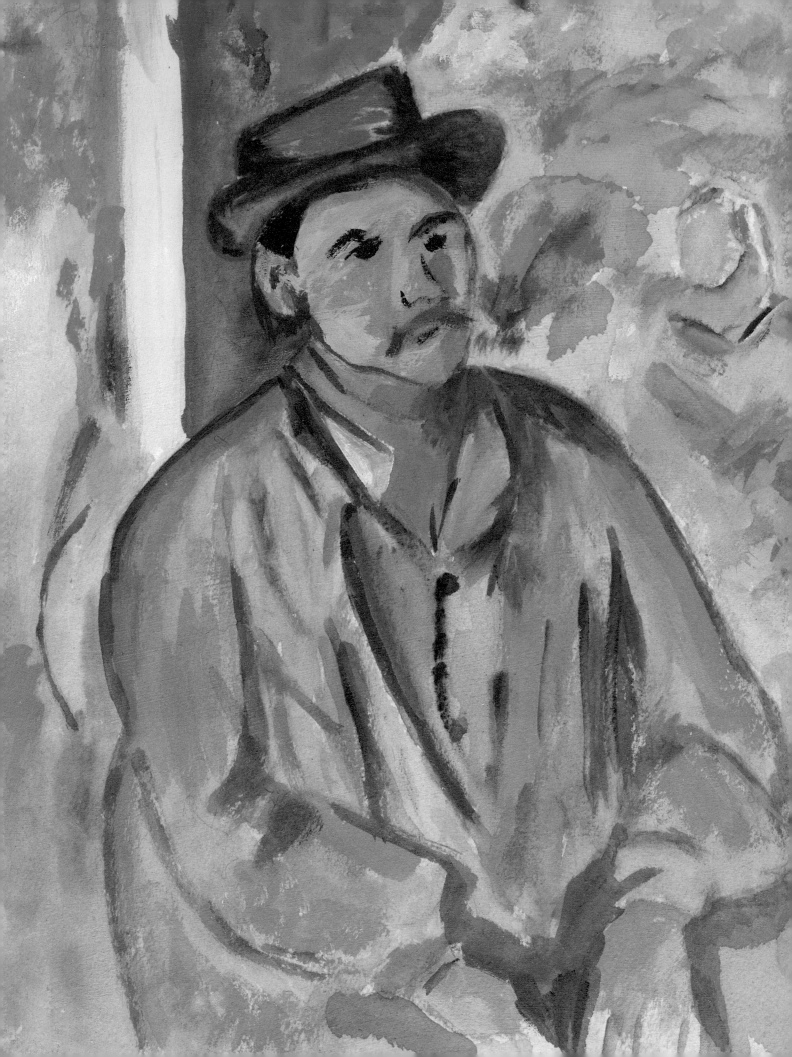

More Paint Mixing: Creating the Colors You Want

*"You reason color more than you reason drawing.
Color has a logic as severe as form."*

PIERRE BONNARD

The colors you see in paintings, with few exceptions, are color mixtures. Colors used straight from the tube are usually too intense to be a good match for the world we see around us. So now it's time for an introduction to the rules that govern mixing colors in preparation for your first painting project.

You'll learn what works and what doesn't when you mix, and uncover some surprising color-mixing secrets. You'll discover that a color can take on many roles: from full vivid strength, high contrast dark or light, clashing complement, or even camouflaged neutral hiding quietly in plain sight.

Colors themselves define the rules you'll learn about. Each color naturally has certain capacities, somewhat like a personality profile. Once you learn more about the individual properties of colors you'll be able to mix them effectively. Your knowledge of color properties will provide guidelines for all your painting experiences and be useful to you as long as you paint, and as long as you look at paintings.

Opposite: **STUDY OF CÉZANNE'S *PEASANT IN A BLUE SMOCK,*** *by Barbara Bosill, student*

Right: One of your best tools can be a simple scrap of "tryout" paper for testing out color and consistency before moving on to the painting surface.

Useful Techniques for the Palette

Before we get started on the exercises, here are some suggestions for how to work on your palette to help you be more successful at mixing paint.

1. Squeeze colors around the sides of your palette, leaving room between them. This avoids contaminating your pure sources and leaves mixing room in the middle of the palette.

2. Avoid crowding your mixing experiments to prevent unwanted color from getting into them. Put more palette paper out on the table if you need more room.

3. Take paint from the sides of a pure paint source when mixing it, rather than scooping it from the top or mixing into the middle.

4. Approach dark, intense colors such as black (though this is not considered a color in a scientific sense) with caution: small amounts cause big changes.

5. Respect the power of complements. As you'll see next, adding just a little of one complement to the other will reduce the brightness or strength of the pure color.

6. Mix until you can't see streaks to achieve a uniform result in the color you want.

7. Don't skimp on paint to save paint. Use a paint box or alternatives outlined in chapter one to conserve your paint. Squeeze out a serviceable amount of paint—usually a dime-size amount for colors and a quarter-size amount for

Pull paint off the sides of pure sources and away for mixing.

white. The process of "wasting paint" is synonymous with the process of painting. (It's one thing if you're throwing tubes out the window, but if you're using it while learning how to paint it is fine.) If you focus too much on conserving paint you may not let yourself learn how to use it effectively.

8. Keep the sponge insert in the paint box moist. You do have to make sure to replenish the water, or there's nothing to keep the paints moist while the box is open. If you don't use the box, follow suggestions on page 17 to keep your paints moist.

Five Important Properties of Color

Orange and blue are the most frequently used color pair in the visual arts. Most of Cézanne's still lifes with fruit, and Picasso's Blue and Rose periods (actually blue and peach), are based on this dynamic color duo. You'll continue to focus on them, not because they need to be your favorite colors, but because you can learn about all five important color properties in a short period of time by studying them.

❶ Complementary Colors

Orange and blue are a complementary pair, and as we'll see, they are different from each other in ways that are significant to you as a painter. Their contrasting natures are expressed on the color wheel, where they sit directly across from each other, just as the two other complementary pairs do: purple and yellow, and red and green. The direct opposition of these complementary color pairs, and the colors derived from mixing them, is a source of visual magic in painting.

EXERCISE: COMPLEMENTARY COLOR WHEEL

Make your own complementary color wheel to strengthen your color understanding and to practice painting. For this exercise, you'll use five colors straight from the tube: cadmium red light, cadmium yellow medium, phthalo green, ultramarine blue, and dioxazine purple. Mix the sixth, primary red, by adding a little cadmium red light to napthol crimson.

Use a pencil on watercolor paper to trace the inside of your masking tape, add a horizontal line, then a cross in the middle of the line. Use medium-consistency paint to fill in the resulting six triangles as you see them in the illustration below. Outline each triangle with a small brush, then fill in with a medium brush.

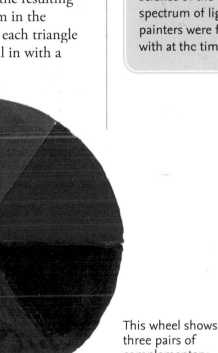

This wheel shows three pairs of complementary colors. Each half of a complementary pair sits across from the other on the wheel.

FIX-IT TIP
To correct your results, these two techniques will help:

Wet-Over-Dry
1. Wait until the paint has dried, then paint over the previously painted shape.

Negative Space Painting
2. If you paint outside the lines (as most of us do a lot of the time!), wait until the paint is dry. Then use white paint to touch up around the outside edges of the shape, if you want to.

❷ Color Values

You mix paint not only to create new colors, but also to make lighter and darker versions of the same color. Knowing how to do this relates directly to how you'll create the illusion of spatial dimension in your work. Adding this spatial quality relies on creating convincing shadow values, which are darker versions of any color surface they are resting on. For example, the color of a cast shadow on a tabletop is a darker version of the overall tabletop color.

Color values are described in context, relative to other colors. We compare one color's value to another's, because both in a painting and in life, we see colors in relation to one another. A color can have many different value identities, depending on the colors surrounding it.

The simplest way to change the value of a color is to add white or black, making it respectively lighter or darker, without changing its original identity. In other words, you can make orange lighter, or darker, but you can still identify it as orange. If the color has a complement, you'll learn how that can also be used to create a value change in its partner.

Layering paint also influences the value of a color. As we touched on in the last chapter, layers of paint create opacity, which blocks out the lightening effect of the white painting surface. Thick layers of the same color paint will therefore appear darker than thin layers. Paint also dries slightly darker than it appears when wet, whether you're creating a work of art with it or painting the walls of a room at home. As you gain experience, you'll learn to slightly lighten a color in anticipation of this value difference between wet and dry paint.

In chapter two, you created a value scale based on diluting the paint. Now let's learn how to create a value scale by mixing paints together.

Color Value Mixing

The more time you spend mixing and applying paint, the more at ease you'll be using your tools and understanding the properties of your paint colors. The illustrated squares here do look a little formal. But they look like that so you can see them better, not because you have to be just as tidy when making your own squares or when filling them in.

Open Time

Timing is everything, or at the least very important when it comes to painting. There are times when an application of acrylic paint is "open," that is, when you can successfully mix into it, and there are times when you need to wait. Though acrylic paint does dry relatively quickly (in a matter of minutes depending on humidity and its consistency), the painting surface can break up if you add more paint to it while it's drying. You'll learn to judge these differences by experimenting and observing the result. Thin paint will feel cool when wet, slightly warm when first dry. Though you can paint over dry acrylic quickly, it takes the paint film up to three weeks to cure (meaning to form a final, more durable finish).

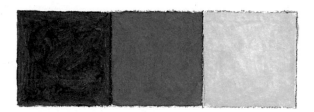

Orange is darker than yellow, but lighter than blue.

EXERCISE: TINTS, OR COLORS PLUS WHITE

Working in medium-consistency paint, you'll make orange lighter by adding increasingly small amounts of white to the pure color. Don't expect to make the value changes perfectly the first time you mix, or at any time. It's standard in painting to mix a color and then adjust it, just as you would with the color wheel, until you get the color you're looking for.

> **FIX-IT TIP**
> To correct your results, continue to use wet-over-dry and negative space painting and add this new technique:
>
> **Wet-in-Wet**
> Add paint directly to the shape you're painting if you need to adjust the color while the paint is still wet.

1. Squeeze out about a dime-size amount of orange, blue, black, and white in four corners of your palette, leaving space for mixing in the middle.

2. Make four rows of 1-inch squares with a pencil.

3. Fill in the first square with pure orange. Using the orange paint left on your brush, pull some paint from the side of the white paint on your palette. Mix both together thoroughly. Test the color you created on the paper, next to the first square. (You can see the small dots where I did that.) If you're satisfied with the amount of value change, fill in the second square.

4. Continue adding increasing amounts of white to the orange on your palette, and testing your results next to the previous square. Remix and adjust as needed, adding more white or orange, and gradually making lighter versions of the original orange color.

Pure orange grows lighter with additions of white.

EXERCISE: SHADES, OR COLORS PLUS BLACK

1. Draw four more squares. Wash out your brush, pushing the hairs down on the bottom of the water container to get rid of trapped paint. Change your water if it's very milky.

2. Start with pure orange in medium consistency and paint the first square. With that paint still on your brush, take a little bit of black from the side of the black paint on your palette. Now mix them.

3. The squares below show how quickly the dark paint changes the orange. It's easy to go too dark. Test the color next to the original with a little mark. Too big a value jump? Add more orange to the mix. Continue to add a bit more black to the mix for each square.

> **SUPPLIES:**
> cadmium red light, ultramarine blue, mars black, titanium white, medium soft round brush or medium bristle

Pure orange grows darker with additions of black.

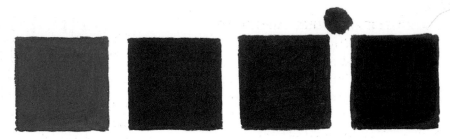

Pure orange grows darker with the addition of blue.

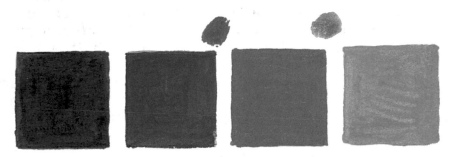

Pure blue grows lighter with the addition of white.

Pure blue grows darker with the addition of black.

Pure blue grows darker as orange is added.

EXERCISE: DARK VALUES, CHANGING VALUES WITH COMPLEMENTS

Next, follow the same procedure, only substitute blue for black this time, and gradually add blue to pure orange. What did you come up with? The result looks a lot like you added black, doesn't it? Adding the darker complement to its lighter partner can create both more accurate and more colorful shadow values than adding black.

EXERCISE: ULTRAMARINE BLUE WITH WHITE, THEN BLACK, THEN ORANGE

1. Draw three rows of four squares. Start each row with a pure blue square.

a. Add white to create gradually lighter blues in the first row.

b. Add black to darken blue in the second row. Keep in mind that blue is already dark, therefore adding black results in a subtle change.

c. Add orange to gradually darken blue in the third row.

Be ready to be surprised! The most startling effect comes when you add the lighter complement, orange, to blue. In small amounts it too creates a darker value blue, much like adding black, despite the fact that it's of a lighter value. Such is the magic of complements.

> **TIP** The addition of increasing amounts of orange to the blue paint would result in tipping the *color balance* of the mixture from a blue to a lighter, rusty orange color.

❸ Color Intensity

Intensity refers to how strong or vivid a color is. When orange and blue sit side by side, the contrast between them makes each appear more intense. This is simply in the nature of complements and is true of the other complementary pairs as well. Compare this to colorful human personalities you may know: strong personalities sitting side by side often cause sparks!

Mixing and diluting generally reduce the intensity of any color because in each case you have less of the original color in the mix. And as you've seen in this chapter, mixing complements together can cause dramatic changes.

❹ Color Temperatures

Orange and blue are *warm* and *cool* colors respectively, which means they have different *color temperatures*. These descriptive terms can serve to remind you that warm colors—the yellows, primary reds, oranges— have yellow, the color of the sun, in their mix. Wintry cool colors— blues, purples, violet, icy greens— have little or no yellow (sun!) in them.

The concept of color temperature is important for several reasons:

1. It will help you mix colors more accurately. For example, green can exist in many different temperature varieties, whether in nature or mixed on your palette. You can mix a warm green from a cool one by adding yellow to cool phthalo. This relationship goes both ways: you can add more phthalo green to a warm green to cool it off.

2. The overall contrast and proportion of warm to cool colors in a painting can add or subtract excitement from a painting.

3. The contrast between warm and cool colors also affects the spatial impact of a painting.

EXERCISE: IDENTIFYING IMPORTANT COLOR PROPERTIES

This exercise is about observing. Simply be aware of the impact on your eyes when looking at the colored squares. Squint to identify the properties of color you've been learning about more clearly.

The complementary pairs we see below are all at full intensity; however, some colors have more power to attract our gaze than others. Do you find that your eyes are drawn to yellow, red, and orange squares more than blue, purple, and green? Warm colors tend to hold our gaze more powerfully than cool ones. They often appear to be closer to us than cool colors, as well. Are your eyes drawn strongly to the dividing line between yellow and purple? High contrast between complements will draw the eye in general. Where the contrast between value and temperature (warm/cool) is the strongest, an area will have greater impact on the eye. Notice that the low contrast of cool/cool temperature and values in the lower right pair has less powerful visual effect.

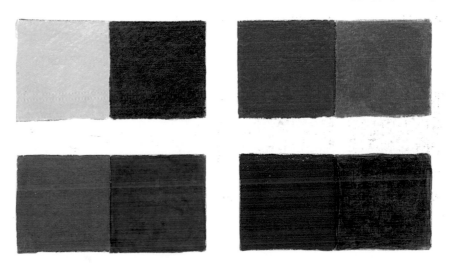

Look at these eight squares to see four of the five color properties you've been learning about at work. Three complementary pairs are shown. The red/green is seen in two variations: warm on the top right, and cool on the bottom right.

SUPPLIES:
medium brush of choice, cadmium red light, ultramarine blue, titanium white, cadmium yellow medium, dioxazine purple, naphtol crimson, phthalo green

❺ Color Neutrals

In any given painting you'll find *neutrals*, sometimes referred to as *optical grays*. They don't have specific names such as purple or green. My mom calls them "nothing colors." One of the easiest ways to create neutrals is by mixing complementary pairs together. Complements mixed together will make each other disappear, their vibrancy and identity all but lost. This sounds very *Star Wars,* and it is! Depending on the color properties of their parent colors and their relative amounts in your mix, you can create a variety of interesting colors in different values.

"I hate neutrals. They're so ugly. They look muddy!" These are common responses when beginners first mix neutrals. Especially when you contrast them to the glamour of pure intense pigments. However, neutrals are painting saviors! We don't notice them at first because they aren't intense, but we'll see that they have a big role to play in the overall production of a successful painting.

EXERCISE: MIXING NEUTRALS

Neutrals created from complements are among your most useful tools for creating a sense of color harmony— as though every color is related—in your painting, since they will bear a resemblance to their color parents. Now let's find out how to mix some neutral colors.

1. Mix blue and orange thoroughly in any proportion that occurs spontaneously. Did you get a more purple or a more rust color? Rust has more orange in the mixture. It's also a warmer color. Purple has more blue and is a cool color.

Now let's shift the color temperature by changing the proportion of cool or warm colors in the mix.

2. If you had a purplish result, now create a rust color by adding more orange to your original, and then add white to the result to create a lighter peachy color. If you got a rusty color, add blue to cool it down to a purplish mixture, then add white to get a light purple gray from that. Notice that the resulting grays you've

Small vertical marks link the complementary pairs. Each pair has been mixed together to create two neutrals, one more like each parent; these appear to the right of each.

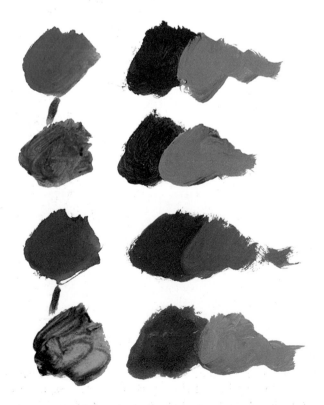
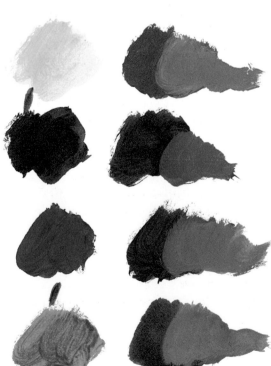

created reflect one parent color more than the other and can also be shifted from warm to cool as well, by adding more cool or warm color.

3. Use the same steps to explore the yellow and purple complementary pair. Depending on which parent color the resulting neutral resembles, tip the color balance back to the other parent. Add white to your results to extend the range of subtle neutrals. Do the same with red/green complements. To create the warm primary red and warm green, add cadmium red light to naphthol crimson, then cadmium yellow medium to phthalo green.

Mixing Summary

What do we know about mixing now? Let's look at what follows:

1. Adding black to any given color will darken its value. Adding white will lighten its value. Adding one complement to another in a complementary pair will also change the value of a color.

2. Every color, straight from the tube, has a value, compared with other colors. Value relates to how light or dark the color is, as though photographed in black-and-white.

3. The value of each pure paint color can be changed by mixing. It can be made a darker or lighter value, depending on whether a darker or lighter color is added to it. The greater the proportion of the new value added, the greater the value and color change. The easiest way to change color value is by adding white or black.

4. You can make a color warmer or cooler by adding warmer or cooler colors to it. The amount of paint added in proportion to the amount of your original color will determine how great a change results.

5. When you make a radical change in colors, for example switching from one color to its complement, it's important to clean the brush and get clean water—this will prevent the color you mix from neutralizing, unless that is your intention.

6. When you add white, black, or its complement to a color, this will reduce the intensity of that color, or neutralize it.

7. Adding larger quantities of one color to the other, or adding those with a strong capacity to tint other colors, can tilt the color balance of a mixture toward the color that was mixed in.

8. When paint dries, the color looks slightly darker than when it's wet. Paint color also looks darker in layers than in wash form.

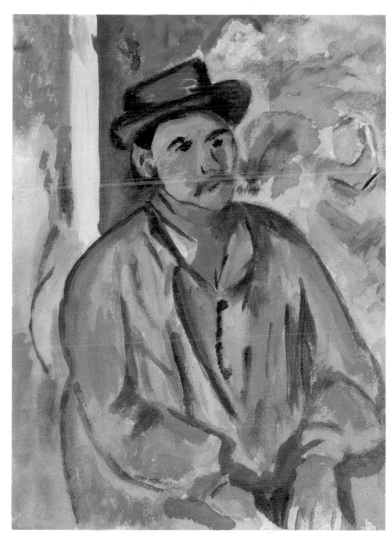

STUDY OF CÉZANNE'S *PEASANT IN A BLUE SMOCK*, *by Barbara Bosill, student*

Cézanne used the blue and orange complementary pair that you've been exploring in his painting. Based on your experience, can you figure out how the warm and cool neutrals were created?

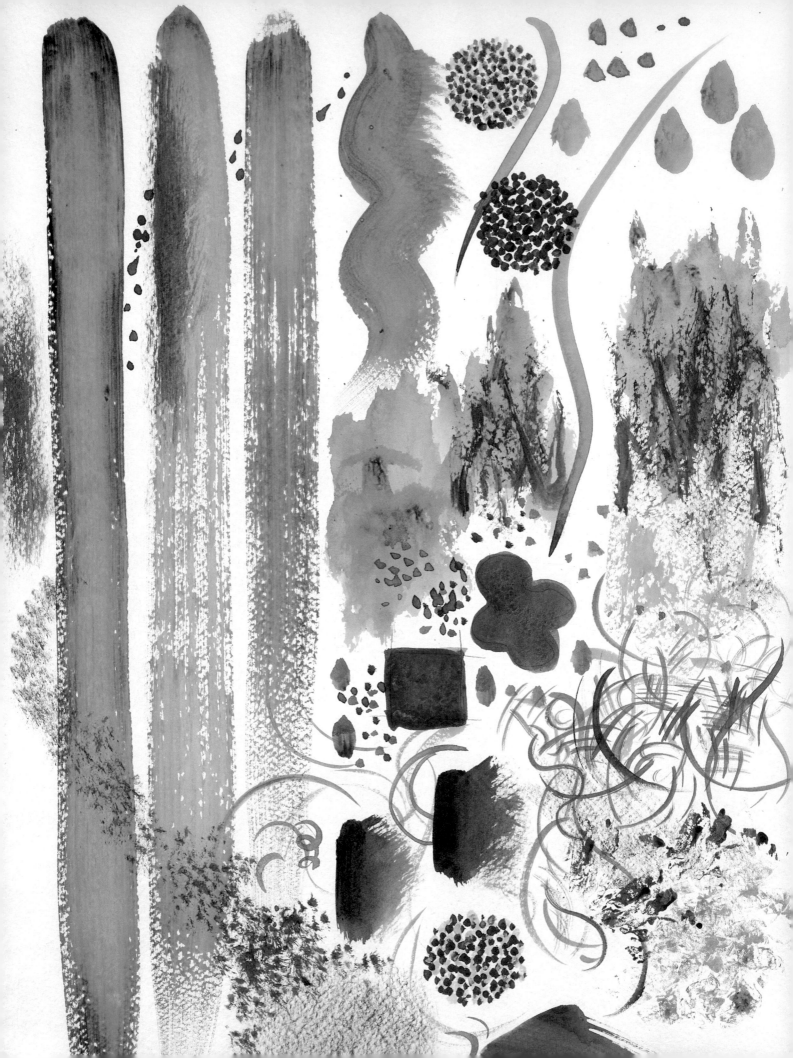

CHAPTER FOUR

Brush Handling: What Your Brushes Can Do

"The emotions are sometimes so strong that I work without knowing it. The strokes come like speech."

VINCENT VAN GOGH

In this chapter, you're going to break out of the box (or should we say square?) to find out more about what your brushes can do. You don't have to be careful with these exercises. You can play, experiment, and move more freely on the painting surface. Put on music if it loosens you up: you can even paint along with it.

Brush handling can be compared to playing a musical instrument. The way you apply your brushstrokes on the painting surface makes a difference, in the same way as fingers on a piano keyboard do. The quality of your touch through your brush to the surface—delicate, forceful, broken up or smooth, quick or prolonged—creates a particular impression. But you certainly don't have to be dexterous enough to play a musical instrument to learn how to paint. Kazoos are my personal limit!

Opposite: Your result doesn't have to look decorative or organized like this brushstroke sampler. You can spread your investigations out over lots of pages.

Right: An example of dry-brush technique.

Handling the Brush

Each brush has the potential to make a variety of strokes and marks. You can create the tiniest, most delicate of marks, as well as dramatic and active strokes, with the range of brushes you have.

A particular brushstroke or mark is the result of all the elements listed below in combination:

1. Length, width, and shape of brush hairs.

2. Amount of brush hairs used—tip only, full face, half the hairs, etc.

3. Texture of brush hairs.

4. Consistency of paint on the brush.

5. Tempo of the strokes—fast, medium, or slow. The interval between strokes has a rhythmic impact.

6. Amount of pressure you exert on the brush.

7. Position of your hand on the brush.

8. Amount of arm, hand, and finger movement involved.

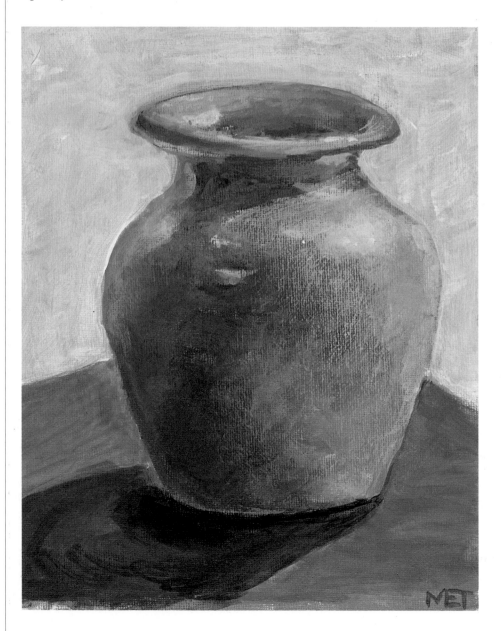

GREEN VASE, *by Mary E. Tangney, student* This beginner used a variety of brushstrokes to create different surfaces.

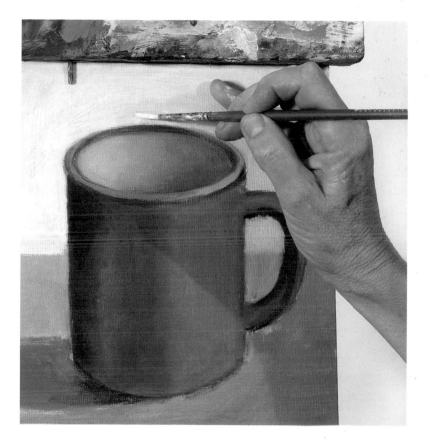

When adding precise detail, it helps to use some fingers like a tripod to steady your hand.

While most painting work is done holding the brush in the same way you would a pencil or pen, you can also move your grip up toward the ferrule for more control in small areas, or farther back for larger, freer strokes. The farther back you hold a brush on the handle, the less fine motor control you have.

Larger brushstrokes use more of your body, with the shoulder leading the movement; your fingers on the brush will be less active than when using smaller brushes. Stand farther from the painting surface to use these strokes. Medium strokes call for you to move in closer. More hand and finger movement are now required, with the elbow leading the movement. Small strokes require that the painter be close to the painting surface. Small brushstrokes are created largely with hand and finger movement, while the movement of the arm is more limited.

There are a couple of techniques that are useful for steadying your hand when using small, precise strokes:

a. Rest your wrist or forearm on a dry area of the painting surface for control when painting on a flat surface, just as you would when writing or drawing.

b. Rest those fingers not holding the brush on a dry area of the painting surface to steady your hand, like a tripod, when working either on a flat surface or at the easel.

As you'll see in the following pages, you'll change the way you normally hold your brush to create different brushstrokes, such as dry-brush, scumbling, and stippling. Painters use any part of the brush they can to get effective results, including the handle and ferrule.

EXERCISE: BRUSHSTROKES WITH MEDIUM-SIZE SOFT ROUND BRUSH

You have more control in medium to small areas with medium brushes than with large ones. Change colors if you like.

Draw two shapes: an uneven squiggly shape and a square. Fill in each, letting your strokes respond naturally to the contrasting shapes. Squarish shapes call for squared-off strokes, while freeform curves require more fluid ones. See Figure 4.

Figure 4

EXERCISE: STIPPLING

This is a technique where you apply short strokes and make little marks with the tip of your brush. Any brush size can be used, depending on the area you want to fill, but a pointed brush makes the job easier. The marks are often dots, but they may be any small shape. It's a useful technique, though generally not applied all over the painting, with the notable historical exception of the "pointillism" technique.

You can stipple in order to:

a. Fill in an area, or adjust a color by applying stippling over it.

b. Create the impression of texture.

c. Create an optical mix. This results when stipples of different colors are applied close to each other or overlapped, resulting in the impression of a new color.

1. Try stippling with the point of your medium soft-hair. While holding the brush vertically, use the tip to make small clusters of dots. See Figure 4.

MELON, BANANA, AVOCADO AND ORANGE, *by Erica Menard, student*

"For the melon I stippled paint over the entire fruit, and then strategically darkened and lightened areas afterward. The most difficult part was arriving at the color, not too green or yellow, dark or light, etc. The texture of the avocado was achieved by "pushing" the paint into the canvas with the end of a bristle brush to create the overripe areas."

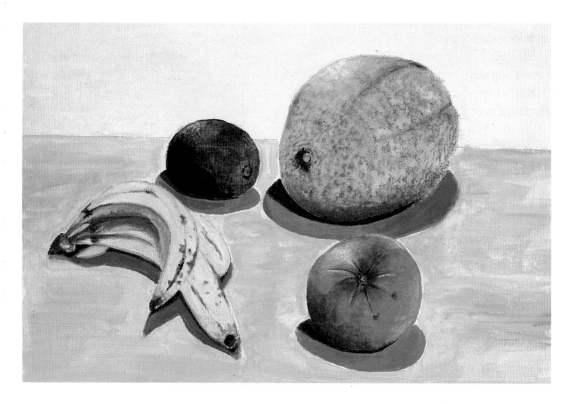

2. Stipple colored clusters of color: yellow and crimson, crimson and blue, yellow and blue. Step back to see whether the impression of orange, purple, and green has been created. See Figure 5.

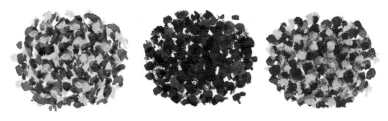

Figure 5

EXERCISE: BRUSHSTROKES WITH SMALL SOFT ROUND BRUSH

The smallest soft round, as well as the smallest bristle, are useful for detail work, especially for creating small linear touches. Since the soft round is more flexible than the bristle, it's more responsive when making lines that weave in and out.

Mix a small amount of medium-consistency paint with your small round. Make hatches—short little lines. Stack them up, then cross them over, like slanted tic-tac-toes. See Figure 6. Experiment making small gestural lines and curving contour lines. See Figure 7.

Bristle-Hair Brushes

One significant difference between your rounds and filberts is that filberts (flats and brights also) come with two different sides: broad and flat (the face) and long and narrow. Roll the bristle filbert in your fingers; take a look at the thin side of the brush, then the broad paddle shape. You can use both sides of the brush for a variety of effects.

EXERCISE: BRUSHSTROKES WITH LARGE BRISTLE BRUSH

Dip your large bristle in medium-consistency paint and scribble with it. Use the tip to make lines and dots. Your large bristle and small bristle can both be used for gestural lines and detail. They'll give you a slightly less fluid feeling than soft rounds. See Figure 8.

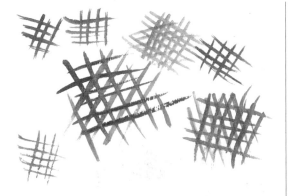

Figure 6

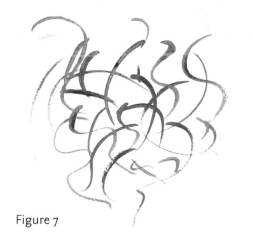

Figure 7

Figure 8

NOTE Optical mixtures occur when your brain rather than your hand does the mixing. For example, when the eye/mind of a viewer sees blue and yellow dots intermingling, it will make a summary of the color seen: green. Seurat's most famous painting, *A Sunday Afternoon on the Island of La Grande Jatte,* is composed of optical mixtures created by stippling.

Dry-brush and Scumbling

Dry-brush and scumbling techniques use the top surface peaks of the painting surface. If they are applied over an underpainting (see page 97), leaving its color visible and untouched, an optical mixture is created, because both top and bottom layers are seen simultaneously. For example, purple can result from dry-brushed or scrumbled layering of crimson over blue, one color on surface peaks, one on valleys. The effect can be bold, or very subtle.

Let's see how these dry-brush and scumbling effects are created, starting with dry-brush. Both techniques can be hard on the brushes, so bristles are more suitable brush hairs to use for these techniques than soft hairs, which will get damaged quickly. The medium-size bristle brush is the best one to use for these exercises.

EXERCISE: DRY-BRUSH

Start with medium-consistency paint. Apply brushstrokes in the manner you would use for filling in a small area. Continue to paint moving away from your starting point, without replenishing the paint on your brush, until you start to run out of paint. Then rub and scrub the brush onto the paint surface to get out any leftover color, until you leave only a faint trace of paint. This exercise naturally results in a veil-like dry-brush effect that just touches the paper peaks. See Figure 9.

Figure 9

EXERCISE: DRY-BRUSH SHORTCUT

You've identified the dry-brush effect and how it evolves naturally. Let's try a shortcut to the technique now.

1. Dip the brush into medium-consistency paint. Make a couple of small downward strokes with the broad side of the brush.

2. Then use a rag/paper towel to remove most excess moist paint from the brush. Use the long narrow side of the brush to scrub back and forth in the paint along the crisp outside edge of the paint you applied. You want your brush to create a soft edge.

This exercise naturally results in a veil-like dry-brush effect that just touches the paper peaks. Use this resulting veil of color on the top bumps of the paper to make a round shape. See Figure 10.

Figure 10

> **NOTE** Artists use any means at their disposal to produce an interesting paint application. Leonardo da Vinci often used his hands to blend, a practice not uncommon in the Renaissance. Jackson Pollack used a stirring stick to fling his paint onto the canvas. The brush handle is used sometimes to write or scrape into the wet paint, creating *sgraffito*, a scratched-in mark.

EXERCISE: SCUMBLING

1. Dip all the brush hairs in medium-consistency paint. Drag and rub the brush in an irregular pattern over your paper, sliding forward, backward, and side to side, moving it along like the family dog that is trying to get rid of an itch. It's a textural effect. See Figure 11.

Try it on top of another dry color for another optical mix.

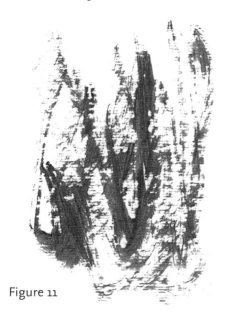

Figure 11

EXERCISE: MORE MARKS

You can create marks with methods other than a brush. For example:

1. Try printing with some paper toweling dipped in paint. Courbet used this technique to help create the impression of foliage texture in his landscapes. See Figure 12.

Figure 12

2. Experiment with the simple act of wiping paint off a painting surface to create a lovely transparent effect. See Figure 13.

Figure 13

Brushstrokes, Marks, and Your Painting

The exercises you have just done are designed to do more than make you familiar with brushes and creating specific strokes. They're intended to prepare you for painting convincing representations of the world around you, since there's a visual equivalent between that world and the paint effects you've just created. The range of painted impressions you see in a painting, from a seamless sky or flower petal to the bright highlight on a vase or the delicate tracery of vines, result from the variations in marks and paint applications created by a brush in hand. This visual echo between life and art makes looking at the world around you even more fun because you're beginning to look at it as a painter does.

For homework: Paint in your mind as you go about your day. Practice mentally matching the surfaces and textures you see in the world around you with the appropriate painting surfaces and marks you've created so far.

How to Fix It

"I am always doing what I cannot do in order that I learn how to do it."

PABLO PICASSO

Beginning painters often believe that a successful painting just flows out of the painter and onto the canvas in one seamless sequence. At least if you have "talent"! But the opposite is true. Paintings are created in layers, as you'll see. And paintings are corrected all the time, in every layer. In fact fixing them—which is the same as developing the work—is an integral part of creating them. Now that you have learned a variety of painting techniques, the next part of your training as a painter is learning "how to fix it." The following methods will help prepare you for the painting projects in the rest of the book, and you'll continue to pick up additional methods to improve your work as we move along.

Let's start with a few of the basics. After all, everyone feels better when he or she knows how to fix it!

Draw over. Use charcoal or pencil to change shapes; draw over dry painted areas with corrections, then paint in the newly defined shapes. This can be done at any time during the painting process to help you correct your painting. I use both charcoal and white blackboard chalk to make changes, depending on which value is easiest to see against the background color. Once I see how the change will look, the residue can be whisked off or blended into the paint.

Paint over. You can paint over any area you want to change when it's dry. If the area in need of correction is wet, wait until it has dried before painting over it if you don't want to mix new paint into a layer of wet paint, which will affect the color and value of the new applications. If you do want the change in color and value that will result, then mix new paint into the wet paint underneath.

Blot. Here are two ways that blotting can be used to fix or alter a wash:

a. If you need to soak up some unwanted wash immediately, use a rag or paper towel to blot it.

b. Blot a clean, moist soft-hair brush on a rag. Then use it to soak up and remove any unwanted extra wash.

STUDY OF A PORTION OF ROBERT HENRI'S *OLD MODEL WITH HER DAUGHTER,* *by the author*
When changing or testing shapes, white blackboard chalk shows up better against dark backgrounds than charcoal. See the chalk marks around the belly on the right side, and all around the arm on the left.

> **NOTE** Advances in technology allow us to look inside the layers of a painting, as though it were an archeological dig. We see the alterations to the painting over time preserved in paint layers, among them clear evidence of the charcoal used to redraw the outlines of figures. Recent investigations of Leonardo's *Mona Lisa* have shown us the corrections made during the course of the painting's development.

Wipe off. To remove wet medium-consistency paint, add water to the surface with a bristle. Scrub with the bristle to loosen the paint, then wipe away with a paper towel.

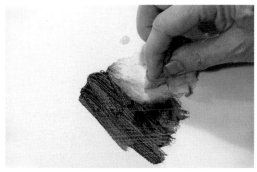

Wiping scrubbed off paint.

Glaze over it. Use a wash and soft brush to add more intense color, create a different color, change values, or neutralize a color. Keep in mind that the original underpainted color will be part of the final result.

Use two levels of the painting surface. You can use the surface tooth or textural bumps created by a previously painted surface to your advantage to get more texture or add subtle color. Paint can be applied to the entire painting surface, and after it has dried, paint is again applied just to the peaks to create interesting color impressions.

Dryish yellow paint brushed over previously painted green and red brings up the surface texture created by the underpainting. The impression of yellow green and reddish orange results from using transparent paint on top of previously painted colors.

Soften a crisp edge. When using medium-consistency paint, you can soften and reshape a crisp edge while wet or after it's dried.

a. For a still wet edge, weave the point of your soft round brush back and forth over the crisp edge to break it down.

b. For dried paint, rub dry-brush over the crisp edge, using the color of the surrounding negative space, or apply paint with your soft round over the edge with small back-and-forth weaving strokes to obscure its crisp definition.

Gesso over it. To erase an area, apply a thin layer of gesso to restore the original white, then repaint when the gesso is completely dry. This can also make the repainted area "pop" slightly.

Spray or mist with water. While the paint is wet, if you have a sudden "Oh, no!" moment, you can use a spray bottle to loosen the undesired paint area. The spray can hit areas you don't want to dissolve, so watch your aim and pressure. This can be difficult on small surface paintings.

Fix-it techniques will help you learn how to solve painting problems that are a natural part of learning to paint.

"I was looking at my painting of the lemon and I thought, this is wonderful to be able to paint over! Because I knew I had to fix the shadow."

Marilyn Wald, student

Pink paint was dry-brushed over a green edge to obscure and soften its crisp edge. Beneath that I applied strokes of green paint over a crisp red edge to create a new shape, then dry-brushed the edges of the new shape to soften it.

Constructive Attitude

Now let's introduce your most important tool, the one most likely to ensure your success in acquiring the painting skill: a constructive attitude. I've watched students with the least amount of initial painting facility develop far beyond their expectations, while other students with seemingly effortless ability fall behind. Why does this happen?

Over the years, I've come to the conclusion that this has a lot to do with attitude. It's not the person with the most easily acquired technique that makes painting a part of his or her ongoing life, but rather the person who has or adopts a productive learning style, the one who is fascinated by each new discovery (and has a good quotient of stubbornness!).

It can be difficult to maintain a good attitude. Representational artwork is challenging; greater technique is required to bring the subject to life than is needed for a generalized impression. If you're highly critical of your artwork, you're not alone—you're in the majority. Beginners are routinely tough on themselves, and shocked that anyone in class likes their work.

A critical attitude can be both helpful and hurtful. To move forward it is necessary to pick out what's not working, so you can fix it. On the other hand, a harsher-than-necessary attitude will block you. Your ability to hang in there with an open attitude and tolerate the period when you don't know everything you wish you knew, and can't do everything you wish you could, plays a significant part in the process. That's why you'll learn how to constructively evaluate your work in the next chapter, a powerful tool that will help you progress with your painting.

"A painter who entertains no doubt of his own ability, will attain very little."

LEONARDO DA VINCI

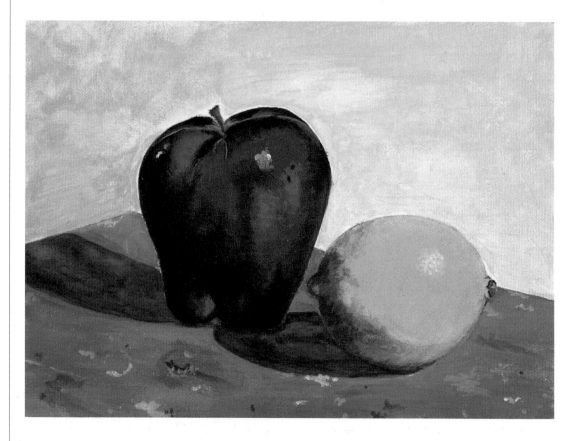

APPLE AND LEMON, *by Erica Menard, student*
The bold, assured impact of this painting was developed using constructive attitude along with other painting techniques.

Tips on Developing a Constructive Approach

If a constructive approach doesn't come to you naturally, take a moment to review the following suggestions. Think of them as part of your learn-to-paint painting technique:

1. Note your successes. You need to be aware of what is working (as well as what isn't), so that you can build on it.

2. Remain open to the possibility that your work will develop, and that you'll learn how to paint with a level of confidence. This is different from having to have a completely positive attitude.

3. Keep in mind that learning to paint is a progression; it doesn't happen all at once. Beginning painters want it now, and are frustrated until they reach the level they envision. Painting is an acquired skill that unfolds with ups and downs as part of its forward progress. So your learning curve may look more like a map of the Appalachian Trail than a simple upward curve.

4. Take the pursuit more seriously than each individual result. Give yourself permission to be "less than perfect" in the process.

5. Acknowledge that mistakes give you a chance to learn the solutions. And without experience in how to fix the painting, you won't develop as a painter. Painting is in large part about fixing the mistakes, and nudging the result into a satisfactory conclusion.

6. Remember, you're carrying some of the answers within yourself. Your aesthetic signature—what you like to look at, your color preferences, and the shapes that come naturally out of you— is already there. Being responsive to your aesthetic impulse is what will allow unique individual expression to emerge.

7. No two people paint the same picture. You have your own unique perspective to express. As I've seen in my own classes, results will always differ from artist to artist, even when a group of individuals is all engaged in painting exactly the same subject.

> *"Every good painter paints what he is."*
>
> JACKSON POLLACK

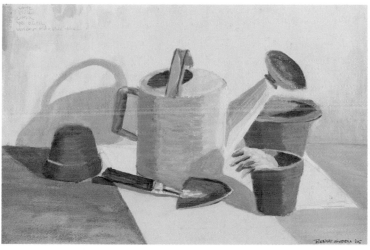

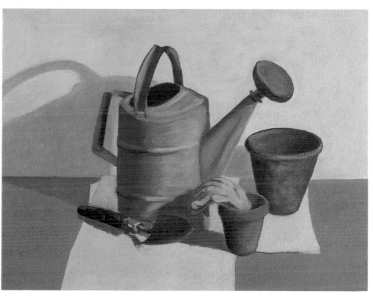

STILL LIFE WITH WATERING CAN, *by Renee Hansen Goddu (top) and Kathleen Bossert (bottom), students*

These two versions of the same still life by different artists are each interesting and unique based on the artist's choice of vantage point, color temperature, amount of value contrast, and elements each has chosen to include in her composition.

Tryout Time: Creating Samplers

"Remember, learn diligence before speedy execution."

LEONARDO DA VINCI

The first part of your painting experience introduces you to tools, painting principles, and techniques. Now you get to apply them in your first painting. You'll see that a lot can be learned about the dynamic properties of painting—what gives them their energetic power—without drawing more than a doodle.

The sampler is a tryout time. Just like the old-fashioned embroidery sampler, your painting sampler gives you the opportunity to create personal artwork while you practice the techniques and apply the principles you've learned about. It will be easier for you to learn how value, color, and compositional lines function in the sampler before you use them in a still life, figure painting, or portrait. All paintings are based on the same principles, so the sampler is a fun and simple way to prepare for representational painting.

Opposite: **SAMPLER,** *by Melinda Caldwell, student*

Right: **SAMPLER,** *by Eva Bergman, student*

Creating the Sampler

We're continuing with a palette limited to orange, blue, black, and white for our first project. I know beginners want to get into all their colors. It's like a candy box! And that's the right instinct. You'll want to find out what's in there, open caps, and take a look. But if you start painting with many pure colors, each one demanding attention, you're at a disadvantage in learning how to achieve harmonious balance in your work. And here I'm not referring to a state of vapid, sweet serenity. Harmonious paintings can be wild and full of bright color and high contrasts. However, even the wild ones should look unified, with every color piece part of a seamless whole.

And there are important advantages for you in using a limited palette of complements, plus white and black. You're prepared to apply what we've learned about the properties of colors. Successful paintings also have a limited palette. This means the colors you see in a painting have been created from a few pure paint colors. As we touched

on earlier, when colors are mixed from the same pure sources, they are related already. In addition, using a limited palette based on complements allows you to use your knowledge of color neutrals to help you create a painting in which colors will look like they belong together, thus giving a sense of harmony.

It's important to choose colors that you like and enjoy working with so that you feel connected to your work. If you are not a fan of orange and blue (or if you just need a change after a while), try using one of the other two complementary pairs: purple and yellow, or green and red, with white and black. That way you can still apply the concepts and techniques you've learned about. Your paint box contains two cool versions of green and red—phthalo green and naphtol crimson. If you use green and red, add some yellow as well to warm up one of them for some warm/cool contrast.

Another option is to create a monochrome sampler, in which only

STUDY OF MAURICE DE VLAMINCK'S 1907 *VIEW FROM A TOWN BY THE LAKE,* by *Julie S. Swearingen, student*

In this study, a beginner has explored the use of a phthalo blue, cadmium red light, and white palette to create the colors in this abstract landscape.

one color (such as blue) predominates. In that case, orange is used only to create blue neutrals. You can use orange, black, or any other single color to create a monochrome.

EXERCISE: PREPARATION/CREATE THE DRAWING

Make yourself comfortable at your workspace, with your sheet of watercolor paper in front of you. The following instructions may seem a little silly, but the result is fun, and will keep you from overthinking and allow you to settle more easily into the moment. Take your pencil in hand. Nothing can be more intimidating than that blank piece of paper! So, let's fill it up.

Place your feet flat on the floor. Concentrate on your feet until you can feel a little energy building in them, like a small tickle. Let that sensation rise to your knees and travel up your legs into your hips. Let it rise to your chest and flow slowly out into your arms until it reaches your hands.

Let this energy come into the fingers that are holding the pencil, then release it out on the paper in the form of a long, continuous line. Allow the pencil line to weave and cross itself at will. Let your pencil hand lead, while you follow. Shapes will be smooth or angular depending on how you feel they should be at the moment. When you feel you've finished, stop drawing.

Turn the paper over and do this again! Feel your feet. Let energy build and rise, letting it out and letting it go through your hands, with pencil on paper. Choose the drawing you like best.

Make a frame around the edges of your favorite side with strips of masking tape. Don't tape your picture to the table with it! The tape will provide a clean, sharp edge to your sampler painting when it is removed at the end. It will also allow you to crop your original drawing,

making it bigger or smaller, depending on the placement of your tape and the width of tape you apply.

Use 1-inch tape to make a 1-inch border around the edge of your piece, or make a narrower frame by folding unwanted tape around the edge. You can also choose to block out as much or as little of the drawing with your tape as you want. Using this technique, you can even make the final drawing quite small if you wish.

Stand up and look down at the drawing you have framed. The natural movement of your pencil in hand will create varying pressure on the page, which in turn gives the impression of space on a flat surface. If all lines remained equal in pressure this wouldn't occur. Instead they would seem to sit on one plane. You can also feel the way your eyes move around, following the pencil pathways. These lines define the shapes in a painting, and are called *compositional lines.* They pull your eye across and around the surface of the painting. The minute you make a mark on the paper you create *pictorial space,* which means that your marks make an artistic energy field wherever you put them, like turning on a power source.

SUPPLIES: pencil, masking tape, bristle and soft round brushes, cadmium red light, ultramarine blue (or phthalo blue), mars black, titanium white, a piece of scrap "tryout" paper

TIP The more crossovers and small shapes you make, the more painstaking it will be to fill in, so avoid lots of crossings if you don't want lots of small shapes. Draw close to the edge of the paper to break up large spaces near the paper's edge.

SAMPLERS USING COMPLEMENTARY PAIRS, *by Kristen Nimr, student* This student made two studies from a larger doodle to explore both the red/green and yellow/purple complements. Each study is accented with black pen.

> "When I am in a painting, I'm not aware of what I'm doing. It is really only after a sort of "get acquainted" period that I see what I have been about."
>
> JACKSON POLLACK

EXERCISE: BLOCKING IN

Squeeze out your four paint colors into four corners of your palette paper, leaving room for mixing in the middle. Orient your drawing to work on in any direction that you want. Fill in the shapes you've drawn any way you wish, using color mixtures you like, any consistencies you choose, and whatever brushes you prefer.

Use this exercise to try out some of the techniques you have learned—such as glazing, dry-brush, or wet-into-wet—and combine them, or even invent something yourself. Your painting can be mostly blue, mostly orange, or a combination of the two, depending on what you feel like trying. If you want to use textured paint, experiment with building up thickness; and if you feel like using only washes, do that. Let your instincts lead you.

Your task is to do what pleases you and to forget about anything else.

To get maximum benefit from the colors, don't forget the beautiful variety of neutrals you can mix to help you harmonize your painting and make the pure color stand out.

This first stage is often relaxing—where you experience a timeless, wordless "zone" often associated with right-hemisphere brain dominance. This helps you deal with the more challenging aspects of your work. The painting process can take you "there," and so painting is not just about the final product, it's also about being in that place where time stands still, a feeling so pleasurable that when you get pulled out of it, it requires some adjustment!

TIP Paint flows across borders if both are washes. Let one wash dry completely before you paint another next to it.

Development Stage

You'll take on a new role in the second stage of creating your painting when you step back to gain perspective on it, and *constructive evaluation* begins. Using this technique you'll identify what works, as well as what needs to be improved in your painting. Then you'll learn how to develop it by adjusting colors, shapes, and values until the whole painting works.

Constructive Evaluation

You generated the first stage of your painting by letting the initial creation emerge, working by instinct based on your understanding of new techniques and principles. When your painting feels almost finished, or when you just don't know what to do next, put it against a wall or a countertop. Step back ten to twelve paces, far enough away for you to see it from a distance. You will see the painting differently by viewing it from this new perspective. Patterns will emerge, the overall value structure will become more evident, and balance and harmony issues will come to the fore.

There can be a Wow, I love it! Or disappointment. But that's why you've put it up there: Not just to admire it, but to improve the work.

Smart painters have been using this technique of stepping back to evaluate for centuries. And it's not a tool exclusively used by artists: we see it applied to any

activity where we want to improve. Think of a football team reviewing tapes of their performance, watching their effective plays and their missteps on the field. (Too bad they can't just paint over them the way you can.)

If you haven't painted before, it may come as a surprise that not all elements of the painting work out in the first attempt. You may not have known that you have to strengthen your painting, to develop it or fix it. Or even that it's part of what's expected. However, nearly all paintings need to be developed. The right to do so is always yours. That's one of the nice things about art: you can change it, and for the better.

Finding Solutions

The key to evaluating your painting effectively is a balanced approach where you see both positives and negatives, learn from what you see, and *avoid* destructive evaluation. It's essential to stay connected. You're engaged in a dialogue with the work. You'll continue to develop as long as you remain interested in your choices. It literally shows when you paint and don't care.

It's time to use what I refer to as your coach and player relationship. All of us already have both these capacities; now you're going to apply and coordinate your own in order to further develop your painting. When you paint according to the rules as far as you understand them, you can compare your activity to the player on the field.

Next you'll use your capacity as coach to review what has been done, to see what works and what needs to be improved.

Coach and player are alternating roles; they conflict when you attempt to do them simultaneously. In general, your coach capacities are associated with the left hemisphere of your brain, which analyzes and makes plans, while your player is connected to the nonverbal (except for poetry!), in-the-moment, creative solutions of the right hemisphere.

Define What Is and Isn't Working

What's not working? Look at your painting and observe where your eye travels naturally. Is there something you see that bothers you? Beginners usually have a good sense about what isn't working for them in their sampler. It can simply be "I don't like that big blue shape," but it isn't "Something in the painting bothers me." It's important to be specific— specific problems have specific solutions.

What isn't a problem? Sometimes beginners have a fear that their work is too weird or strange, dark or depressing, especially when they think of what other people might say when they see it. Dark paintings and grayed-down neutrals can have their own mysterious beauty. You don't have to create a "nice" or pretty painting or whatever you imagine anyone else would approve of—remember, you are the only one you need to please.

"A man paints with his brain and not with his hands."

MICHELANGELO

DOODLE USING BLACK AND WHITE, by Kristen Nimr, student

"I'm such a black-and-white person that I did this. I'm not a color person and I also love texture."

What is working? What you like is what works. Not what you anticipate someone else will like or you should like. If you're overwhelmed with what doesn't work, you need a foothold to begin the process of reworking. Even if beginners dismiss what they've done and think, "It's horrible," they will often grudgingly admit that they really like a particular color area in the work.

Look for it. Once you find it, you'll have a key to what works for you. Then you can rework the painting by adding more of that pleasing element, whatever it is: a color, a soft neutral. Artists also routinely make a painting by cutting a small piece that works out of a bigger piece that doesn't.

Color, value, shapes bother you? Check out the fix-it techniques in Chapter Four

"Creativity is allowing yourself to make mistakes. Art is knowing which ones to keep."

ANDREW WYETH

and match your problem with the right fix. You may want to repaint or redraw a shape. There's no right answer when it comes to what appeals to you. The technical aspects are the tools you need to facilitate that decision. You don't have to "know the answer" right away. Often you live with it until you "know" what you'd like to try. And see if it works.

Out of balance? Do you look at your painting and your eye gets stuck in one area, off to one side, and you don't like the way that looks? A painting needs movement and balance, like a mobile. The most common problem with a sampler painting is that it is out of balance. When a painting is out of balance, it simply means that the viewing eye will just get stuck in one area when you want it to move through its visual pathways freely, exploring all the aspects of the work.

How to Fix Balance Problems

The source of balance problems and the solution to fixing them both lie in the power of certain visual elements to attract our eye immediately and hold it. This is an inescapable fact, grounded in human physiology. And it doesn't mean that we don't examine other elements too as we gradually explore the painting.

For example, if you were to pick up the *Mona Lisa* and turn it upside down so it looked like an abstract design, your eyes would gravitate automatically toward a large, crisply defined central shape, painted in medium-consistency warm colors (Mona), more than the less-defined shapes painted in thin, cool, milky colors (landscape) surrounding it.

Imbalance in your sampler and any painting occurs most noticeably when a large proportion of the heavyweights—those elements that capture our attention most strongly—are gathered in one corner or half of a painting.

The solution for imbalance in the sampler is to redistribute the weight, especially some of the assertive elements, into other areas of the painting. This distribution of visual elements within the painting creates a *composition*. Much as in real life, we want these contrasting elements to coexist in a balanced relationship in order to make the whole work harmonious, rather than splintered into sections. When we achieve this it's called a *balanced composition*.

Give some thought to how you do this. Don't just repeat colors and shapes at equal intervals or you'll get wallpaper. Experiment. Check out your additions from a distance to see how the balance changes. You're working on a visual puzzle.

Let's compare the two versions of one sampler painting below to see how redistributing some key elements can turn an unbalanced composition into a balanced one.

It's usually not a problem when the heavy elements in your painting fall in the middle. In fact, it centers the painting. Placing the thickest, lightest, purest colors centrally is a principle applied in successful representational paintings, where the focus has to be more centralized. However, a sampler is more like an overall energy field, and a central focus isn't necessary. Even in representational painting, however, your color needs to be shared with the rest of the painting so the center looks connected to the whole. This is in line with the kindergarten axiom: share your treats and there will be greater harmony.

Paintings usually contain a mixture of heavyweights and lightweights, or assertive and recessive elements, distributed across the painting surface. The contrast between them creates variety and interest.

Balancing with Color

You may have a sense about where to put your color: use that feeling inside to guide you. To balance out a pure color such as orange (or any other color you may be using) introduce it around the painting in a number of guises to create a visual path. The eye will pick up on these references and connect the dots, following these color references around the painting. Just like Hansel and Gretel!

Here are some tips for ways you can create a color path using variations on any single color in your painting:

1. Paint over other shapes throughout the painting with that color, or with slightly lighter (white) or darker (black or darker complementary pair) versions of it.

2. Use neutrals, derived from the color, with or without white, to help draw the eye to other areas.

3. Dry-brush it, or use it as a glaze/wash to introduce it elsewhere in a subtle form.

TIP Our eyes are more instinctively drawn to some elements than to others.

Assertive Elements
- Center of the painting
- Emphatic lines, and shapes with strong outlines
- Pure color
- Thick paint
- High-contrast areas
- Warm color
- Light color

Recessive Elements
- Edges of the painting
- Faint compositional lines, and soft-edged shapes
- Neutral colors
- Thin paint
- Low contrast
- Cool colors
- Dark colors

Before

SAMPLER, *by the author*
In the "before" unbalanced image your gaze is pulled to the lower right by high contrast, pure blue and orange, and crisply defined edges. In the "after" image I added crisp edges, more contrast, and lighter, warmer colors to the left to balance the composition.

After

Know When to Step Away

If you can't decide what to do, sometimes you just need to leave. Take your mind off it for a while, and then look again after a break. When your coach is stumped and can't figure out how to fix what isn't working, your player can't do much. Your coach and player may need a time-out. Stepping away clears your mind for new solutions to arise. It doesn't mean you aren't connected. It means you're using a strategy to refresh your connection. Just picture yourself hanging out with Leonardo at a Venetian café and you may relax a little bit more when you take your break.

Why Does It Work to Take a Break?

It's been suggested that your brain continues to work on a problem long after you consciously put the problem aside. Have you ever tried unsuccessfully to recall a name, the lyrics to a song, or a state capital, then taken a break, only to have the answer pop up hours or more later out of the blue? A similar dynamic is at work in painting. Sometimes you're tired, sometimes the brain is looking through a vast archive of buried information, so time is required.

Other times more than a retrieval of information is involved. You're looking for a new idea, a different way of approaching something, an insight. Creative breakthroughs come to people in many fields, from physics to music to the visual arts, after they take a break from the problem solving itself. Often such breakthroughs require several days to take place.

Over the centuries, artists have had a mysterious feeling that art comes from somewhere else. This is due in part to the fact that the process of painting can become trancelike and very much a spontaneous process. We access parts of our brains suited for nonverbal, visual problem solving and a new capacity we may not associate with "thinking." But we are continuously solving or working through problems, just as in dream states we now know that the brain continues its functions, though we are only vaguely aware of this. In fact, it has a name: *creative emptiness.*

Finishing

When you think you're finished developing your sampler, remove the masking tape. Then look at it on the wall set off by its crisp white paper frame. Finishing is a personal decision. You could work on something forever! Leave it up to look at when you walk by to help you decide. You can always add finishing touches if you feel like it, or maybe you're really finished!

Your Emerging Aesthetic

The most basic evidence of personal style begins when you create something as simple as the doodles you drew for the sampler. The first lines you draw create shapes that are uniquely your own, reflecting the way you move. Your choice of colors—warm or cool, muted or high-contrast—as well as the consistency of paint you choose, gives early evidence that your inner personal aesthetic is shaping your artistic choices as a painter.

When beginning painters in my classes and workshops create their samplers, with no more preliminaries than you have had in this book, class members are astonished by how unique and different every resulting painting is. You called upon your own personal aesthetic to create the sampler, and it will continue to emerge, evolving as you evolve, influencing your choices as we move into representational painting. You can use it as a guide.

The key to developing your aesthetic is to "listen" to it. You're working now to develop skills to better support your unique vision and its expression in the painting medium.

Applications of the Sampler for Representational Painting

Each masterpiece you see in painting books or museums has been created with an awareness of what are called the formal elements of painting—color, value, shape, line. These elements form a vocabulary for the secret language of painting. You've just been using this visual language to express yourself by creating, evaluating, and developing your sampler.

Take a look at the student's study of Cézanne's *Still Life with Apples* below to see how Cézanne used the methods that you've been learning about to unify and balance his painting. Mixtures of red/green complements, plus yellow and white, provide a limited palette from which all other colors were mixed, creating color unity. Notice how vibrant reds, and high contrast along the crisp white edge of the plate, leads your eye back toward the center, even though the table edge and lemon are tilting diagonally down to the left.

Though the sampler is an abstract painting, the same principles and techniques you applied to create it continue to play a central role when you paint a still life, portrait, or nude. These formal aspects function as the driving energy in all paintings. The material you've covered so far will give you the necessary techniques, tools, and understanding you need to continue your exploration of color, and to create your own representational paintings in the coming chapters.

STUDY OF CÉZANNE'S *STILL LIFE WITH APPLES*, by Liz Finkelstein, student

Use this study to identify the techniques that Cézanne has used to balance this unorthodox composition.

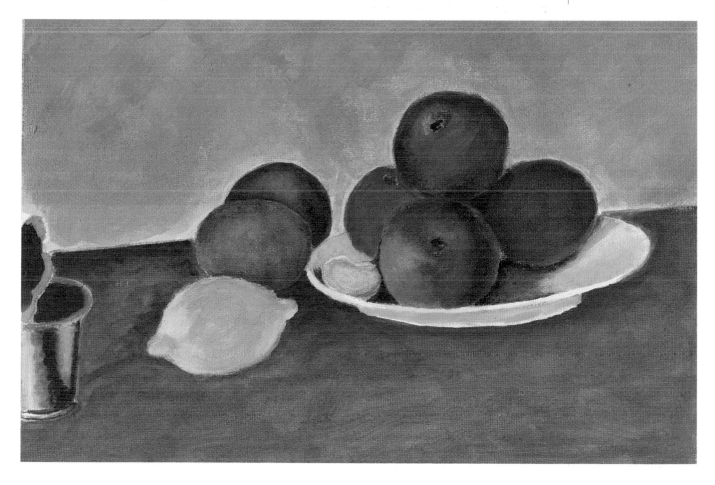

CHAPTER SIX

Exploring Color Relationships: Making Color Charts

"Color is my daylong obsession, joy and torment."

CLAUDE MONET

When we see a color chart in a book, we often nod in recognition and turn the page quickly, rather than stop to explore it. When you make one yourself, however, that response changes. Handling your painting materials, mixing and applying the color, leads you to a firsthand understanding of essential color relationships. Not to mention that the results are quite lovely to look at! In fact, I've been surprised by how much my students enjoy creating them. And they tell me it's because they learn so much about color doing so. They pencil in information on color mixtures they made on their charts, put them on the walls where they paint, and refer back to them regularly for help in tracking down particular colors they need for a painting. Experiment with making some charts to see if they are useful to you as well.

Opposite: **STUDY OF MATISSE'S MADAME MATISSE,** *by Renee Hansen Goddu, student*

Right: **GREEN BOTTLE,** *Diana Ringelheim, student*

The Primary Color Wheel

The small three-color wheel is your one stop color source. Just like an ancient talisman or Rosetta stone of color, it's your key to truths about color. The primary colors—red, blue, and yellow—are the source of all color. They contain all the "color DNA" from which all other colors are derived.

In nature—meaning in the spectrum of light—primaries can't be derived from any other existing colors, while all the other colors in the color spectrum can be derived from the primaries. The three secondary colors—purple, orange, and green—are created from the primaries. Red and blue together make purple, red and yellow make orange, blue and yellow make green. Tertiary colors—reddish orange for example—are created from one primary, in this case red, mixed with an adjacent secondary, orange. Look at the charts shown on these two pages to see these relationships.

EXERCISE: PRIMARY, SECONDARY, AND TERTIARY COLOR WHEEL
You see three color wheels at right and opposite—the primary, secondary, and tertiary. Paint your own wheel in order to experience how colors expand and develop from the essential primaries.

Colors on this chart are taken directly from the tube when possible. Chemistry allows us to use colors that are closest to what we see in the spectrum of color in light. If we were to mix green from ultramarine blue—the color that matches primary blue—with yellow, the result would be dull in comparison. You can make each wheel separately, or simply create the large wheel, which is a combination of all three wheels. The largest wheel shows you the relationship between primary, secondary, and tertiary colors.

SUPPLIES:
medium-size soft-hair brush, small soft-hair brush, pencil, naphthol crimson, cadmium red light, ultramarine blue, cadmium yellow medium

Primary Color Wheel
1. Trace a circle, then make a "Y" in the middle. Fill in cadmium yellow medium in the top triangle, ultramarine blue in the lower right, and mix a primary red with naphthol crimson and cadmium red light and then fill in the bottom left triangle with it.

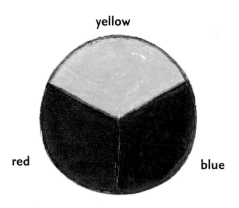

Primary Color Wheel

Secondary Color Wheel
2. Add a half-circle cap on top of each line at the edge of the primary wheel. Fill in the secondary colors above their parents: cadmium red light where red and yellow meet, dioxazine purple where red and blue meet. Mix some yellow into phthalo green and fill in warm green where blue and yellow meet.

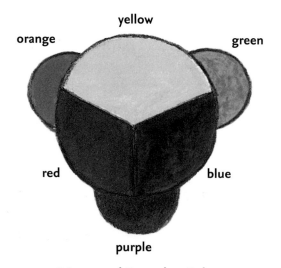

Primary and Secondary Colors

Tertiary Color Wheel

3. One primary mixed with an adjacent secondary gives you a tertiary. Add a triangular shape on either side of the half circle, six in all around the circle. Fill in each with the following different colors, using the labels to help you. Start at the top upper left triangle with yellow orange, and continue filling in each triangle clockwise around the circle.

Mix:

1. Cadmium yellow medium and some cadmium red light = yellow orange

2. Cadmium yellow medium and some phthalo green = yellow green

3. Ultramarine blue and some phthalo green or blue = turquoise (greenish blue)

4. Ultramarine blue and some dioxazine purple = bluish purple

5. Naphthol crimson and some dioxazine purple = violet (reddish purple)

6. Cadmium red light and some naphthol crimson = reddish orange

> **TIP** The primary wheel has a memory feature to help you recall complementary pairs. When you mix two out of three primaries, the resulting color will be the complement of the remaining primary. For example: blue and red create purple, the complement of yellow, the third primary.

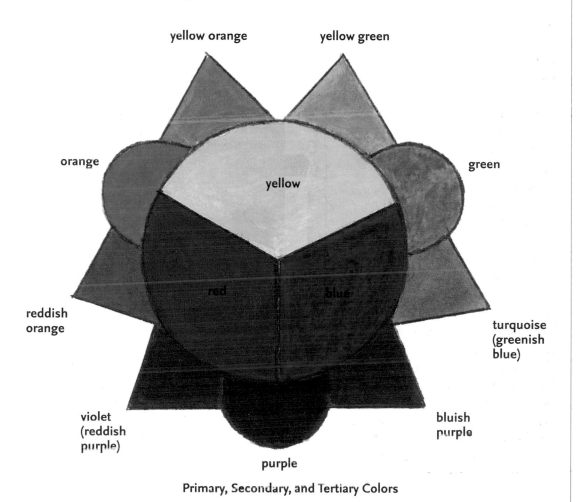

Primary, Secondary, and Tertiary Colors

Tints and Shades

SUPPLIES:
two pieces of 11 × 14 watercolor paper to fit the chart in easily, ruler, pencil, small and medium soft-hair brushes, all the colors in your collection, masking tape

"I had no idea that a lot of these colors when you add black and white would make what they made. I had no idea of all different colors you could get just by adding white and black. I'm amazed."

Nancy Brown Condon, student

We were partway through a painting class when I suggested a student could use burnt sienna to warm up a color. He looked at me blankly and I realized that he hadn't opened all his colors yet.

This is natural. Vibrant colors— brilliant yellows, intense reds, mysterious blues—grab our attention, while the quiet earth colors—burnt umbers and sienna, yellow oxides—remain on the sidelines. As we learned in the last chapter, that's how we view paintings as well. More intense colors take center stage, while subduer colors provide the setting and support that isn't always appreciated.

But now it's time we meet the whole team. Your goal will be to get a look at what other colors are at your disposal. You already know how tints and shades are made from mixing them with orange, blue, black, and white in chapter three. You'll simply be extending that skill to your other colors now to get practice creating the value variations of every tube color—and to store up experience recognizing these colors so you can call them up when needed. Create the chart opposite to do that, but in doing so remember that it does not have to be perfect.

There's another practical benefit that arises from this chart: it prepares you to create the illusion of spatial dimension in your paintings. Once you can create tints and shades of all your colors you're better prepared to create the two variations —colors in the light, and shadow colors—needed to create the illusion of three-dimensionality.

EXERCISE: TINT AND SHADE CHART
Each of your tube colors has a value relative to the others. You'll see these on the chart in a vertical value scale starting with the lightest value (yellow) and ending with the darkest (burnt umber). In the middle of each horizontal line is the pure color, which has a range of light and dark values that can be expressed in a value scale; these appear horizontally, with values getting lighter to the right of the pure color and darker to the left.

1. Line your ruler up horizontally with the top of your paper, starting two or more inches below the paper's edge. Trace the top and bottom horizontal edges of the ruler. Place a strip of tape along the top and bottom traced edge of the ruler. Then place your ruler along the bottom edge of the tape, and trace the ruler again. Repeat.

You'll need to create nine to ten bands, depending on how many colors you purchased. Your ruler width determines the width of each horizontal band. If you prefer to draw your lines freehand, that is also fine. It's okay if your squares come out lopsided.

2. Place your ruler vertically in the center of your horizontal lines and trace both sides of it. Your ruler width determines the width of each vertical band. It's okay to draw over the tape, as it will be removed later. Add three more vertical lines to the right and left, creating seven squares per line. Don't separate verticals with tape.

3. Fill in the center square first with pure color in medium consistency. No washes. (You may need to paint two layers on this square to get a more opaque, truer version of the color. Paint over the first layer later when it's dry.) The vertical sequence of colors will be cadmium yellow medium, cadmium red light, naphthol crimson, yellow oxide, burnt sienna, phthalo green, phthalo blue, ultramarine blue, dioxazine purple, and burnt umber.

4. Then create a value scale of tints to the right of the center square by adding varying amounts of white to the pure color. The lightest square should be the one on the far right. Create shades with increasing amounts of black added to

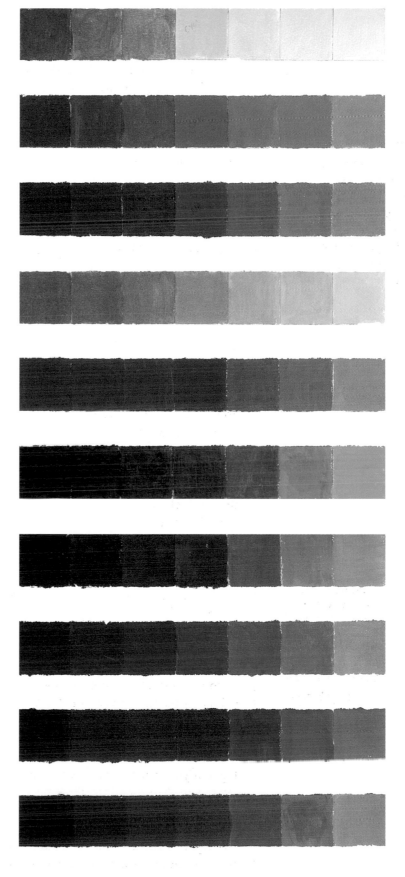

> *"Shadow is a color as light is but less brilliant! Light and shadow are only the relation of two tones, one variation of that color in the light area, the other variation in the shadow color."*
>
> PAUL CÉZANNE

the pure color, with the darkest on the far left. Add only a tiny bit of black at a time; with the dark colors it is especially easy to make one long, dark rectangle. Glaze over the color at the end to pick up the color if needed. Finish one color and its variations before moving on to the next.

5. You can be sloppy filling in along the top and bottom edges of your squares because the tape provides "a mask" (a protective cover for the painting surface), but try to be more precise on the left and right sides of the squares where there is no mask. (You can always touch up spillovers with white.) You don't have to achieve the right color straight from the palette. If you see color that needs altering, change it with the wet-and-wet technique, applying the necessary color over the square on the page. Or wait till the square dries to change it. Remove the tape when your colors have dried.

TIP Some students like to make notes on the charts to remember the mixtures and label the colors.

TINT AND SHADE CHART,
by Anne Smith, student

Extended Color Wheel

"I enjoyed the color wheels but found I couldn't paint within the lines!"
Diana Ringelheim, student

NOTE Earth colors— yellow oxide, brown, burnt sienna—don't appear in the spectrum of light. You can create their equivalent by mixing colors on the extended wheel. In pure form these three colors can look harsh. Mixed, they become rich and wonderful colors. Add black or blue to the browns to take the edge off them, use yellow oxide to lighten colors where the goal is a warmer but not intense result.

The extended color wheel is both an expansion of the color relationships you're familiar with and a visual representation of timeless color principles that have existed in light since the beginning of time. When we look at the color wheel, we see the expression of a number of universal color properties.

Warm and Cool Colors

The wheel divides in half horizontally into warm and cool colors—the warm colors are on the top, the cool colors on the bottom. In addition, the wheel divides clearly into contrasting light and dark values. Notice that warm colors are lighter values than cool colors.

Complements and Near Complements

The three complementary pairs are opposite one another on the wheel. However, any color opposites on the wheel will function as a complement does. As you know, complements once mixed can make each other disappear. Or weaken each other, depending on the amounts added. Yellow, green, and violet are direct opposites, and will neutralize each other when mixed. Once you get used to the idea that near complements will neutralize each other, you can create shadows and neutrals from them as well.

Analogous Colors

Colors that sit next to each other on the color wheel are analogous colors, similar in makeup, and contain similar colors, for example, primary red and orange. These create more harmony with each other in a painting, but not necessarily the excitement created by contrasting colors. Mixing analogous colors together will alter the colors but not neutralize or change their natures radically. Notice that analogous colors can cross over the middle line—primary green and phthalo green, for instance.

EXERCISE: EXTENDED COLOR WHEEL
Making the chart is a simple and efficient way to familiarize yourself with the differences between working with the darker transparent colors and warmer, more naturally opaque colors. Paint a chart to make it more real, fun, and relevant to your development as a painter. Having created the wheel, you'll have more experience with the relationships and the colors it holds. In the future, you may want to refer back to it.

Colors for the Extended Color Wheel

WARM:

primary red (a warm fire engine red)	naphthol crimson and cadmium red light
orange	cadmium red light
yellow	cadmium yellow medium
yellow orange	cadmium yellow medium, a little cadmium red light
yellow green	cadmium yellow medium, a little phthalo green
primary green	cadmium yellow medium, a little more phthalo green

COOL:

crimson	naphthol crimson and a little ultramarine blue
violet	dioxazine purple and naphthol crimson, or ultramarine blue and crimson
purple	dioxazine purple, or ultramarine blue and naphthol crimson
ultramarine blue	ultramarine blue
turquoise	ultramarine blue and phthalo green, or phthalo blue
phthalo green	phthalo green

1. With your pencil trace a circle on watercolor paper using a circular-shaped object. Make a horizontal line across the center of the circle, and put a dot in the middle. Draw a big "X" through the dot to create six pie segments. Divide those in half to make twelve. Don't worry about creating equal size pie segments. The focus here is accurate color and color sequence.

2. Fill in color, starting with any segment you like. To help you paint crisp edges, paint every other shape, so you don't have to be concerned about smearing wet edges. Use your smallest brush to outline each pie shape first, then fill in with a medium brush. Keep turning your paper around for easier access. You may need two layers for opaque coverage, especially in the cool hemisphere. Remember to let the first layer of paint dry completely before adding a second layer.

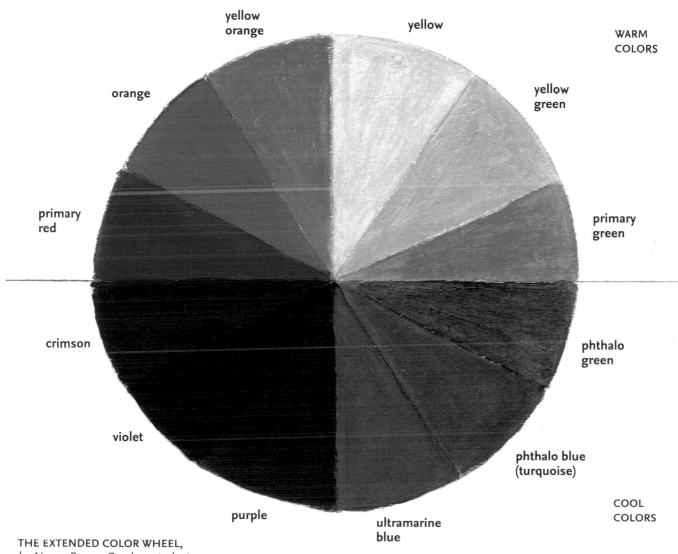

THE EXTENDED COLOR WHEEL,
by Nancy Brown Condon, student
The extended wheel gives us a snapshot look at a variety of different properties of color.

Glazing

Now that you've learned more about the properties of color, let's learn more about glazing. Glazing is a widely used form of optical mixing in which wash is applied over a dry, previously painted surface (or underpainting) to alter the color impression of that surface. You were introduced to glazing in the previous chapters, but if you would like to get into the technique more deeply, try making the more complete chart in the following exercise.

Transparent colored glass has a counterpoint in transparent wash. When I first read Leonardo da Vinci's accounts of experimenting with colored glasses, I imagined him wearing colored bifocals, a bit like John Lennon! Of course, he was holding individual pieces of colored glass and looking at the countryside through them. He was seeing what would happen if he looked at a purple object through yellow glass: you got "a bad mixture," meaning a cancellation of color. But crimson through yellow? A nice mixture, resulting in orange.

Leonardo da Vinci's observations relate directly to how glazing works, as well as to the power of complementary colors, because the color we see when we look at two colors simultaneously, whether looking at them through a wash or glass, depends on the two colors involved. Leonardo predated the discovery of color complements in the 19th century with his experiment when he saw that two particular colors seen simultaneously through a transparent layer would yield a bad result, or neutralize each other, while another combination would result in a vibrant pure color.

> *"Take some coloured glasses, and through them, look at all the country around: you will find that the color of each object will be altered and mixed with the color of the glass through which it is seen: observe which color is mixed better and which is hurt by the mixture."*
>
> LEONARDO DA VINCI

SUPPLIES:
ruler, blue tape, soft-hair round brush, pencil, cadmium yellow medium, cadmium red light, phthalo green, ultramarine blue, dioxazine purple, naphthol crimson

EXERCISE: GLAZING CHART

Patience is the most important technique here, because each layer of paint must dry completely before the next layer goes on! Use a hair dryer to speed up the process. It's a good project to do over the course of a few hours, when you can just do a little at a time. When you look at the results here, it is hard to imagine that the colors you see are the result of layering.

1. The setup for the structure of your chart is similar to the Tints and Shades Chart setup. However, this time you want to separate each square by taping both horizontally and vertically. Leave on all the tape until you finish the project.

2. You should now have thirty-six squares. Label colors in the same sequence vertically and horizontally just as you see on the chart, so you can keep track of them.

3. Start with cadmium yellow medium on the upper left. Fill in the first horizontal line of squares with yellow wash, painting right over the tape. Fill in the rest of the horizontal lines with the colors listed vertically on the chart.

4. When these are completely dry, turn the paper counterclockwise so that crimson appears at the top left. Layer wash in the color labeled to the left on top of what you've already painted. So, to start, crimson will be painted horizontally from left to right over all the colors—from crimson to yellow. Then go to the next line and paint dioxazine purple over all the colors, continuing down the chart. To obtain more intense results, go over these colors with the same wash (crimson over crimson, etc.) and let dry.

Your result can be very intense or very subtle, depending on the color of the square underneath (or underpainting), the strength of the washes used, and the number of layers you apply. The transparent quality of wash allows you to see both the colors of the wash and

	cadmium yellow medium	cadmium red light	phthalo green	ultramarine blue	dioxazine purple	crimson
cadmium yellow medium						
cadmium red light						
phthalo green						
ultramarine blue						
dioxazine purple						
crimson						

"When a transparent color is laid upon another of a different nature, it produces a mixed color, different from either of the simple ones which compose it."

LEONARDO DA VINCI

GLAZING CHART, *by Nancy Brown Condon, student*
This student is particularly adept at creating a glazing chart.

underpainting at once, creating the impression on the eye of a new color. Depending on the colors used, this technique can not only create a new color, but also darker or lighter values, more intense versions of the same color, or a neutral color. The only time you will see a pure version of any color is in a square where it crosses only itself.

The benefits of using glazing technique are twofold:

1. It saves time. Acrylic paint layers dry quickly enough to let us glaze over effectively in a short period of time. Instead of remixing, you can adjust color with the application of thin layers of glaze, which can be built up gradually for more control of value, color, or intensity changes.

2. You can achieve subtle results. Use a few thin layers of glaze to slightly neutralize, darken, lighten, intensify, or adjust color. A dark mixture of complements can be used as a glaze to push a surface back. Depending on the number of applications, the surface can be pushed back farther and farther.

NOTE Flemish and Italian Renaissance painters used a combination of oil paint in opaque consistency and glazes to achieve a three-dimensional look. First, a painting was created in opaque monochromatic (one color), often in shades of brown. When that was completely dry (which with oils could take weeks or even months), glazing began: transparent paint was layered on the underpainting, slowly building a jewel-like colored, transparent surface over it. This tinted the monochrome, which in turn could be seen through the color.

Keys to 3D:
Creating Spatial Illusion

"I never saw an ugly thing in my life, for let the form
of an object be what it may—light, shade,
and perspective will always make it beautiful."

JOHN CONSTABLE

Now it's time to learn how to give the illusion of spatial dimension to your painting. The skills you will learn are the keys to creating convincing representations of the world you see around you, and they'll also be useful in creating more impressionistic painting styles. You'll be able to assess whether you "got it" because you'll paint from a visible subject right in front of you with which you can compare your results. So let's add this spatial element to your artwork by learning how to create shadows and apply them effectively in order to bring out dimension in the shapes you'll be painting. It's challenging and fun, and the result can be quite magical.

Opposite: **THREE SPHERES,** *by Barbara Bosill, student*

Right: **TWO ONIONS,** *by Julie S. Swearingen, student*

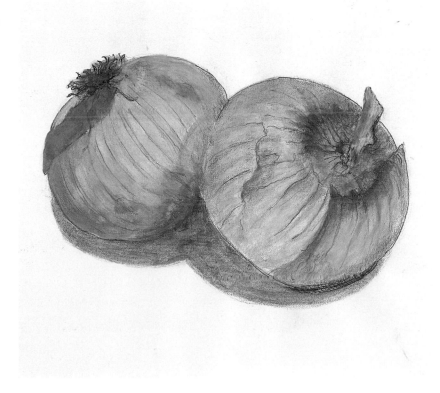

The Importance of Shadows in Creating Dimension

The success of a representational painting relies on an understanding of how to create the impression of a three-dimensional space on a flat surface. Shadow values play an important part in creating that illusion. They send a signal to the viewer that the world you have created in the painting is subject to the same effects of light and shade as the world we live in. This helps to give the impression that you've created a believable representation of a shared "reality."

NOTE The play of light and dark over shapes, which "models," or imparts dimension to their shape, is called *chiaroscuro* (kyar-oh-SKOO-row), another lovely sounding Italian word that you'll see in art history books.

Shadow Value Structure

The shadow value structure is part of the overall value structure of the painting. Shadow values are composed of:

Form shadows, located on the object itself. Form shadows are dark value shapes seen in contrast to the areas of the form in the light. They generally have a crisp edge along their outside contour and a soft edge where they transition into the light value areas on an object. Form shadows give objects an impression of volume.

Transitional shadows, narrow, soft-edged shapes found in the area between form shadows and areas in the light. These shadows form a middle value between high-contrast dark and light values on an object.

Cast shadows, images of the object "cast," or thrown, onto a surface other than the object they are derived from. These shadows create the impression that the object is grounded on a surface.

A point of balance shadow, or darkest area within the cast shadow, found under the object. It reinforces the impression of an object at rest and subject to gravity. It is also an *accent,* or one of the darkest areas within the shadow values. Accents are the dark counterparts to *highlights,* which are the lightest areas found within light value areas.

Each of the shadows and aspects of light mentioned has a unique shape, reflecting the shape of the objects and light conditions that create them. Among them, the form shadow will play the greatest part in giving objects the look of spatial dimension.

Lighting your subjects enhances the patterns of light and dark, creating more pronounced patterns. This gives you a better chance to observe the interlocking light and dark shapes you'll need to give your painting a spatial effect.

The easiest way to observe these interlocking value shapes, and the transitional shadow between them, is to squint hard while looking at your subject. Squinting reduces your ability to perceive details, thereby helping you to focus on basic value relationships.

Lighting also provides one of the visual elements that make the world of art and the real world it portrays look more mysterious, dramatic, and alluring. You may notice that the higher the contrast—with deep shadows playing against well-lit areas—the more dramatic the result.

When you paint, you'll fill in light and shadow values on the object with light and dark value of the same color paint. You'll create the transitional shadow, and its soft contour, which is a blend of both color values. The ability to create the transitional shadow will be an important element of *modeling the forms,* the technique used by painters to re-create the impression of light falling across objects, which results in a believable version of our spatial world.

Draw First, Then Paint

Learning to mix color is the most challenging part of painting and takes the most time. However, you draw each time you paint in order to create the

underlying recognizable image that you build on, as well as to better understand the value scale of the painting and to make decisions about composition.

There's a reason drawing is called the foundation art. Each painting that you make, as well as those you've seen in museums and galleries, is preceded by a period of drawing preparation. It's the basis for your understanding of what is going on in front of you, and is the way to take your observations to a deeper level. Your painting is built on principles you learn in drawing, which introduces you to the fundamental concepts in basic form, such as how values create the illusion of three-dimensionality.

"The precision of naming takes away from the uniqueness of seeing."

PIERRE BONNARD

TEAPOT, *by Liz Finkelstein, student*
Shadow values play an important part in the overall value structure of your painting. Can you locate the form shadow, cast shadow, and point of balance shadow? Notice how the transition between form shadow and light area on the teapot is soft.

Universal Painting Principles

Beginners often assume that every new subject, whether a still life, portrait, or nude, requires a new approach. In our everyday world, the name of an object does set it apart from other objects. At first, paintings seem to be about the name of the subject matter—that final recognizable image of landscape, bowl of fruit, or portrait of Mona Lisa. And when you paint, you do change color and shape from subject to subject.

However, the principles that govern how you draw or paint your subjects to give them "life" and dimension remain the same whether you're painting the roundness of a model's arm, the turn in a bottle, or the cheek of an apple. And it makes your painting task easier when you

concentrate on the color value shapes that make up an overall image rather than on the name of that image.

You'll be aware of the name of what's in front of you the same way a florist will know the names of the flowers she's working with. But the job at hand requires thinking of those flowers foremost as colored shapes that must work effectively together in space and with the shape of the container holding them. Remember, this shift in the way you look at the world takes time to occur, as your brain responds to a new set of commands. You're learning to look at the world through new eyes, from the perspective of a painter who looks at the world for the purposes of painting.

TIP If you have no prior drawing experience, read the material on the next page on accented drawings, but skip the "how-to" exercises. Resume with "Modeling the Forms with Medium-Consistency Paint," which contains basic and accessible drawing instruction.

Creating Dimension with Wash

SUPPLIES:
medium soft-hair round brushes, pencils (a regular HB pencil, 2B, and 2H if you have them), your choice of paint colors, waterproof pen

It's not how much paint covers the surface, but how effectively it's used that matters. You can create expressive, dimensional-looking paintings simply by using your drawing skills, then applying wash. In this section, you'll learn how to create a variety of washes—graphite wash using pencil dust and water, gray wash from diluted black paint, and color washes—and how to apply them for this purpose.

Graphite Wash

Graphite wash is water tinted with graphite (pencil lead) particles. Water and particles of graphite blend together to create a gray wash that smoothes out the graininess of pencil shadows and transfers light-gray wash into the light area of the object as well. By adding this gray wash to your drawing, you'll give it the appearance of a painting. The bonus is that values have been put in place before adding water: you don't have to paint them in.

Scribbles Tryout

1. A standard HB pencil is fine for this. If you have a 2B pencil and a 2H pencil, they will give you more distinct value contrasts. Use the 2B for drawing objects with a darker value range than a HB, a 2H for a lighter range. Scribble lightly and then add pressure with the pencils you have.

2. Apply clear water to your pencil scribbles to see the range of grays you can create. You can control the value of a graphite wash with the amount of graphite you apply, either through adding layers, by putting more pressure on your pencil, or with your choice of pencil.

EXERCISE: ACCENTING WITH GRAPHITE WASH

Use graphite wash on a drawing to lend it a subtle, unifying gray smoothness.

1. Choose small, light-value objects. Light them to create shadow values, if needed.

VALUE STUDIES, *by Julie S. Swearingen, student*

This artist experimented using pencil and graphite wash, then adding some gray paint. The more experimenting you do to see what works for you and what doesn't, the better.

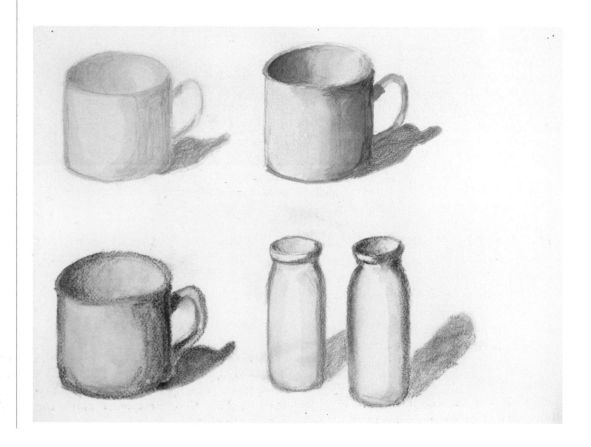

2. Select and draw one object. Squint, add shadows with fine scribbling. Outline highlights lightly.

3. Add a thin layer of clear wash to the entire drawing, which will pull graphite from the pencil drawing, creating a light-gray wash. Cover all but your highlights. Shadow values will be visible through it.

4. When this dries completely, step back, view the painting in a vertical position, and deepen the shadows further with more pencil and water, if needed.

EXERCISE: ACCENTING WITH GRAY WASH

Create your drawing with a light indication of shadows, rather than by making a complete rendering. Create a gray wash by diluting black paint. Start with a pale wash, applying it to the crisp edge of the shadow area. Soften the transitional edge between light and dark by blotting the brush, adding it to the edge to drink up excess wash. Let dry completely. Wash over the entire piece to create the local value, or leave as is.

EXERCISE: ACCENTING WITH PEN AND GRAY WASH

Experiment with adding pen to a pencil/wash drawing to provide high-contrast definition. You can continue to layer wash and pen, waiting for each layer to dry. A waterproof pen is necessary for this layering, and it shouldn't be used on wet surfaces.

EXERCISE: ACCENTING WITH COLOR WASHES

Instead of a clear wash, apply a wash of the overall local color of the object. The wash will color the object in the light area, and the shadow pencil values will be seen through it, lending dimension. You can control the color intensity desired by gradually adding more layers of the same wash. Wait until each layer is dry to do this, or add more when paint is open.

2-4-05

VALUE STUDIES: APPLE, ORANGE, JAR, AND CASSEROLE, *by Diana Ringelheim, student*
"These studies are made with gray wash and pencil . . . so forgiving!"

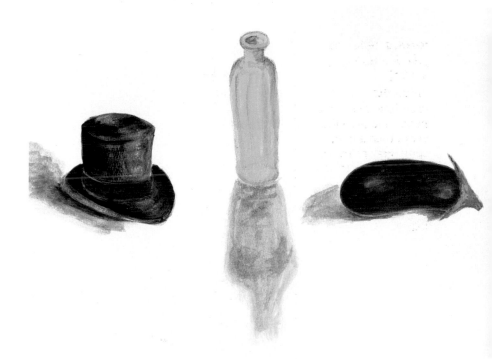

BOTTLE, EGGPLANT, HAT, *by Diana Ringelheim, student*
"The triple study of top hat, green glass, and eggplant was made using layers of wash, ending with a bit of dry-brush white here and there for shine. The objects were drawn in pencil first, then color was added with wash."

Modeling the Forms with Medium-Consistency Paint

"At first, I thought dry-brush was horrible. I hated it. Now I'm starting to really get it. It feels so fluid. I was just using these big blobs of paint until I realized I don't have to use this much paint."

Liz Finkelstein, student

Medium-consistency paint, especially when layered, creates opacity, allowing you to paint over underlayers and make changes. Opacity can be used to give surfaces the appearance of greater solidity and weight as well, because you are in fact adding weight to your painting by adding a somewhat thicker substance. Thicker paint creates the impression that the painting surface is advancing toward the viewer, because it's literally closer to you. It has a three-dimensional quality of its own and sits slightly higher off the painting support, especially in comparison with wash, which is a thin film and seems to recede slightly from the viewer.

The contrast between thick and thin paint creates the impression of spatial differences, just like the contrast between color temperatures. You've learned that certain shapes—thickly painted in warm, light color—will seem to advance toward you in contrast to shapes that are thinly painted, cooler, or darker, which recede. This is known as the *push/pull effect*. And this impression relates directly to the impact of light areas versus shadow areas on individual subjects that you paint. When light areas seem to come forward on an object and shadow areas to move back on the same object, you are creating the impression of a dimensional change on that object.

You'll hear the words advance and recede in relation to the *picture plane.* This isn't a real surface you can touch, but it does correspond to the actual surface of the painting. The picture plane describes the imaginary flat surface of the painting, which separates the everyday world we live in from the imaginary world of the painting, much like Alice's mirror in *Through the Looking Glass.*

Creating Effective Shadows with Medium-Consistency Paint

Additional techniques are needed to create shadow areas effectively with medium-consistency paint. You'll learn how to adapt two techniques you've already been introduced to—wet-over-dry and wet-in-wet—to create shadow value shapes. We'll start with the wet-over-dry method and later in the chapter move on to some exercises with two wet-in-wet techniques that are a bit more challenging.

Wet-Over-Dry

In this wet-over-dry method the first paint to go on the painting surface creates the shadow values. The bristle brush is used to create them, with a dry-brush technique used to soften the transition edge. Once this dries, the color of the shape is applied over it with wet paint. I like to start beginners with it for the following reasons:

1. Beginners get good-looking results quickly.

2. Beginners often forget to put in the shadow values entirely, because they're so focused on mixing color and applying paint. So we try to get these important values in there first.

3. Beginners don't like to feel rushed; wet-in-wet methods mean they have to work against drying time.

Use the shortcut for the dry-brush technique you learned in Chapter Four for the following exercises. The coarse hairs of your bristle brush can provide a subtle, soft effect. If there's a lot of paint on your brush, you need to make sure you take it off at the transition point between dark and light. One of the important factors to remember in

using dry-brush is that less is much more. Sometimes just a whisper of this technique can speak volumes. Experiment, take your time, practice. You can cover a sheet with your tryouts.

EXERCISE: MODELING A RECTANGLE INTO A COLUMN

1. Sketch or trace a rectangle with a pencil about 2 inches wide and 3 inches tall. Correct the symmetry by making sides parallel to those of your paper. Apply black paint in medium consistency in a narrow band along one side of the rectangle, starting at the crisp edge.

2. Remove excess wet paint from your brush, as though you were cleaning off the paint. Turn the brush to the long, thinner side and scrub the hairs back and forth in the wet paint just along the edge of the black paint, softening it. Let this dry completely.

3. Apply your favorite paint color in medium consistency (not wash, or too gloppy!), starting on the opposite unpainted side of the rectangle. Phthalo green worked well for me here. Continue to paint right over the dry shadow. Stand up and look at your work. You should see the effect of the dark value through the color, creating a colored shadow. If you want your shadow darker, add a little more black to the crisp edge, mixing it with the color. Let it dry.

Constructive Evaluation

Paintings are created at the end of your nose, or arm, but viewed from farther away. Step back, then look at your painting in a vertical position. Your blending technique doesn't have to look seamless up close—it only has to give the right impression from an average viewing distance.

TIP If you need to fix the symmetry of the shadow, use white to correct it when it's completely dry. Turn the painting around to reverse the position of your rectangle. Paint with white over the area you want to correct using a thin dry-brush technique. Let this dry completely.

SUPPLIES:
medium-bristle brush, pencil, mars black, your favorite paint color

Use your brush to break down the edge of the black paint you applied after you've wiped down its bristles.

Wiping off looks like cleaning up. However, it's a crucial part of the dry-brush technique.

Begin applying paint on the light side of the rectangle.

Paint over the black shadow. Don't try to cover it completely, as you want the shadow to show through. Let it dry completely.

EXERCISE: MODELING A CIRCLE INTO A SPHERE

1. Trace a circle about 2 inches in diameter with your pencil: the inside of a masking tape roll works nicely as a template.

2. With your pencil, lightly scribble in a crescent moon–shaped shadow that is pointed at both ends.

3. Paint in the shadow using the tip of the brush for narrow shadow points; wipe off excess paint, then soften the shadow edge with dry-brush. See Figure 1.

4. When the area is completely dry, you can correct with white paint, if needed.

5. When the shadow (and any correction in white) is completely dry, paint your choice of color over the light area and over the shadow area. See Figure 2.

Figure 1

Figure 2

Constructive Evaluation
Step back. Does either your rectangle or circle look transparent where your strokes can be easily seen over the light area? If so, put on another layer of paint of the same consistency, or add white to your color for opacity. If your shadow gets too light, add some black to it.

Highlights
When all your surfaces are completely dry, it's fun to add a highlight with your small bristle. Make, then test, your white dry-brush over another color on scrap tryout paper.

Column
Apply the highlight as a vertical line in the brightest area of the color on the rectangle. Drag the white dry-brush in a vertical line until you build up brightness. See Figure 3.

Sphere
Put the highlight in a round application with soft edges on the cheek of the circle in the light areas. Add a little bit of impasto in the middle for greater brightness. See Figure 4.

 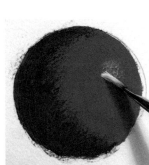

Figure 3 Figure 4

Negative Space Painting
You can correct ragged, uneven edges by painting in the negative space around them. Use white or black here to straighten out or define the edges. This technique will be useful in the future, with whatever background color you have. See Figure 5.

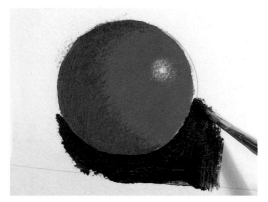

Figure 5

Constructive Evaluation

Step back to see if your paintings work at viewing distance. Have you created the beginnings of turning a rectangle into a column, a circle into a sphere? If so, congratulate yourself! You're modeling the forms!

> "You don't totally own the skill you are working on for a while. You're just at the beginning and not totally confident. It takes time. Once I get the skill then I need to remember that it's applicable to all the different genres."
>
> *Pam Booth, student*

Two Wet-in-Wet Techniques

Wet-in-wet techniques are useful for creating shadows and for painting in general. When using wet-in-wet techniques, the paint in both the light areas and shadow areas is wet. Success depends on judging the "open time" of the paint, and being ready to go, with your steps clearly in mind so you can work while the paint is receptive. Here are some practice exercises:

EXERCISE: WET-IN-WET METHOD #1

1. Draw a rectangle with your pencil. Sketch in a shadow shape.

2. Create a light gray, the "local color." Brush it over the entire rectangle. Add black in the shadow area, starting at the crisp outside contour edge. See Figure 6.

3. Mix black paint with the wet underpainted color to achieve shadow color. Soften the transition edge, weaving the tip of your brush hairs back and forth to blend the light area and shadow edge.

> **TIP** Every object has its own unique shadow. The form shadow will have the local color of the object in it. Start looking at the world around you to mentally practice how you would mix and apply the form shadow color.

With both wet-in-wet techniques, you don't want to create a ridge of thick paint at the transitional shadow area. Remove excess paint that builds up when you are softening the shadow edge. See Figure 7.

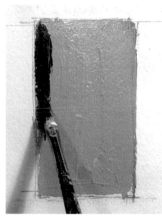
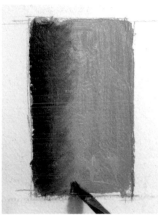

Figure 6 Figure 7

EXERCISE: WET-IN-WET METHOD #2

1. Draw a rectangle with your pencil. Sketch in a shadow shape lightly.

2. Create a local gray color. Use black, or create a dark gray for your shadow color, if you like.

3. Paint up to the shadow edge with the local color. Apply the shadow color up to the light edge, then blend, weaving the paint back and forth using the front hairs of the brush. See Figure 8.

4. You can finish off by smoothing the paint over the transitional area with light vertical strokes. See Figure 9.

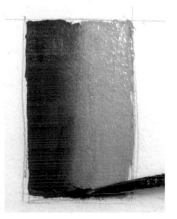

Figure 8 Figure 9

Lost and Found Edges

The melting effect, or "apparent lack of clear separation," between some shapes is visible on areas along the outside edge of these spheres, and also in the transitional areas between shadow and light. My dry-brush "tryouts" appear below like puffs of colored smoke!

Whether you see a sharply defined shadow edge or one that seems to melt into the background will depend on the amount of surrounding contrast. The term used to describe this difference is "lost or found edges." In the case of a dark background, contour edges of a shadow get lost in the background. In contrast, it's easy to find the crisp edges of the form shadow against a light background.

> **NOTE** Leonardo da Vinci is credited with the technique called *sfumato* (sfoo-MA-toe), the application of soft "smoky" transitions between form shadow and light areas on shapes, as well as between shapes and surrounding space.

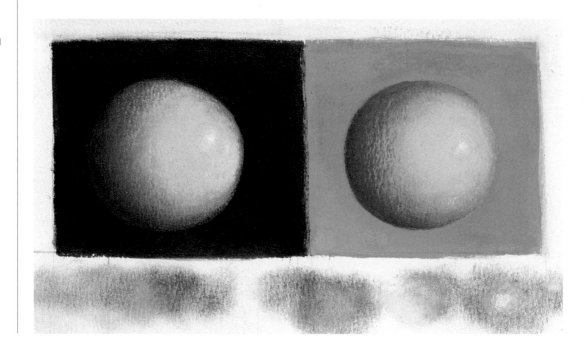

Creating 3D Objects

I brought some nice subject matter to a beginner's class devoted to drawing and then painting the form shadows on white objects. Among the pitchers, bottles, and egg cartons were toilet paper rolls and paper towels I'd grabbed as an afterthought. Everyone liked those the best. They provide a nice transition from rectangle practice to 3D object, and I recommend them especially for those inexperienced with drawing.

Even if you're rusty or haven't had training in drawing, I think you'll find this process accessible. If you'd like more information, *Drawing for the Absolute and Utter Beginner* will give you detailed instruction on how to draw the basic shapes in this exercise with accuracy.

Using Your Easel

If you have an easel, you can start working with it now. Easels are adjustable to your height. The lower horizontal ledge holds the bottom of your drawing pad or canvas. When standing in front of the easel, your eye level should be just

above the center of the canvas. You don't want to be looking up or down at the canvas. Adjust the easel so that the canvas is approximately vertical, then slightly tilted back for comfort, if you like. If you don't have an easel find a comfortable chair, put your pad on your lap, and rest the back of it against a table.

EXERCISE: DRAW A PAPER TOWEL ROLL

1. Put your subject on a table in front of a plain background, for example, a white wall. Light it with one reading lamp (or mounted clip-on light) to one side and slightly to the front to bring out form shadow and cast shadow. Don't light it from behind (backlighting). Close off other light sources.

2. Put your newsprint pad on the easel. Break off a small piece of charcoal, about ¾ to 1 inch long. Rub on paper to flatten one side. Draw the cylinder shape with the end of the charcoal. Make two vertical lines to create the sides and width of the cylinder, with an ellipse (flat disk shape) on the top and bottom.

3. Step back and check to correct symmetry. Verticals should be parallel to the sides of your paper.

4. Squint to find the shape of the shadows. Apply vertical strokes to create the crisp form shadow on the cylinder edge. Let up pressure where shadow and light meet, making lighter strokes at the edge. Soften them by smudging with your finger, or if you prefer, with a Q-tip.

5. Fill in the cast shadow (lying on the table) if you want to include it. Apply horizontal strokes within the cast shadow to make it seem to lie flat on the table surface. Add the darker accent under the cylinder at the point where the balance shadow is evident.

6. Put the drawing near the "model" and step back. Correct if needed.

The movements you used in applying charcoal are similar and transferable to the process of applying brushstrokes. Both should be made in reference to the direction of the surfaces you're looking at.

EXERCISE: PAINT A PAPER TOWEL ROLL

1. Draw on your watercolor paper with pencil or charcoal. Indicate where the shadow values will be with light scribbling.

2. Fill in with paint, following the steps from your choice of the previous rectangle to tube/column techniques.

SUPPLIES:
newsprint pad, vine charcoal or pencil, kneaded eraser, towel roll, mars black, titanium white, bristle or soft-hair brush, watercolor paper

"Drawing the paper towels and roll was a confidence builder before we tackled the painting."
Lucia Brown, student

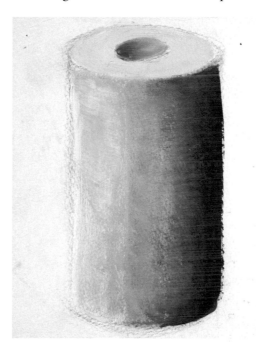

PAPER TOWELS, *by Julie S. Swearingen, student*

"I used charcoal on watercolor paper to do the drawing and shading and added mixtures of white and black paint on top of that to develop the light and dark value changes."

3. Step back frequently to compare subject and painting from a distance. Your blending technique doesn't have to be seamless: It just needs to give the right impression from farther away. Make necessary corrections, and add finishing touches. Take breaks, and take as long as you and the painting need.

4. Do you see areas of reflected light within the form shadow? If so, paint them in with a gray glaze or dry-brush. Squint hard so you see that these lighter areas fall within the overall shadow and are not as light as the light areas.

Brushstroke Direction

Stroke direction can create space. Now that your paint is somewhat thicker, the direction of your brushstrokes starts to show more, and this matters. When you paint, use the brush as though it was an extension of your hand, something through which you could feel the surface in front of you. Respond empathetically to what you see. And move with the direction of the surface to re-create it on your canvas.

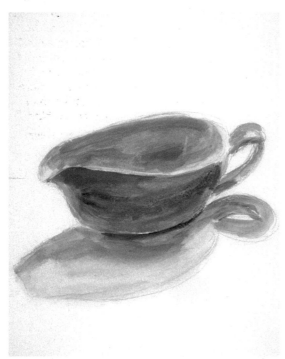

Before

GRAVY BOAT, *by Mary E. Tangney, student*
The horizontal brushstrokes inside the gravy boat make it look as if there is something covering the opening (before). Painting over them with vertical brushstrokes creates the impression that the container is empty (after).

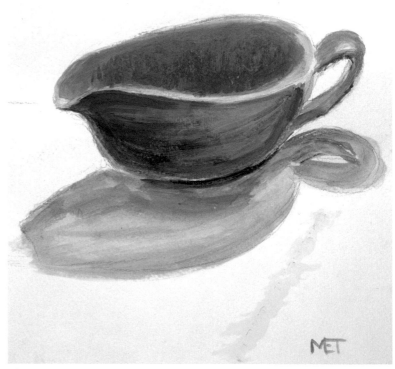

After

The Color of Shadows

What's the color of a shadow? It's always a darker value of the color in the light. Traditionally, brown or black were added to create shadow colors. We use black for our initial exercises because it's the easiest choice. However, these colors have drawbacks. Black is not considered a true color and can have a deadening effect on others, reducing the overall color quotient. Brown alone tends to leave a muddy appearance on the canvas.

In my classes, I suggest using "faux black" (a term I coined): a mixture of ultramarine blue and burnt umber that creates a black substitute. Ultramarine blue and brown are useful colors on your palette in any painting. Mixed together, these two colors make a color-full black substitute. They also allow you to create a warmer or cooler dark, depending on the proportion of each in the mix. With white added, the grays available are multiplied

as well, and can range from the earthy brown grays to cooler blue grays.

EXERCISE: CREATE FAUX BLACK

1. Mix ultramarine blue and burnt umber together to create a black color. Add white at the edge of your mixture.

2. If your resulting gray is brownish, add more blue to the original mixture. If the original mixture is bluish, add more brown. A warm/cool balance will give you a true black; add white for a true gray.

As you know, complements can also be used to create shadows. In many cases the result will be more accurate. For example, when test painting a green cup and a pumpkin-colored cup for a workshop, I found that only the addition of crimson to the former, and blue to the latter, created an accurate color. If you need to add a darker hue to the shadow than the complement will give you, supplement with faux black.

NOTE In order to realize more accurate shadow color, the Impressionists applied to their paintings what they had learned in Chevreul's *The Principles of Harmony and Contrast of Color.* These were considered revolutionary discoveries on the nature of complementary colors.

"It was interesting to see how colors dulled down when you added the complement but the color still would shine through. It was a lot more interesting than if you added black."

Pat Glass, student

A mixture of burnt umber and ultramarine blue results in faux black (middle), as well as cool and warm darks (top right and bottom right). The addition of white creates an interesting range of grays.

Adding white to black results in less colorful grays than when burnt umber and ultramarine blue are mixed.

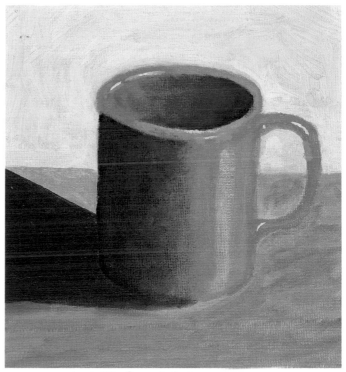

GREEN CUP, *by Caitlin Gury, student*
The shadow on this green cup was created with crimson. This shadow color looked more accurate than when black had been added.

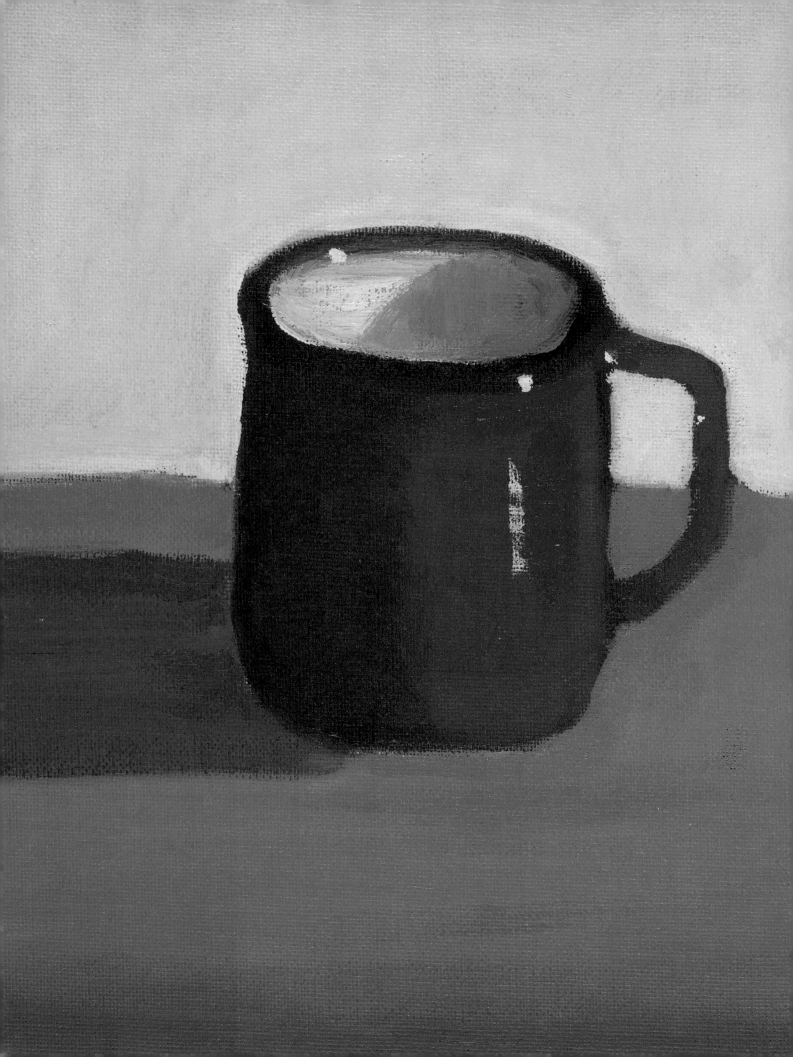

CHAPTER EIGHT

The Basic Format: Still Life Painting

"Draw your pleasure, paint your pleasure,
and express your pleasure."

PIERRE BONNARD

This chapter lays out a basic prototype you can use for any painting on canvas. All the material you've learned so far has been preparation for this exercise. In the process of creating your own painting you'll gain the understanding that all paintings are created in a few basic stages. As you go forward with new painting projects, additional material will be added to this basic format.

Your subject is a simple, opaque one-color container—plastic mug, enamel cup, casserole dish, or pottery jug. These common shapes are useful subjects for beginners. By painting a simple container, you can learn the basic techniques needed to create the illusion of three-dimensionality in whatever other subject you might want to depict—flower, fruit, face, or figure. Every subject you'll paint is a container of some kind.

Opposite: **CUP,** *by Pamela Willmer, student*

Right: **BLUE POT,** *by Dora J. Odarenko, student*

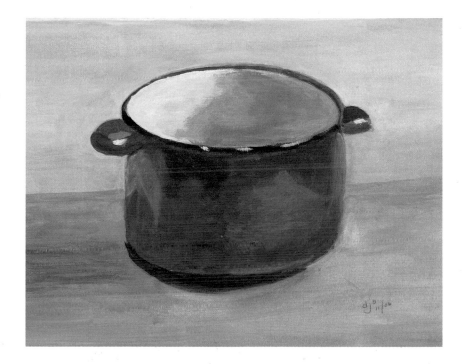

The Basic Stages of Creating a Painting

> "The actual experience of creating a painting was eye-opening. The process is really like a complex construction project—you have to build upon each prior step to create a realistic image that replicates or interprets the object as you see it."
>
> *Norman Rosner, student*

The purpose of this exercise is to experience the steps used to create a painting on canvas. If you feel a bit confused during the exercise about where everything is going, this is an understandable response. It's somewhat like looking at a pile of puzzle pieces and wondering what the heck the final puzzle will look like. But then, as you put the pieces together, the final form slowly emerges.

After following the progression of projects to this point, you are familiar with the techniques used to create a painting on canvas. Only now all the stages are piled on top of each other! Although creating a painting is a continuous process, we'll start each new stage with

step number one. You'll have the best outcome if you focus on completing each individual stage, rather than on the final product as you imagine it should be.

A container is an ideal first painting subject because few drawing elements are required to draw it, and those can be learned quickly and easily checked for accuracy. The palette can be kept limited so that the mixing challenges are minimized, and a variety of useful techniques can be learned in painting one simple subject.

We use this material in a 5-hour workshop, where people who have no drawing or painting experience learn how to create a painting from start to finish. Workshoppers had the same basic preparations as you've received so far. However, they have to work under pressure due to the time constraints, while you'll have more time to practice and comprehend the process at home.

Set Up Your Still Life

1. Find your subject. Pick an opaque container in a single color with a basic, symmetrical shape from your treasure trove.

2. Arrange your still life elements: subject, background (a plain white wall, white sheet, or piece of paper) and table color (gray or brown surface or cloth). If your subject has a handle, consider turning it around so you don't have to paint it. Your first project is challenging enough. I spent more time on my handle than on the rest of the painting!

3. Light your subject with artificial lighting from one side and slightly in the foreground to create a simple pattern of

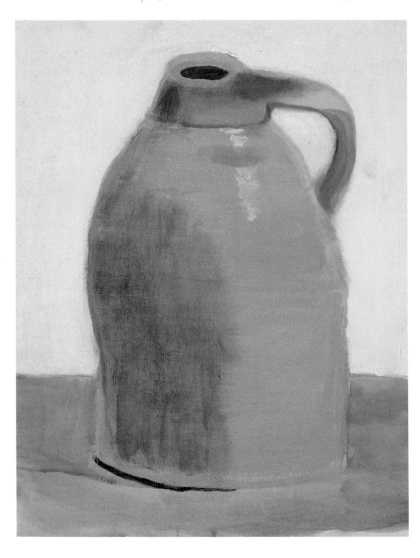

BEIGE JUG, *by David DePeano, student*

By creating a recognizable shape, adding a shadow value structure, and mixing neutral colors successfully, this student was able to create a believable painting of a hand-thrown jug with a substantial feel to it.

form and cast shadows. Turn off the rest of the lights in the room or keep them low. Avoid backlighting.

4. Create a comfortable place to paint in relation to the setup: close enough, but not too low or high. If you have an easel, you will want to use it with this painting project. Draw and paint from the same position relative to the setup, whether at the easel or not. If you draw from one position, but paint from another, the images will be different, and confusing for you to reconcile.

Create Your Composition

The moment you create an image on your canvas, you've created a composition— an arrangement of positive and negative space shapes. On canvas, the outside contour of the canvas defines the edges of your composition in a very definite manner. The subjects you paint within this defined area are the *positive shapes*; the surrounding shapes created by it are the *negative shapes*. You can control your composition rather than have it just "happen." That way, your chances of creating a balanced and harmonious painting will increase.

Composition is an invitation, a type of visual hospitality. As an artist, you're searching for the composition that will best lead the viewer's eye into your work to show him or her what you find interesting and beautiful.

Preliminary Drawing

Explore your compositional options by making small "tryout" drawings on scrap paper to figure out where you want your subject within the compositional rectangle. Charcoal is the best medium for creating *thumbnail* or small compositional drawings: responsive, easy to change, it lends itself to bold drawings. You can do as many of them as needed in order to decide on what you want. These drawings help you visualize how

the composition will work on canvas so you can adjust it beforehand. You'll use these as a guide when you transfer your drawing to canvas. Spending some time up front saves you the time that might be wasted on a painting with a composition that didn't work from the beginning.

Be sure to add the shadow structure, which influences the balance within the composition. Make a decision about whether your canvas will be in a horizontal or vertical position: select according to which shape looks best with your object. Draw a frame of four lines around what you've drawn to represent the edges of the canvas: these are called *framing lines*. Ask yourself if you could do with less negative space or need more.

Simple Compositional Guidelines

You want the eye to focus on the subject, and less on the space around it. But the surrounding space also has an effect— good or bad—so you can't ignore it. Keep in mind the following five compositional goals:

1. Reduce the space around the object so that it isn't overwhelmed by negative space. You don't want to be looking at a lot of empty and uninteresting space.

2. Leave enough surrounding space for the object not to appear cramped or squeezed out by the edges of the painting.

3. Center the object slightly to one side of the vertical horizontal midline.

4. Make a mark in the middle of the four framing lines.

5. Don't let the subject slip below the horizontal midline. In a representational painting, your focal area—the area of greatest interest—will be central, simply because that's where human beings tend to look on account of our binocular vision.

> "The eye should not be led to where there is nothing to see."
>
> ROBERT HENRI

TIP Check out *Drawing for the Absolute and Utter Beginner* for more in-depth instructions on compositional drawing.

Same-Size Drawing

Before you start painting it's important to make a detailed drawing of the subject that stresses the important values, especially the shadow values. The final drawing should be the same size you intend to paint it on the canvas, and within the framing lines you've drawn representing the edges of your canvas.

This type of preliminary drawing is useful in a number of ways. You get to know the subject more closely. Your hands become educated about how to apply the necessary lines and shadows to a surface. You're making the equivalent of a page in an adult coloring book. The drawing is then filled in with color using a step-by-step process.

Transfer Method

The following method allows you to transfer your same-size drawing onto canvas.

1. On a flat surface, trace your canvas with charcoal in the middle of a page of newsprint pad, so that you will have a drawing space the same size as your canvas. Mark the middle of each side of your outlined rectangle with charcoal. This will relate to the vertical and horizontal guidelines in your thumbnail, and help you position the subject similarly.

2. At the easel or from the position you plan to paint in, draw your subject inside this outline with charcoal, using your thumbnail sketch as reference.

> **TIP** If you have chosen to draw a handle, use the negative space inside it as a guide. Draw the outline of the negative space, and then you can draw the handle around it.

3. Once you've created your drawing, step back to see if it's tilting or upright relative to the sides of the outline. Charcoal erases easily! Adjust your drawing. Vertical lines should be parallel to the sides of your canvas. Keep in mind that changes at this point are part of the process: they should be occurring and aren't mistakes.

4. Apply the value structure. This means that every colored surface will have a gray value relative to the rest. Is your container darker or lighter than the tabletop? Let your drawing show these relative differences. Then apply the shadow values, which will all be darker than the surfaces they rest on. Remove the drawing from the pad.

> **TIP** It's not a big deal to change objects in midstream. Some objects are more fun to look at than to paint, or too frustrating to draw. If that's your experience, stop now and start with a new object on another page. If you're going to spend time painting it, make sure you like it.

5. Working flat on the newsprint pad, trim the drawing along the two vertical sides with a scissor, leaving approximately 2 inches of flap on top and bottom.

6. Cover the back of the drawing with charcoal, using the side of the charcoal.

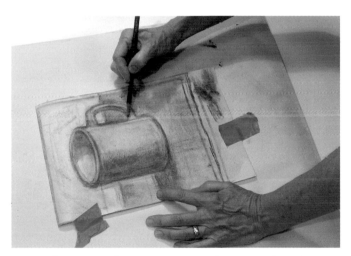

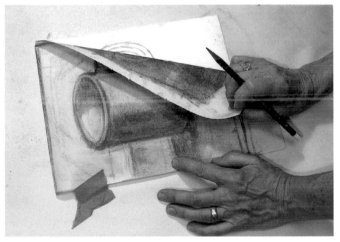

7. Place your drawing image side up on the white side of the canvas. Line up the trimmed edges of the drawing with the sides of the canvas. Tape the top flap to the back of the canvas. You will have created a sandwich effect in which the canvas and the drawing facing you are like two pieces of bread, with the charcoal the filling between them.

8. Draw over the lines of your drawing with a pencil, or the end of your smallest brush handle. Scribble in shadow shapes; don't outline them. The pencil will change your drawing slightly, though it's easier to draw with it than with the brush handle. You're using enough pressure on top of the drawing lines to cause them to transfer through the charcoal "carbon" onto the canvas.

9. Check to make sure everything is transferring by peeking under a loose edge of your drawing. If anything is missing, go over it again.

> "The transfer process is a great help and a relief because I always think that a good drawing of mine is an accident, one that I will not always be able to repeat on the canvas."
>
> *Diana Ringelheim, student*

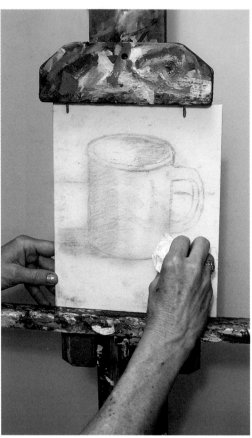

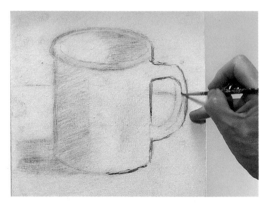

10. Remove your drawing. Put your canvas on the easel, and wipe off any excess charcoal from your canvas, using a rag or towel. Don't wipe or scrub. If this makes you nervous, test a small portion. The transferred drawing will remain visible. If you notice anything that looks "off," just correct it now with charcoal before going on to the next step.

11. Make the charcoal drawing permanent by going over the lines with a small soft-hair brush and a thin, fluid mixture of yellow oxide. Fill in the shadow value structure, rather than outlining. Use the flat and continuous transferred lines as a guide only. Revitalize the drawing, referring to your subject as you "draw" over the transferred lines with your small brush. Let your painted line break up spontaneously as you work. The transfer process is finished. Take a break; let the work dry completely.

THE MUG, *by Arupam Laumas, student*
Here we see that the scale, shape, and shadow values of the original drawing can be maintained in the painting by using the transfer method outlined above.

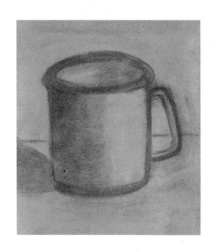

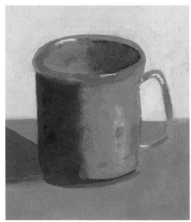

Blocking In

In general, choose a bigger brush to paint in a bigger surface, where you want to do the job of filling in quickly and efficiently and no detail is required. As the painting progresses you will be working down in brush size from large to small.

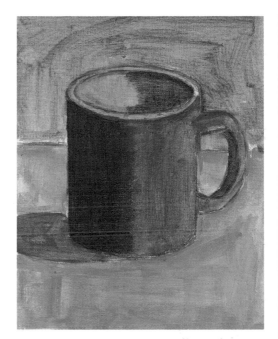

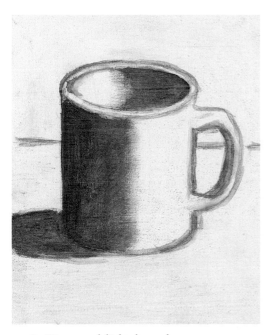

1. First establish the value structure with the medium-size brush. I recommend creating "faux black," or use black if you prefer. Brush on the form shadow, cast shadow, and shadow inside the object on top of the yellow oxide.

> **TIP** When you paint a color in preparation for painting over it later, it is called *underpainting*. The purpose is to add extra color dimension to the area, and often to give a plain white surface some color interest. In any painting, when your setup contains a white surface, you need to paint it in to make it look like part of the artwork.

2. Mix the local color of the object. When the form shadow is completely dry, create the underpainting by washing paint over the entire container and the background with this color, using your large brush. Add white to faux black to create the cast shadow, then add more white to that to create the table color (if it's gray), using the large brush to block it in.

Constructive Evaluation

3. Stand back and look at your work. The value structure will be in place and every surface of the canvas covered in thin paint. It will look spontaneous and fresh. This gives you, the artist, a snapshot of the entire painting in rough outline. Every piece has a part to play and affects every other piece. Take a break or continue.

SUPPLIES:
large soft-haired or bristle brush, medium-size bristle brush, small soft round, titanium white, ultramarine blue, burnt umber, the colors needed for your chosen object, a "tryout" scrap

"I like how it is
okay to correct the
shape of the piece
with charcoal once
the painting has
actually begun.
That was much
easier to do than to
try to paint in the
corrected shape."

Lucia Brown, student

Development Stage

Your goal in this second stage is to create a more substantial, specific, three-dimensional-looking object. This is the stage where most of the painting work is done. You'll use your previous experience in mixing the color you want (Chapter Three), and "how to fix it" (Chapter Five) to correct values, colors, and shapes in this stage. Beginners are usually surprised that you can fix it, fix it, and fix it some more throughout the painting process. In some ways, it's the name of the game. It requires more time spent stepping back to notice, then figuring out your next step based on what you see. Don't paint if you don't know what that is. Take your time, take time away, and think before you move.

1. If you take a break, review your work from a distance to determine three to five things you could do to strengthen the work, no more than that.

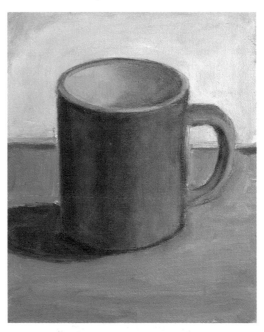

2. Apply white paint over the dry underpainted background (if the wall is white), cutting in close around the container to correct its contour if needed. *Cutting in* is the term used to describe painting crisp defined edges of a shape from the negative space. Make some horizontal brushstroke applications on the table foreground to reinforce the impression of a level surface. Correct the color. In my painting, I added more yellow oxide to the cadmium red light to lighten and warm up the cup color, and a mixture of cadmium red light and ultramarine blue for a more accurate cup shadow. Alter shapes where needed. I used charcoal to correct the back table edge in preparation for repainting.

3. Each time you apply a significant color, make a value change, or check on transparent vs. opaque issues, step back at least 10 feet to see how it fits in with the whole before you paint a large area. Beginners usually leave 1 foot on the base of the easel and curtsy backward, craning their heads back! This won't work.

Developing Three-Dimensional Illusion

4. To bring out three-dimensional impact, add greater value contrast: deepen shadows where needed, and lighten the lightest areas. Remember how most of the paints you've used in medium consistency are somewhat transparent in the first layer?
You may need to put on another layer to make the object look opaque, and solid.

Developing the Color

5. Refer to your charts for help when correcting colors. To re-create a color, mix lighter versions of the original thin paint to better match the color. Remember that layers or thicker versions of a color look darker when dry than the same color did in the thinner consistency used for blocking in.

> **TIP** Based on your experience with complementary colors, you can use the complement to develop your shadow color more accurately, especially if your shadow color doesn't look right.

Developing Blending Technique

6. Use the wet-in-wet technique when it works and the paint is open, along with the wet-over-dry technique you used initially for shadow transitions. This is where your practice in both techniques and in how-to-fix it comes in handy. Remember, the blending technique has to work from a distance, not from the end of your nose. Relatively loose applications can result in very convincing shadows from the normal viewing distance. Transitions between values for painters such as Velázquez or Titian, among many other greats, were created to hold up at viewing distance, rather than only a foot from the surface.

If you don't step back to evaluate your work from viewing distance, you'll be holding yourself to the standards of a medieval monk creating an illuminated manuscript rather than to those of a modern painter free to use more forgiving techniques.

Developing Spatial Progression

7. In our world objects closer to you physically overlap and hide aspects of what is behind them. Technically, this means you need to assert the primacy of surfaces, one in front of another, by painting the contour edges of the closer form over the object behind it.

Pay attention to which surface is closest to you, which is farthest, and how surfaces in between line up. Once you have this progression in mind you'll be ready to create an effective relationship between the surfaces.

Review the Development Stage

8. Step back, way back. At this point you're looking at a recognizable painting that may not be inspiring or exciting enough for you. Colors aren't as fresh looking as they seemed when you were blocking in. They get too dark. Maybe the painting and you are in the doldrums.

If you feel that way, congratulations! You're just where you should be. And this stage isn't over. You can refresh your painting in several ways. Your subject matter isn't going to fade or walk away, so you can take your time with this.

"Shadows which you see with difficulty and whose boundaries you cannot define...these you should not represent as finished and sharply defined, for the result would be that your work would seem wooden."

LEONARDO DA VINCI

Developing Lost and Found Edges

9. Let nature define what you represent. If you don't see a crisp edge, don't put it in. If you see a soft edge in the shadow, leave it that way. Your work will seem flat, stiff, or "wooden" if you make all the edges crisp, since three-dimensional objects naturally have both lost and found edges—edges that can be clearly seen and those that can't, depending on the light conditions around them. The blocking-in process, because of its more generalized approach, naturally creates both soft and crisp edges. Retain some of the soft edges where they work as you develop your painting.

Developing Push/Pull

10. Does the front curve of the container call for a slightly lighter, warmer, more vivid version of color you've already painted? Maybe the container handle as well? Another layer of color could give your work more dimension by pulling the light surface areas out still further.

"I was intrigued that such a limited palette can capture so much life. My painting has mistakes, of course, but they don't detract from my pride and pleasure."

Dora J. Odarenko, student

"The finished
paintings all looked
much nicer when
we leaned them
against the wall and
stood back from
them. I looked at
the painting as a
whole and actually
thought, 'Hey, that's
not so bad for my
first effort!'"

Lucia Brown, student

"Layers of emotion
as well as paint!
From loving it to
hating it to Oh what
did I just do to it!"

*Debbie Gehrlein,
student*

Finishing

Finishing touches give your painting an extra level of excitement and dimension. This stage requires less actual painting, and more observation. Add darkest accents and highlights, strengthen contour lines here and there. Treat these elements like puzzle pieces to fill in with the appropriate color and consistency of paint. Finishing is fussing, in a way. There's always something you can do. Only you know when you and the painting are finished.

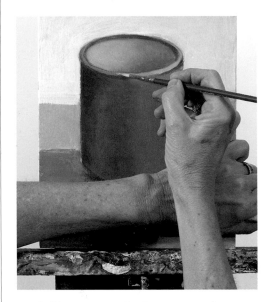

1. Rest your painting arm against your other forearm to make detail work at the easel easier. Here I'm applying small strokes to create a crisp edge on the front lip, slightly overlapping the paint behind it to make it seem to pull forward in space. Darker shadow accents applied above the lip within the cup opening make it pop out more. If you need to soften the back lip of the container or the back edge of the tabletop for spatial impact, apply dry-brush or a thin wash on the background.

TIP Live with your painting. Keep it out near your subject matter so you can pass by it, taking a look during the day.

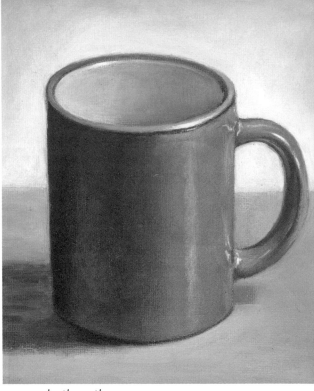

CUP, *by the author*

2. In addition to adding detail, you can add interest to large value areas, such as the container, background, cast shadow, and table, by breaking them into smaller areas of value contrast. For example, you can see that the lighter areas I added around the cup, when surrounded by darker values, spotlight the cup. Add highlights—neutrals ones with glazes or dry-brush, and/or bright ones with small soft-hair brushes and pure white impasto. The final cup painting you see above represents some work done in the development stage—more paint layers, corrected color—as well as finishing touches.

3. Step back to check your work at a distance. Highlights you thought were bright close up often have to be lighter and thicker to hold up. You may continue to see areas of your painting that you need to address.

It's a surprise to beginners when they realize that paintings are built in layers. However, eventually you'll hardly be conscious of the way you got your results. It won't feel like a step-by-step process. These descriptions of a fluid process are meant to give you an overall sense of the progression of a painting, but the process is hardly a straight line as you repair, observe, add, and subtract.

Common Problems and Solutions

Review your work constructively to see if you can recognize any problems you've had in painting the cup (before) and use the solutions for these common problems (after). You'll recognize that solutions are directly related to principles you've learned about earlier.

Problem: Cast shadow looks three-dimensional, not flat. It looks like a hole in the table!

Solution: Add a layer of horizontal strokes within the shadow here and there to flatten the value variations and reinforce the dominance of the flat plane of the table. Lighten the shadow, using the color of the table mixed into it.

Problem: "How do I make an object look like it's actually sitting securely on the surface rather than lifting off?"
—Pam J. Booth, student

Solution: Add the point of balance shadow—to ground the object on the resting surface. Give the object something solid to sit on as well. Apply slightly thicker paint to the foreground table surface. Use horizontal stokes to create a level resting surface.

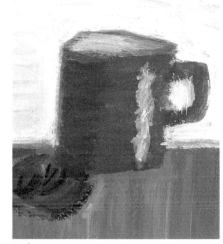

Before

The "before" painting has a composite of problems that beginners often encounter. I painted the "after" version on top of it to solve the problems. I redrew/repainted the leaning, wobbly cup; painted horizontal strokes over vertical ones on the table and added them within the cast shadow; painted vertical strokes on the cup; blended the transitional shadow; and repainted highlights.

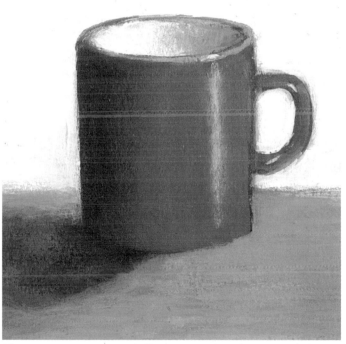

After

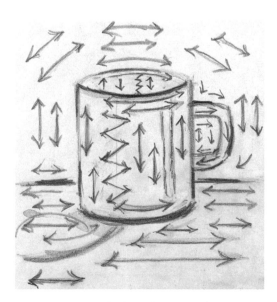

Beginners run into problems with brushstroke direction. The arrows represent the direction of brushstrokes helpful in creating a believable 3D image.

"The shadows of any color whatever must participate of that color more or less."

LEONARDO DA VINCI

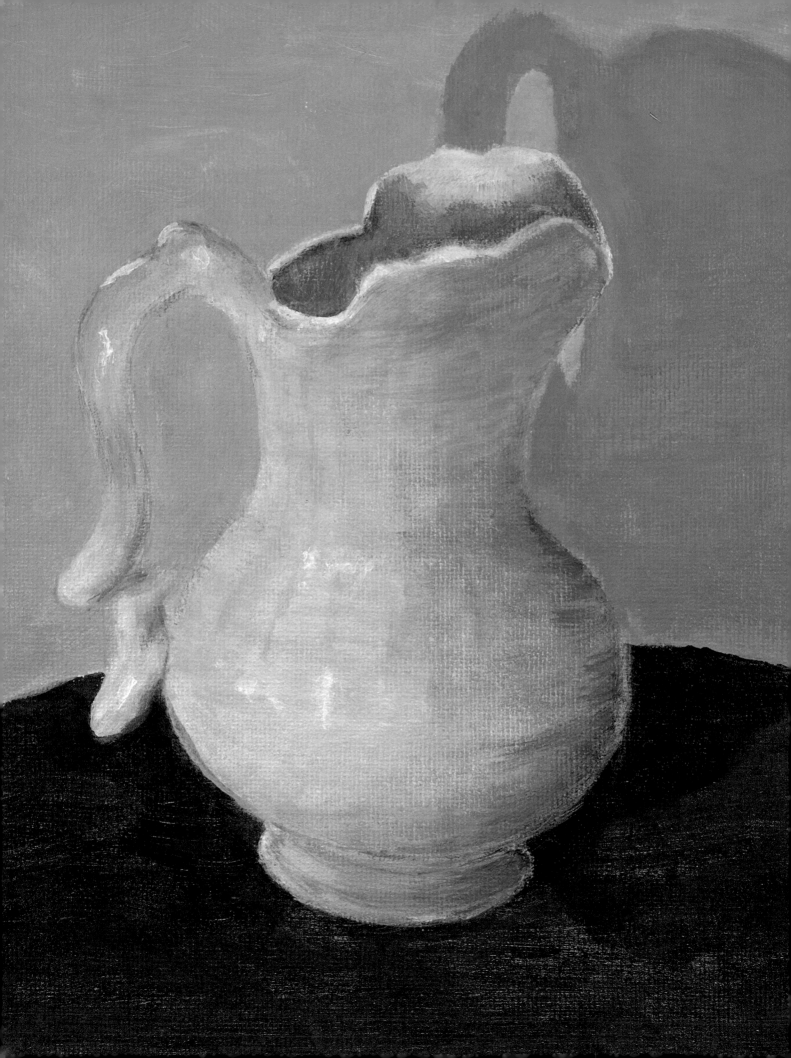

Beyond the Basics: Creating Your Own Still Life

"Find out what you like if you can. Find what is really important to you. You will have something to sing about and your whole heart will be in the singing."

ROBERT HENRI

In this chapter you'll build upon what you've just learned about painting a container in order to work on new shapes and new surfaces. Whatever you choose to paint next will also be a container of some kind, with a front, back, and sides, even if its shape is now asymmetrical. Whether it's a piece of fruit you can hold in your hand or a study of a masterpiece seen in a book, you will be able to apply what you've learned to give your subject the illusion of dimensionality. Form shadows on objects will always be specific to their shape, as will the cast shadow. When you re-create the light and shadow values related to those objects effectively, a convincing representation of their dimensional qualities will result. So you'll continue to replicate the color value shapes that you see in a new subject, and explore how they all fit together to build a recognizable image.

Opposite:
WHITE PITCHER, *by D. Gehrlein, student*

Right: **STRAWBERRY ON A GREEN PLATE,** *by Renee Hansen Goddu, student*

Getting Ready to Paint Your Own Still Life

The first step is to select your subject. Choose a single item that will energize you just because you like to look at it. Ask yourself if you have a good chance of painting it and whether you would enjoy doing so. Let this guide your choice.

When I was auditioning subjects for my small painting, I fell in love with the lemon that you will see later in the chapter. It might have had to do with the color, or the fact that it looked like an endearing character with a nose! Search for a strong connection to help you select your own subject. And remember when making your choice: good lighting brings out the best in every subject!

Paper or Canvas?

Many students enjoy returning to work on paper at this point. Your small Strathmore pad can be used for small paintings, such as I've done with the lemon study. Its size invites you to make a lot of small studies, an advantage at this stage that can lead you to explore more diverse subjects and techniques. This pad is best for color sketches, where you don't saturate the entire paper with wet paint. However, once a first wash layer goes on, it will take a fair amount of opaque layering. You can also choose to use primed or unprimed watercolor paper, or a canvas, for this project. If you liked working on the canvas, primed watercolor paper (sealed with gesso) gives you a surface more like canvas and allows you to build up opaque layers easily.

How to Seal Watercolor Paper

You won't know how you feel about primed watercolor paper until you use it. Here's more about that, for this or another project: Tape your paper to a strong piece of box cardboard, the back of a canvas board, or foam core, using

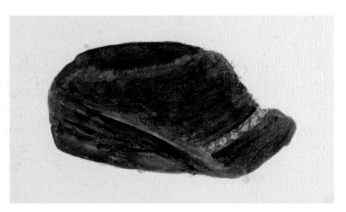

FUR HAT, *by Stephen Monahan, student*

"I usually don't like still life. This one is of my favorite hat. It's a still life I guess, but it's more interesting to me."

SKETCH BOOK PAGE, *by Renee Hansen Goddu, student*

This page provides a unique glimpse into the artist's process of discovery and exploration.

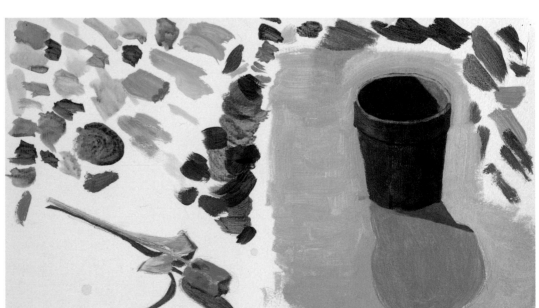

blue painter's tape. Use the tape to create the boundaries of the shape you want to paint within, if you want to paint in a space smaller than the paper.

I find it easiest to create a smooth surface with a sponge brush from the hardware store, but you can also use a 2-inch hardware brush. Put some gesso in a flat container with sides (I recycle take-out food containers for this). Dilute just enough with water to make a consistency more like yogurt than sour cream. Cover the paper with two layers of gesso, one applied horizontally and one vertically. The second coat is applied while the first coat is still wet. When the gessoed paper is completely dry, you're ready to paint.

Transfer Methods

Once you've decided on your subject and your painting surface, the next step will be the same for everyone: draw your subject. You can either draw, or continue to paint on the drawing surface, or transfer the drawing to your painting surface of choice. You have the option of drawing directly on the canvas, or transferring your drawing to canvas with one of the techniques learned in this section. If you decide to draw directly, you can spray the charcoal line to fix it and avoid redrawing with yellow oxide paint. If you aren't yet comfortable with drawing, you can explore one of the transfer techniques in this section that doesn't require drawing.

It's more important to plan out the negative space for paintings on canvas than for work on paper, because artwork on paper can be cropped afterwards at framing if enough paper is left around it. If you work on canvas, make a small sketch first to decide how large within the rectangle and where to place your subject with its cast shadow. An interesting arrangement of positive and negative space is important on either surface.

> "I drew directly on the canvas surface and it was a very big mess. I had it really dark and it was all over everything; I brushed it off and it doesn't even show."
> —*Liz Finkelstein, student*

TIP If you're drawing an asymmetrical shape freehand, start with a very generalized sketch. Rather than focusing on all the detail first, imagine that your subject was wrapped in paper, so that only its most general features are suggested. Use long, broken lines to sketch this general contour shape. Once you have that, add specifics to the contour, such as features within the shape and details, as you observe them.

TOOL, *by Marilyn Wald, student*
This artist has filled in enough negative space to anticipate framing.

"I need the 'live thing.' I do better when I can actually see the object than painting from a picture."

Anne Carr, student

You can continue to use the charcoal/newsprint method we learned in Chapter Eight for each painting project. However, it does alter the original drawing. Here are some other alternatives.

Photocopy Transfer

If you're proud of your drawing and don't want to alter it in the transfer process, substitute a photocopy of your drawing for the transfer. "Fix" the original drawing with charcoal spray (ventilate!) to preserve it and use it for reference in the painting process.

For those of you who don't draw, this method allows you to continue with your learn-to-paint experience by providing you with "the drawing." You can use the photocopy transfer of a photo you've taken or a masterpiece you want to study to create the drawing's foundation.

Cover the back of the photocopy of your drawing or the image you've selected with charcoal to create a photocopy carbon and, using a pencil, proceed with the transfer process as usual for a precisely transferred image with no harm to your original. Make sure to transfer the shadow structure. If you decide to use the original drawing, use the end of your smallest brush handle to transfer it rather than a pencil, to avoid alteration of the original. Whisk off excess charcoal, and use a small brush with yellow oxide to refresh the line, if you're painting on canvas.

A small drawing or other source—whether general or detailed—can be enlarged with a photocopier to the size you want to use for the proposed painting. Then use the standard transfer prototype.

To retain the impact of a subtle, detailed, or complex drawing, make sure you transfer all the small lines and value smudges from your source drawing. This is an important step in detailed drawing transfers that depend on subtle lines for impact, such as the face. Work slowly on a flat surface, transferring all these important lines from your drawing to maintain continuity between it and your painting surface. Check under the drawing pages during the process to make sure the lines are coming through.

Photographic References

Once you start working with anything perishable or living that could get up and walk away, photography becomes an ally. Take a photo or several to refer to or work from. If you're working with a photograph as a reference it's helpful to make a color and a black-and-white photocopy, which serves as a helpful reminder of the relative values within the value structure. The color photocopy isn't a color source so much as a way to see detail close-up without becoming confused by lack of color. A photo is your best source for true color, other than the real model or subject, though not everyone likes to work this way.

DEMONSTRATION: PAINTING THE SUBJECT OF YOUR CHOICE

Now that you have selected your subject and transferred your drawing to the painting surface, it's time to start painting! You'll follow the same basic stages for developing your work as you used in the previous chapter. Refer to my painting demo of a lemon opposite to help visualize these steps.

Drawing

1. I intended to work on primed watercolor paper. This drawing was supposed to be a rough sketch to explore compositional options. But I just didn't feel like stopping! Sometimes, despite the best-devised plan, your painting seems to happen to you. I started with a sketch to plan scale and placement on the paper, using the 80 lb. unprimed Strathmore paper pad, then added details.

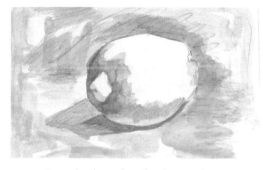

2. I washed in the shadow value structure with burnt umber and ultramarine blue over pencil, and let it dry.

Blocking In

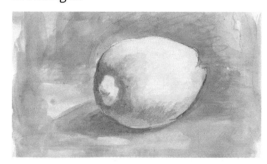

3. After the value structure was in place, I applied local color over the drawing, with washes of cadmium yellow medium and a burnt umber/ultramarine blue/white mixture. Shadows on the lemon were remixed and applied. You can see the value structures created by this process through these layers.

Development

4. Shadows and other colors were corrected: cadmium red light was added to yellow to correct the lemon color. Remember, as you add layers and paint thickens, brushstroke direction shows. Let strokes move descriptively with the surfaces, as though you were applying paint on the actual surface of the subject where it had to accommodate a variety of shapes and planes. Avoid flattening out curved surfaces by using horizontal or vertical strokes. Have a sense of the basic stroke shape you'll make before you apply it. You can even try it out physically before you put it on the surface, like making a practice swing in baseball.

Finishing Touches

5. Details were added in this stage, but you'll notice some thicker paint and deeper shadows applied in the development stage. I added white and faux black gray stipples to replicate details of the lemon texture. Gray pencil overlays were added to loosen up the impression.

"You will have to experiment and find things out for yourself and you will not be sure of what you are doing. That's all right, you are feeling your way into the thing."

EMILY CARR

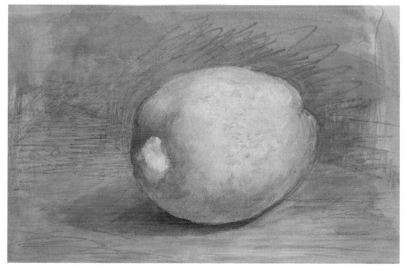

LEMON STUDY, *by the author*

Getting the Color You Want

> "Painting would be so much easier if all the colors came premixed, but on the other hand, I felt very satisfied when I finally came up with the right blue for the pitcher!"
>
> *Melinda Caldwell, student*

The biggest challenge in painting for the beginner is "getting the right color." The ability to re-create the color you see in nature, and the color you used last week in your painting, or the color you just ran out of, is the same skill. It takes time, study, and experimentation to become a skillful color detective.

Beginners often think it would be a good idea to mix up large batches of color so you won't run out. If you mix a large amount of paint, but are not experienced yet, it's most likely you'll have a lot of useless color. As disappointing as it is to mix the right color and then run out, imagine the mess if you mixed three times that much and wound up with the wrong color!

While you're developing your ability to achieve the right color, keep to smaller objects, such as a study. Then you're less likely to have to re-create a large amount of the right color. Keep the color of your object basic and color minimal in the negative space.

Keep in mind that color does dry slightly darker than what you see on the palette. It also dries darker once there are several layers. Therefore, in layering on paint you need to mix slightly lighter than the outcome you're looking for.

Guide to Finding the Right Color

The colors we see in nature are of infinite variety. A targeted search, using your color charts and the questions here, will help you to identify exactly what color you're looking at. Identifying it more specifically will help you reach your goal. Let's see how this translates into mixing paint. In the example at right, I started at the top with the color I wanted to re-create (top and bottom colors are the same), then showed you the steps needed to do that, using a series of questions that you can ask yourself for any color that you would like to re-create.

1. What's the closest basic color to this target color? *Green.*

2. Do we see the influence of another color? *Blue.* More specifically? *Maybe ultramarine blue.* Mix phthalo green with some ultramarine blue.

3. Does the target color look less vibrant, somewhat neutralized compared to this new mixture? *Yes.*

4. Does the target color have a complement? *Green and red are complements.* Add a little red.

5. Is the color we mixed a darker or lighter value than the target? *Darker?* Try adding black. *Not it. Lighter?* Try adding white. *Yes, got it!* We've re-created (lower right) the target color—a slightly neutralized, medium value bluish green.

How to Fix the Color

Do you need to change the paint you've applied because it's just not the right match? Check the charts you've made, and then ask yourself, Do I need to…

Change value? Add white or black to change the value of the color respectively to lighter or darker ones. Add the complement or near complement to darken the color and make more accurate shadow colors. Use the faux black mix to darken and help keep your darker values color rich.

Add intensity? Add more of the original color, either by standard mixing, or by glazing.

Reduce color intensity? Add small amounts of a complement or near complement; or black, white, or burnt umber.

Or neutralize it? Add more of the above to create a grayish neutral, which removes color identify.

Change temperature? Cool colors are easier to warm up than warm ones are to cool off. Adding yellow or yellow oxide to some cool colors will warm them up. Be aware of the complements: yellow and purple make gray.

Analogous colors. Colors that are close neighbors on the wheel are analogous or similar in makeup. Mixing them together doesn't change them radically, the way mixing distant cousins across the wheel will do. But it can change their color temperature. A step to the right or left of any color you see on the wheel can warm or cool it, depending on the direction you move: toward the cool hemisphere or toward the warm one. For example, primary red can be cooled with crimson—a step toward the cool hemisphere.

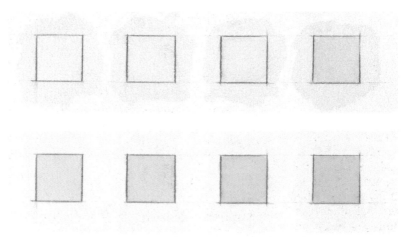

Color and black-and-white versions of the same chart show that as a color's intensity is increased, its value grows darker.

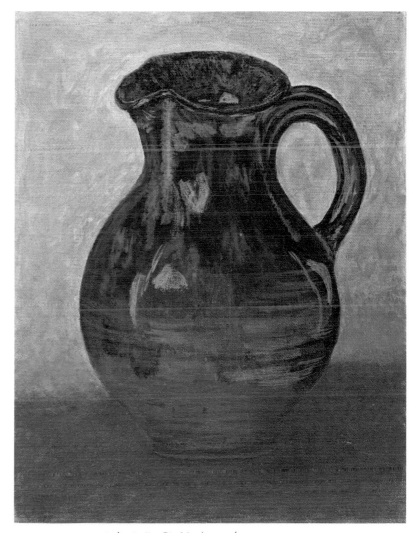

CERAMIC PITCHER, *by Anita St. Marie, student*
This artist has made good use of neutral gray washes to bring out low luster patterns on her subject.

Mentor Painting

COLOR SKETCH OF LAUTREC'S *DR. GABRIEL TAPIE DE CELEYRAN,* *by Amy Norton Barnett, student*

This student's sketch captures the attitude of the subject, color, and setting of Lautrec's painting in a confident, abbreviated manner.

Great art is intentional. Magic happens, but on the path toward it knowledgeable artists use every technique available to them from paintings of all ages. Artists are influenced by each other's work. Where they see something significant they…appropriate it! The great Spanish painter Velázquez met the Dutch artist Peter Paul Rubens in Madrid, where Rubens introduced him to the work of Titian. Influenced by the brush, handling technique of both great artists, Velázquez's brushstrokes became more spontaneous.

You may not be in Madrid or Paris; however, any good library will have its section of art history books, usually with wonderful color plates. "Keep in good company" with the artists you find in those pages. "Steal" from them to learn more. And by all means, supplement what you learn with a visit to see the real thing if there's an art museum nearby. You can view the work of the master artists you find mentioned in this book online as well.

Beginners use this practice throughout the class as an illuminating and interesting way to expand their technical knowledge, with the added benefit of learning more about art history and the artists they love.

To learn from a "mentor":

1. *Look through art books to find a painting you love.* Out of the multitude of paintings to choose from, beginners seem to be drawn to the right mentor… someone they admire, and with whom they feel some aesthetic bond. It can be the colors that attract, a mood; and sometimes in the case of a portrait, we find a family resemblance once we see it up on the wall in class! What usually occurs is that the painting chosen relates to aesthetic choices the beginner has already begun to make in his or her own work.

Love is blind—and beginners sometimes can't resist choosing a bad reproduction of a painting they love. Make sure the reproduction is a good crisp one, and is large enough to work from.

2. *Choose either a portion or the entire painting to study.* You don't lose your individuality or creativity by copying. If that's all you do, yes; but an exact duplication isn't the goal. The annals of art history are full of masters who learned by copying from the greats. It didn't hurt them, so you're safe!

3. *Draw from your mentor painting freehand, trying to be accurate, but not perfect.* You can make an informal sketch of it, or a more finished version on paper or canvas. In the process of freehand drawing, even if it is quite accurate in relation to the original, your hand and sensibility will naturally distort the original. If you choose to crop the painting you may need to reorganize the composition by moving objects around. These changes will make the final result

look like part your own aesthetic. That's where you come into the mix…in those unique, little changes. For those of you who do not yet draw, continue with a photocopy transfer.

4. *Fill in the drawing with the paint mixtures you see.* You may unlock some technical skills, much as a choreographer might watch Fred Astaire in order to pick up ideas, but wouldn't attempt perfect replication of his dance routines. Replicating the movement of brushstrokes is the equivalent of learning any manual skill: a dance step, a frying pan toss, or the swing of a bat. It may help you become a better color detective. It may encourage you to experiment or to feel freer in adding color, or allow for a build-up of thicker paint in your own work. The type of media you work with, the painting surface you choose, even the subject matter you like, doesn't have to be a match with the mentor's in order to learn lessons you can apply.

"Keep in good company— that is, go to the Louvre."

—PAUL CÉZANNE

STUDY OF MAURICE UTRILLO'S *FABRIQUE*, *by Barbara Bosill, student*
The choice of a street scene gave this beginner practice creating a variety of surfaces and subtle colors.

STUDIES OF JOHN SINGER SARGENT'S *DAUGHTERS OF EDWARD DARLEY BOIT*, *by Renee Hansen Goddu, student*
A pencil sketch and color sketch have been used by a student to study a masterwork by Sargent.

Common Problems and Solutions

As you progress with your painting, continue the process of evaluating your work. Stand back from your painting to identify problems using constructive critiques. Let's focus on some solutions to common problems in the painting process.

"If everyone knew how hard I worked to get my mastery, it wouldn't seem so wonderful at all."

MICHELANGELO

Problem: "I never painted an apple because I was afraid of the stem part and didn't think I could 'get it.'" —Debbie Gehrlein, student

Solution: Compare that scary stem area of the apple to two hills with a valley in between them. The stem grows out of the valley. The front "hill" of the apple hides the bottom of both the stem and far valley. Most beginners paint the stem and far hill, leaving out the hill in front. Build up paint on the apple "hill" (cheek) in front and define its contour crisply where the stem disappears behind it.

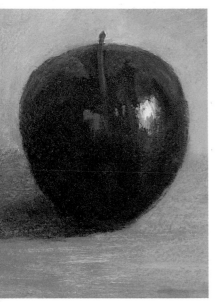 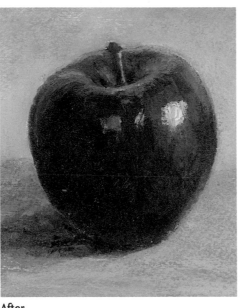

Before **After**

APPLE, *by the author*
In the "after" image you see how the missing cheek closest to the viewer is added, cropping the bottom of the stem.

"Inspiration is highly overrated. If you sit around and wait for the clouds to part it's not liable ever to happen. More often than not work is salvation."

CHUCK CLOSE

Problem: No matter how many layers of paint you apply the result isn't popping out the way you want. How do you get the "pop" back?

Solution: Use white to paint over the area of your painting where you want to get the pop back. Apply thin coats, with flat strokes, so you don't create a heavily sculpted surface that will poke out. Soften the transitional edges. When that's dry, repaint the area with color.

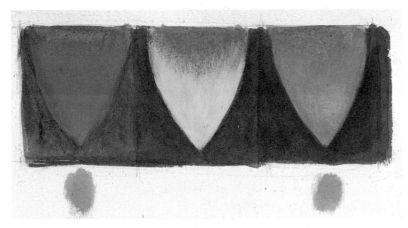

Sometimes layers of color only darken an area and vibrancy is lost (left). Add white to the area that you wish to pop out (middle). Let dry completely, then reapply color (right). Note that reapplied color to the bottom right and left are the same. The white underpainting makes the repainted area look lighter. Defining the negative space edge also makes shapes pop out more.

Problem: You like painting a series of one particular object, but wonder if you should be painting the same subject matter over again.

Not a Problem: "If it's good once, it's good twice." I like my own saying here, which can apply to many things, including chocolate.

"I know that to paint the sea really well you need to look at it every hour of every day in the same place so that you can understand. . . . That is why I am working on the same motif over and over again."

—CLAUDE MONET

Problem: Many beginners have unrealistic notions about what learning to paint "should be" that can block their progress. Check out these misconceptions to see if your attitude needs adjustment.

1. It's effortless once you become a good painter. *False.*
Once you have experience you're more forgiving of mistakes, because you see them in context and feel more confident about fixing one. And you also have wonderful periods of wordless activity when the painting seems to unfold naturally. However, it still requires focus and work every time.

2. If you get it right one time, the next time you'll be even better. *False.*
It's like life with its ups and downs; there are paintings that work and those that don't. That's the natural rhythm. But you are still moving forward because you're learning. The most noted painters work hard at it, do lots of paintings, not all of which turn out well, and don't give up—though they do leave the studio in a huff. Mistakes are fixed and the painting reworked, but we don't often get a chance

THREE ONION STUDIES,
by Liz Finkelstein, student
"I feel I have to do my work slowly. So I'm getting the onion OK, so I just keep doing onions, onions, and onions! Besides, I like onions! I had fun adding layers of pen and paint. I was happy to get it in black-and-white and I thought, I'm never going to be able to do it in color; and I was really happy when it came out. I put it up in my dining room."

to see this because we only view the final surface in all its pristine glory.

3. You should be learning this faster! As quickly as you learned drawing. *False.*
Painting is considered a more challenging artform than drawing. Drawing traditionally has been seen as a handmaiden to painting. Michelangelo destroyed or hid his drawings so that his finished works would seem to have been conjured out of nowhere, and so no one would see how much preparation went into his paintings!

If you find painting more difficult, it's because it is more difficult. If it's taking you longer, then you're right on track!

The learning curve for drawing is shorter than for painting, because drawing has fewer variables. And there are fewer technical challenges to learn. Painting takes twice as long as drawing does to get to the point where you feel you have a general understanding of how the process works and enough tools in your belt to fix your work.

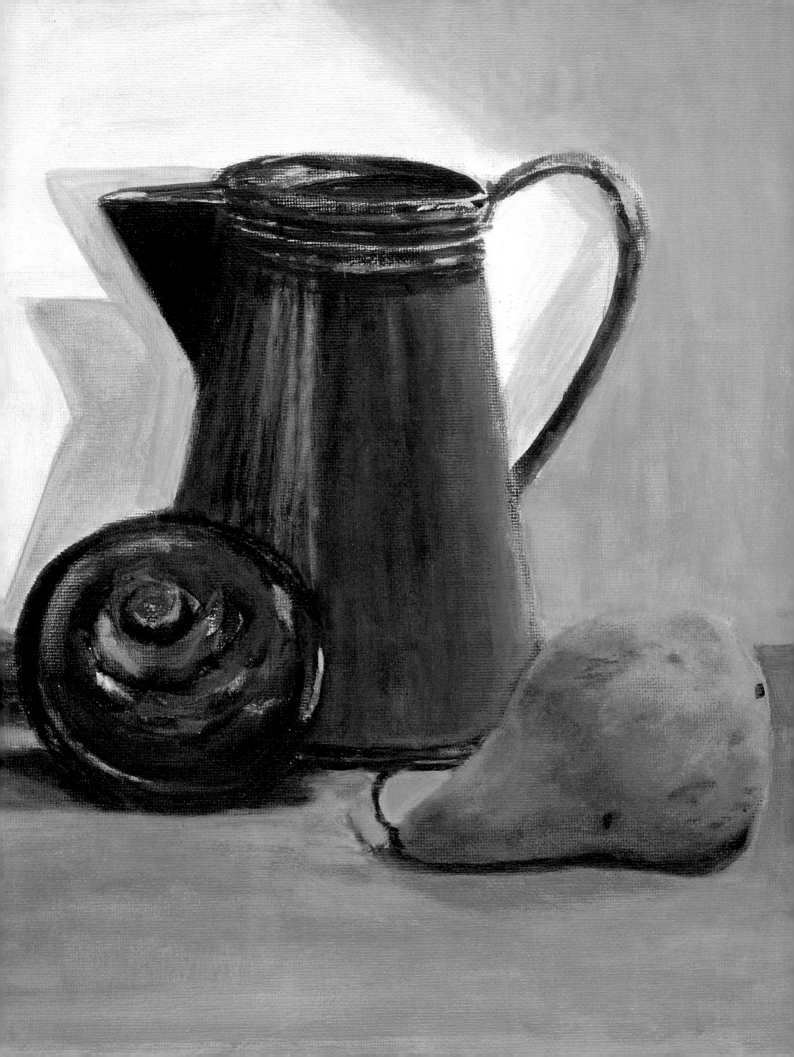

Creating Compositions: Still Life, More Than One Subject

"A painting that is well composed is half finished."

PIERRE BONNARD

Now that you've had some experience painting single subjects, it's time to learn how to paint several subjects together effectively. Not only will you learn how to create new colors and shapes, you'll also explore new dynamics that arise when you arrange several objects in relationship to one another.

Creating a composition, as you know from your sampler and previous paintings, is a balancing act. When there are more elements to juggle, the experience is more exciting and more techniques are required of you, the juggler, to keep everything moving smoothly! While you'll continue to rely on the basic painting format, you will also learn additional techniques to bring harmony into a more complex composition, and you'll find a step-by-step demonstration from me to refer to while you create your own.

Opposite: **STILL LIFE WITH COFFEE POT AND PEAR,** *by Pam Booth, student*

Right: **TWO ONIONS,** *by Pat Glass, student*

Creating Your Still Life

Time for the audition! Gather objects from your collection, as well as fruit and veggies—more than you need to start with. Begin with objects that inspire you. Experiment with other color options for background and table; keep those colors simple and neutral. Try out plain-colored cloths behind and underneath potential subjects. Look at the section on fabric in the next chapter for some technical insight if you want it to play a significant part in your setup. Or stay with what you have been using if it works.

Step One: Arrange Your Still Life

Take a look at the subjects you've gathered. Do any arrangements excite you enough to paint them just as they are? If not, play with groupings of two to three objects. Contrast in shapes, color value, and size can make for interest, as can overlapping shapes or separating one from a grouping of three. You're organizing colors and shapes that will keep you energized and connected throughout the painting process. So avoid making choices for sentimental reasons alone or to illustrate themes, such as "sports" or "cooking," as the result often looks forced. Resist selections based on: "This might look nice in the living room," or "Maybe I could give this as a gift if it turns out well." Instead, experiment until you feel excitement from looking at the colored shapes together and feel an urge to paint them.

If your still life looks stiff and contrived, try arranging the objects by feel, without looking at them as you create the setup. Sometimes the best still life arrangements are accidental. Roll some of the fruit and veggies out of a paper bag. Ask a friend to help you arrange them. In still life classes beginners work in teams to build still lifes together from a large collection of possible still life subjects. And if you have a sense of humor, then use that! If you want more spark in your setup, try either adding a complementary color, vivid colors, or contrasting value to your group of objects.

When you have your setup, post a "do not touch" sign. Sometimes the still life is just too inviting! Family members have to be warned that they can't eat still lifes, even if you set them up right in the kitchen. (Especially if they ever want a home-cooked meal again.)

We set up a large, rustic, and apparently irresistible still life on the studio floor at the school—a blanket, bales of hay, etc. We had the studio door open on a warm fall day and in popped a golden Lab from the neighborhood that headed right for the still life, cozied up to it, and fell asleep. We knew he couldn't be a permanent feature, and according to still life rules (no subjects that can get up and walk away, at least when finished snoozing) we eventually had to coax him back out the door.

Light your setup to create simple, easy-to-identify shadow values. Reduce other light, except for what you need to work by.

STILL LIFE WITH ROBOT, *by Candace Chase, student*
Combining traditional and unexpected elements adds interest and personality.

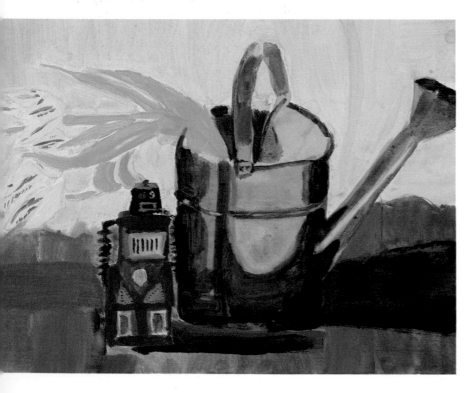

Step Two: The Composition Game

A compositional plan becomes more important once there are more visual elements to balance. You can now apply many of the tricks of the trade you've learned creating the sampler (which had numerous shapes in it) about how to attract, lead, and hold the viewing eye. Your goal in playing the composition game is to keep the eye within the painting, exploring all aspects of the work, and returning most frequently to the focal area—the artist's chosen center of interest. As part of the game, you'll also need to avoid possible pitfalls that will lead the eye out of the painting, for example, making emphatic brushstrokes leading out, or overemphasizing the table edge in back of a still life or the edges of the painting.

Preparatory Sketches and Thumbnails

The preliminary sketch, thumbnail, and color sketch are your most important tools in the composition game. Make a sketch of the setup on your small pad. You may find, as you draw, that only part of the setup excites you. Do a thumbnail from your sketch of the whole image or the portion that attracts you in order to see the basic structure of your proposed composition.

A thumbnail with the addition of the color you intend using for the painting constitutes a *color sketch*. A preliminary color sketch allows you to explore color mixtures you anticipate using and helps work out the painting's balance of color. As you know from the sampler, certain colors attract more attention than others and need to be balanced out. If you don't feel like making a color sketch of the subject in recognizable form, make a tryout on scrap as you work to figure out how to derive the colors.

After the thumbnail, make a detailed same-size drawing with a clear shadow value structure, and then transfer it to

canvas. This is especially important to do with a complex painting subject. Not only does this guide you to a deeper understanding of what you're looking at, but the drawing itself will be a reference, especially valuable for keeping the shadow value structure in mind.

Many beginners who drew directly on canvas or paper with success in the last project, without making a thumbnail, ran into problems trying to do the same for the more complex still life. It's simply much harder to do. If you want to draw directly on canvas, then at least make a simple thumbnail to decide on the basic arrangement of positive and negative shapes beforehand. If you're a total drawing beginner, use photocopies of your own photographs or mentor sources in order to continue your painting experience.

NOTE Compositional ideas and preparatory drawings, along with a signature style, were often considered the most important parts of the painting process. Rubens developed his paintings in stages, beginning with quick sketches—like thumbnails—to explore compositional ideas. Color sketches and a detailed drawing with live models came next. The final painting was actually realized by his apprentices, with Rubens adding the finishing touches.

DEMONSTRATION: STILL LIFE: MORE THAN ONE SUBJECT

Once you've transferred your drawing continue to follow the basic painting format: namely, to block in, develop, and finish your painting. Remember to use constructive evaluation to further your process. Refer to my painting demonstration below to see how to use the basic painting format while painting a larger number of objects. Apply any of the principles on unifying and harmonizing your still life on pages 120 and 121 that you find useful.

I had fruit, vegetables, plates, and bowls galore to choose from, but was coming up with nothing magical. So I set out for the farmer's market, where I found fresh cherries that glowed like precious gems. Luckily, a bowl I had borrowed had the same matching garnet color. A washed-out vintage tablecloth provided some relief from these intense colors and had some detail that provided a color tie-in. Once my composition was lit, I had shadows to play with as well!

Blocking In

1. I chose to paint on primed watercolor paper taped to cardboard, which I then set on the easel. After making a thumbnail, I drew my subjects in charcoal on the painting surface,

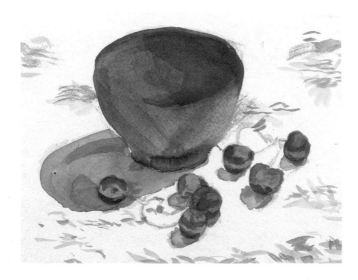

and sprayed that with fixative. Using a large soft-hair round brush, I blocked in shadow colors with washes mixed from phthalo green and crimson. When those dried, I brushed colored washes over them mixed from a limited palette of yellow oxide, white, phthalo green, and crimson.

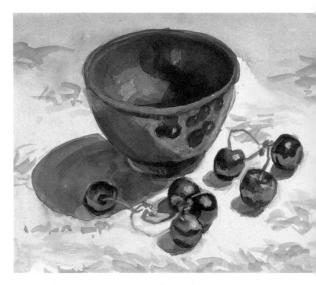

2. Continuing to work with a medium soft round brush and washes, I underpainted the tablecloth with neutral green, then developed value contrast throughout with darker washes. I added smaller color variations within the larger shapes on the bowl, for example, to include the reflections of the cherries. Using washes of opaque white, I underpainted the cherries to build surfaces out and corrected the outside shape of the bowl using negative space painting.

"A good painting is a remarkable feat of organization. Every part of it is wonderful in itself because it seems so alive in its share in the making of the unity of the whole, and the whole is definitely one thing."

—ROBERT HENRI

Development

3. I washed crimson glazes over the bowl and cherries to intensify the color. Using a medium bristle brush and medium-consistency paint, I built up some of the surfaces, applied cooler shadows, and softened the edges on the bowl and tablecloth to reduce contrast of patterns. I added dry-brush strokes within the shadow and on the bowl to bring up the table surface.

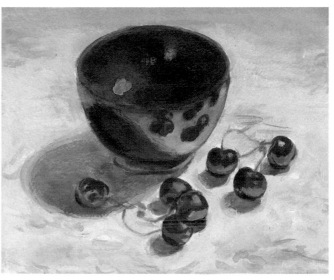

A practice sheet helped me preview how the local crimson color of the fruit would look painted as a glaze over its two shadow colors.

Finishing Touches

4. I used yellow oxide and white to warm up the tablecloth. I added details to the tablecloth pattern and developed the cherry stems and their cast shadows. Using dry-brush and glazing I refined the colors. Finishing touches included adding opaque highlights, deepening shadows, and using thicker paint to pull out the rim of the bowl and define the edge.

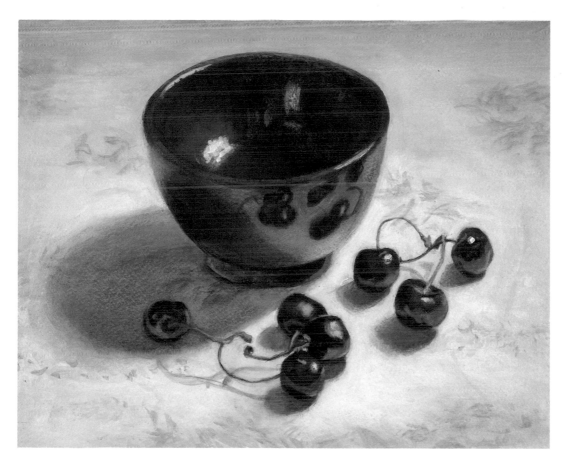

STILL LIFE WITH CHERRIES, *by the author*

Unifying and Harmonizing Your Still Life

Use any of the following techniques to further balance and unify the elements of your painting. Keep in mind that you need to create a balanced compositional plan first with your drawings; otherwise it's going to be difficult to use these tools to achieve one.

1. *Limited palette.* Assess the setup thoughtfully. Choose colors for your palette you think you'll use, not just enough to complete one object, and not all the colors you have. Think of your limited palette as your color DNA. Derive color mixtures from this group, so that colors have common bonds, which create relationships.

2. *Complementary colors.* If your still life has a palette with a complementary pair, it will help you to create unity. Neutrals and shadows can be derived from their mixtures.

3. *Physical relationship.* When objects overlap or touch, relationships are created between them. If you set up three subjects, separating one out from the group, this creates a different dynamic.

Inanimate objects can take on human social characteristics. A quiet drama can be going on! Stems on fruit or spouts on pitchers, cup handles, all have human counterparts: noses, faces, arms. If objects face each other they will seem to relate, while a pitcher with a spout facing out will seem to be looking beyond the painting. Pears can tilt toward one another like friends, or shy away from one another. These psychological directionals can lead the viewer's gaze.

4. *Lighting.* The effect of light flowing over your setup creates unity. Every element becomes subject to value changes coming from the same direction.

SHELL AND CUP,
by D. Gehrlein, student
"The shell is from the ocean, represented by the blue cup, and the skin tones of the shell contrast with the ceramic cup made by my human hands. Each of these objects would have been boring and naked without the other to contrast against."

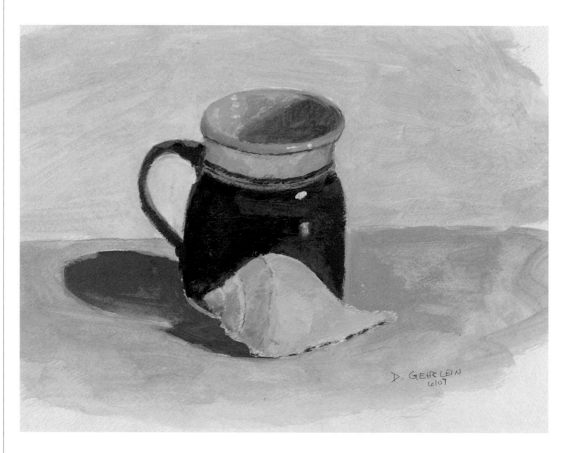

5. Surroundings. Color behind and under objects (literally common ground) tie objects to each other. A *toned* canvas has one color underpainted over the entire canvas; this is another way to relate colors.

6. Strong compositional lines. A fold in fabric can provide a strong compositional line, leading the eye effectively from one grouping to another. An *implied compositional line*—small references and accents that imply a line—will do the same.

7. Color referencing. You can move pure color around the painting in disguise using washes and dry-brush, or the neutral version of the pure color.

The eye will pick up on these subtle references and follow them throughout the painting, bringing more of the painting into visual circulation.

8. Reflected Color. Elements of your painting may pick up color from adjacent color areas. Look for color reflected in glass, on cloth, and even on fruits and vegetables. You'll see reflected color picked up on cast and form shadows as well.

STILL LIFE WITH CHIANTI BOTTLE, *by Julie S. Swearingen, student*
The surrounding crimson cloth casts a blush color on still life objects, unifying them, while its folds animate and add interest to the negative space.

ONION AND BROCCOLI,
by Nina Marino, student
Remember that you can continue to experiment with the materials and approach you find satisfying.

AQUA STILL LIFE, *by Eva Bergman, student*
A diagonal shadow in the fabric at the upper right leads the eye to the pail. On the left it forms a dark value barrier, focusing light and attention on the still life objects. This artist has effectively used neutral mixtures of the two principal colors (orange and phthalo blue) throughout the work to tie the painting together.

Common Problems and Solutions: Still Life

Problem: The color arrangement looks static, unrelated; every piece looks isolated. The orange is on the orange, the red is on the apple.

Solution: Make a color sketch ahead of time to work out color relationships. This can simply be a color-mixing tryout with no drawing reference. If you need to do this after you're under way, work out how you'll share and move the paint around with a small color sketch rather than on the painting itself. Can neutrals be created from mixing some of the purer colors? Can reflections create color relationships?

Problem: The background is distracting. Have you ever watched TV outtakes where someone in back of the newscaster disrupts the scene? That can happen in your painting, too. You find yourself looking at a background instead of at the central area. Too much high contrast or crisp detail in a background can push it up into the foreground plane and draw the eye from the focal area.

Solution: The solution is to reduce high contrast in the background. This can be done by introducing a middle value. See the student example below.

Another cause for concern may be that you let loose in the background areas when you didn't feel you had to be detailed. The result may be big, active, high-contrast strokes that may be full of life but also detract attention from the focal area. While brushstrokes can change in size from area to area, be aware of creating high contrast when you do so. Reduce contrast by adding smaller strokes.

Self-Coaching

Here are some examples of how beginners coach themselves. They may help you be a good coach to yourself.

Problem: I feel guilty doing this "just for me."

Solution: Would you encourage a child or friend to develop their capacities? Be generous to yourself as well. After all,

Before

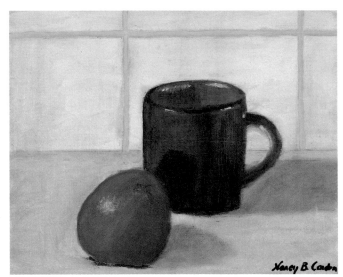

After

BLUE CUP AND ORANGE, *by Nancy Brown Condon, student*
Notice how your eye is pulled to the high contrast lines in the background (before).
The student muted the lines in the background tiles to solve the problem (after).

LITTLE BROWN POTS,
by Tricia Vanacore, student

"I really hung in with this piece. For some reason these little brown pots kept calling me back about ten separate times. And this benefited me, not trying to do the whole thing at once, not just the first time. The more I looked at it the more I thought, I can do this and this, but I wouldn't do it right away."

you are someone's child and friend! How many fewer dancers, musicians, athletes, and scientists there would be if we all began to reconsider doing anything that was a form of self-expression.

Problem: "It was hard to get my mind to step back from the details. I couldn't even start my painting. I couldn't get past all the details."—Debbie Gehrlein, student

Solution: "So I went to the computer and fuzzed the photo down to get the details to drop out."—Debbie Gehrlein, student

If you happen to be nearsighted and wear glasses it is possible to turn this into a temporary advantage. Simply take off your glasses while you work on blocking in your image. You will get the same effect: the details will be fuzzy.

Problem: "I can get off track when I get stuck on one area of the picture that doesn't seem to be working out to my satisfaction."—Pat Glass, student

Solution: "I know that I then need to take a break and come back to it later, but sometimes that's hard for me to do. I tend to want to stay at it until it is fixed.

However, I realize that won't occur until I take a break and review what's going wrong. If I stay at it I tend to keep using the same solutions, which obviously aren't working!"—Pat Glass, student

Problem: "Sometimes I feel like I'm not going to be able to do it and I can't do it. And I can't remember what I'm supposed to do. Where do I begin, what brush?"
—Pam Booth, student

Solution: "This stops me from being able to look at my work calmly. So I step back and let the part of me that knows a little bit more than I think I know come out. I remind myself to look at that shape, look at that color, experiment, try a little."
—Pam Booth, student

Problem: Fear of making mistakes.

Solution: "I was painting the other day and suddenly found I wasn't afraid of making a mistake because what I've found is that when I make a mistake it usually turns into something or takes you in another direction. So mistakes are part of the whole thing. In general, it's all part of the fun!"—Liz Finkelstein, student

Elements for Your Still Life: Flowers, Glass, and Fabric

"I perhaps owe having become a painter to flowers."

CLAUDE MONET

Flowers, glass, and fabric can each stand alone as interesting subjects to paint. Or you can choose to combine any or all of them in a still life. The information in this chapter will teach you how to paint each of them successfully, so you'll feel comfortable using them in any way that suits your needs. Most of us love to look at flowers. The variety of beautiful colors and shapes they offer make them among the most popular subjects for beginners. And a glass container can be a beautiful addition to your flower painting. But how to paint glass? The first obstacle to painting glass is the notion that you can't paint something that's transparent. But you can, once you follow the right steps. Fabric is useful and expressive, whether in a supporting role or on its own. And it will show up, whether on a model or in a still life, so it's smart, as well as fun, to learn how to paint it.

Opposite: **LILY IN VASE,** *by Kathleen Bossert, student*

Right: **BLUE FABRIC,** *by Donna Faber, student*

Painting a Single Flower

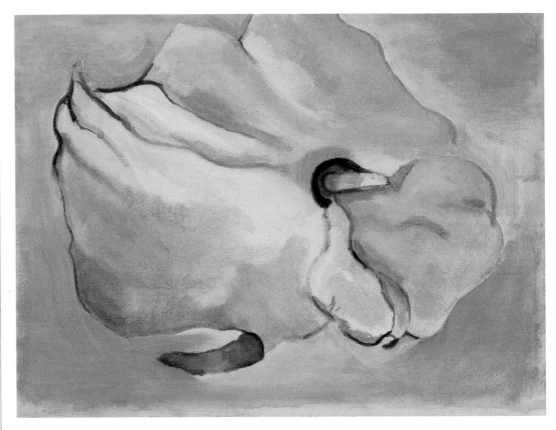

I feel it's best to start with just one flower, and no container at all. Look for a flower with a simple sculptural shape: tulips, pansies, daylilies, sunflowers, and daisies are good choices. A rose or peony is extremely challenging, as is a marigold or chrysanthemum, with their composite heads full of a trillion petals. Or you can start with a mentor painting and copy one of your favorites. Follow along with my step-by-step demonstration to help you visualize the development of your own painting.

Put your flower in water. Or leave it in a six-pack from the nursery, as I did. Think of Georgia O'Keeffe and get up close to your favorite one. Feel free to leave out not only a container, but also most of the stem from your picture. Trim off as many leaves as you don't want to paint as well. Whether you're painting one flower or a bouquet, the decision about what detail to present in crisp focus, and what to leave less developed, is important.

Flowers fade, and this is something you should consider. After you set up your flower, and before you even start painting, you may want to take a photo of it, with and without a flash, to see which one works better. It's preferable to work in a light, bright room instead of lighting the flower; a bulb emits heat that can cause the flower to wilt.

> *"I found I could say things with color and shapes that I couldn't say any other way—things I had no words for."*
>
> GEORGIA O'KEEFFE

DEMONSTRATION: PAINTING A SINGLE FLOWER

1. I placed a six-pack of pansies on a stack of books so I could see one flower I wanted to paint at eye level, sketched the pansy and leaves around it with pencil on the small sketch/paint pad, and blocked it in with light value color washes. The palette was based on purple/yellow complements and neutrals derived from them, using white, crimson, ultramarine blue, burnt umber, cadmium yellow medium, and cadmium red light to create them.

2. It looked as if there was a layer of orange under the purple of the petals, so I underpainted orange, then when that dried, painted purple over it. Using gesso, I underpainted the lightest, most opaque areas on the petals and leaves, preparing to make them pop. Then I let the paint dry.

3. I painted over the yellow area of petals with a more opaque mixture of cadmium yellow medium and cadmium red light to correct color and add intensity, and added more purples and oranges to adjust petal color. I deepened shadows, and defined leaf and petal edges at flower contour with my smallest brush to make it stand out more. I used the same brush to add darker green to the foliage, as well as to make delicate creases in the leaves and petals.

PANSY PORTRAIT, *by the author*

Painting a Bouquet

The process of arranging flowers in a container can take time. You want to love the way the shapes and colors look together, enough to really motivate yourself, so add and subtract until it works for you. Lighting your arrangement properly can further enhance its beauty. Remember to choose flowers with relatively simple construction in order to keep your painting experience enjoyable. Once you're satisfied with your flower arrangement, use the following basic steps to guide you, and refer to my demo to help you visualize how the bouquet painting develops.

Setup
1. Arrange your bouquet either in front of a plain color neutral or a white background.

Draw
2. Study your bouquet and develop a composition. Select your method of drawing preparation and transfer. Your sketch needs first to reflect the overall shape of the bouquet, then the detail. You're working with a three-dimensional shape composed of many parts, much like a model's hair or the foliage of a tree. Make a selection of details in order to suggest, rather than depict, all of them.

Blocking In
3. Once your drawing is on the surface you intend to paint on, block it in with thin paint. Include any background color within the bouquet, if it can be seen. On paper, color surrounding the bouquet can be suggested rather than filled in up to the edges. Step back and let dry.

Development
4. Identify some flowers, stems, and leaves toward the center of the bouquet to define more crisply and make more

opaque. Develop these, adding more layers of paint, shadow values, and "lost and found edges." Leave others in the paler, soft, loosely painted state created in the blocking-in stage.

Your selection of varied soft and crisp focus will give a dimensional feel to the bouquet. If you paint every element in focus, your bouquet will become flat. Instead, you're portraying only one focused gaze, a moment in time, not a multitude of them. And only a handful of elements are in crisp focus within any one gaze.

Thicken paint in areas where background can be seen within the bouquet, if they are assertive. Squint to see the shadow value structure on the overall bouquet and apply it. If your container is throwing a strong cast shadow, other shadows will be present on the bouquet. You may want to put a thin cool faux black wash on the container to increase dimensionality.

Finishing Touches
5. Add accents where you see them. Glaze colors to make them more or less intense. Strengthen selected contour edges using your smallest brush. Make any adjustments you feel are needed.

DEMONSTRATION: PAINTING A BOUQUET
Arranging the flowers for my demo took me longer than the painting! Discarded flowers and vases filled the kitchen before I found something that captivated me enough to paint. Working quickly, I completed most of the painting in four hours, adding some finishing touches the next day. The result was rather impressionistic, with just enough polish to make it appealing.

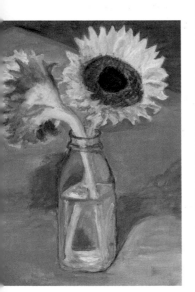

SUNFLOWER IN VASE, *by Junko Goto Donovan, student*

Note that flower stems in water will look discontinuous above and below the water line in a transparent container.

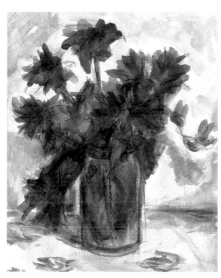

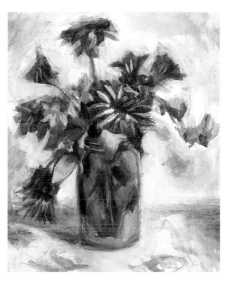

1. Working indoors with the bouquet under artificial light, I made a quick charcoal thumbnail to work out the composition. Then using both my setup and my thumbnail as a guide, I drew directly on the canvas with charcoal. When the drawing was done, I sprayed it with a fixative.

2. Using washes, I blocked in most of the painting loosely with a large soft round brush. I allowed my strokes to go beyond the contour lines of the bouquet, since I planned to crisply define that area later by cutting in around the edge with background color. My palette was based red/green complements with colors mixed from phthalo green, naphthol crimson, yellow oxide, white, and cadmium red light.

3. Using medium-consistency paint and small and medium brushes, I underpainted the lightest, most opaque-looking elements toward the front of the bouquet with gesso, preparing to make them pop. I cut in around the bouquet contour and interior with opaque background color to define flowers and leaves. Then I toned down the tablecloth and background color with neutrals.

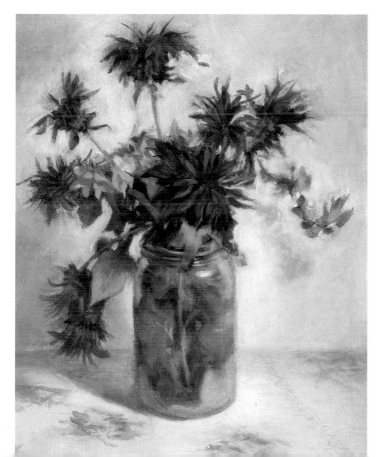

4. Once the gesso underpainting was dry, I applied color over it: crimson glazes on petals, warm green on leaves. Using a small brush, I added detail to tablecloth, glass, and shadows, as well as to leaves and flowers at the edge of the bouquet, painting these on top of the background color. I created a spotlight effect on the bouquet by adding warm white around it and darkening values near the painting's edges. A highlight of white impasto on the container was a finishing touch.

BEEBALM BOUQUET, *by the author*

Painting Glass

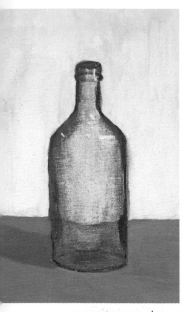

GLASS BOTTLE, *by Ruth Atkins, student* Try the wiping technique (see Tip, opposite page) for creating transparent effects.

Painting glass is easier than you might think: beginners with no prior experience in drawing or painting were able to accomplish this seemingly miraculous feat during a five-hour workshop. Sometimes it's just a question of looking carefully at what's there for the first time, then following a sequence of steps to take you to your goal. My demonstration accompanies your instructions to help you visualize how the painting develops. Either create a study on paper, or on canvas. Here are the steps:

Setup

1. Decide on a table surface and background color. Choose a simple glass container, without decorations or print on it. Light it to create a few highlights.

Drawing

2. Draw the glass container to get to know the shapes. Look for these keys to creating the impression of transparency:

a. The background and part of the table will be visible within the bottle. If you see the edge of the table through the glass, the line will look distorted.

b. You'll see the back curve at the bottom of the glass. This establishes transparency when the back of something is visible through the front.

c. Highlights will be visible on the front surface of the glass. Apply a light gray for local glass color, erase back for highlight, or use white chalk. Transfer or re-create your drawing on the surface of your choice. Don't fill in the local glass color value in the transfer stage.

Blocking In

3. Block in the surfaces around the glass, as well as inside the glass. If you have a white wall you'll simply see the color of the glass, which will be gray in a clear glass. Add cast shadows.

4. Paint the gray value shapes around the contour and inside of the glass, and especially the bottom back curve, using a small brush. Use a darker, neutralized color for colored glass shadows (with faux black, black, or a dark complement added), not a pure color.

Development

5. Paint surrounding surfaces with medium-consistency paint using negative space painting around the container to define its shape. This step will help establish the difference between the wall color seen through the glass and its true color on the wall.

6. Mix the color of the glass. If your container is clear, with no obvious color, you'll create a light gray. (To see this difference compare the value of clear glass with a pure white wall.) The next step is another important key to creating transparency; the layer of paint you apply needs to have some transparency so the underdrawing and colors are visible through it. The visibility of the back

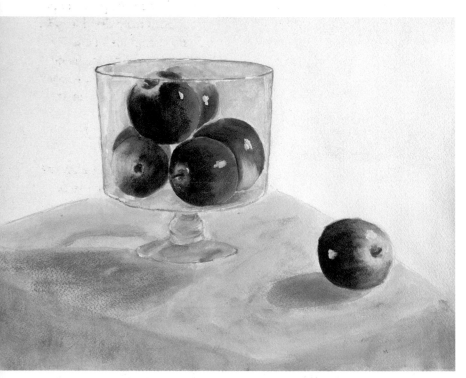

STILL LIFE OF APPLES IN A GLASS CONTAINER, *by Liz Finkelstein, student*
You can incorporate glass into your still life after you've studied how to paint it.

surface curve establishes the back surface. Use a medium bristle brush to apply the color of the glass in thin medium-consistency paint over the entire glass, or use a wash using a large soft brush. Let dry completely.

Finishing Touches

7. Deepen shadows where needed using wash or dry-brush; add dark accents, if necessary. Look for surface texture on the foremost surface of your glass, especially where it crosses over the line of the bottom back curve of the container. This may be a subtle grayish or bright highlight. Use dry-brush or washes with soft rounds to create these. (Don't add water to the glazed surface; scrub with a bristle, or you'll lift the paint.) Paint on highlights to bring the front surface of the glass forward. Use thick, pure white for the brightest and dry-brush with subdued gray for the less intense. Don't pat down or mix in the brightest highlights. Step back to evaluate.

DEMONSTRATION: PAINTING GLASS

The simple shapes and colors I chose for this setup gave me more than enough inspiration and challenge when creating this demo. My palette was simple as well: phthalo green, naphthol crimson, white and cadmium yellow medium. Lighting not only created additional interesting shapes for me to paint, but also gave me shadows and highlights—and a way to enhance the illusion of transparency and three-dimensionality.

> **TIP** Wiping off is another great technique for painting glass. You may discover this if you unintentionally put paint on too thick, then have to wipe it off with a rag. This creates a wonderful transparent effect. You may actually prefer to substitute this for the above method.

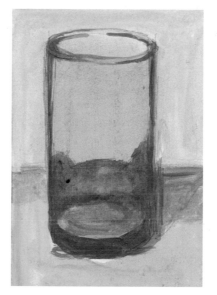

1. I drew with pencil on gessoed paper, blocking in all areas thinly. I underpainted the background wall with yellow, and painted the part of the wall seen through the glass a yellowish green. I added the wavy distortion of table shape seen inside the glass, and painted in the darker gray/green contour shapes of the glass.

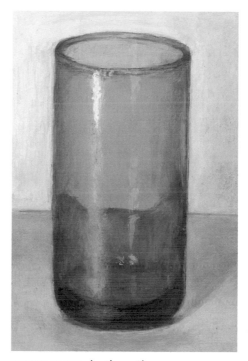

GREEN GLASS, *by the author*

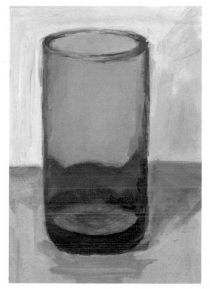

2. Using medium-consistency paint, I overpainted the wall with white, using negative space painting to correct the shape of the glass. I added cast shadows to the wall and table, and corrected the table color. When the glass shape was completely dry, I applied green glass color in a thin medium consistency using a medium bristle brush over the front side of the entire glass container.

3. I dry-brushed a green/crimson mix to the inside edges of the glass to darken and push them back, creating more three-dimensionality. The front lip of the cup was defined by applying contour lines with a small brush. I added a bright highlight with pure white impasto, and neutral yellow reflection with dry-brush. Light values on the table and background were lightened to set off the glass.

Painting Fabric

Fabric is an infinitely variable substance, composed of soft, tubular elements. You'll find it easy to forget about the subject and concentrate on the shapes moving in and out of the light. Make a simple study on paper, or develop a painting on primed watercolor paper or canvas. My fabric demo will serve as a step-by-step reminder of how a fabric painting looks as it's developed.

TIP Photographing your fabric setup is good insurance, as is a good thumbnail or drawing, especially if you have family members who come and go where you paint.

Setup

1. Drape a small, one-color piece of fabric in simple folds over a chair or railing or a doorknob. Pin it on a wall if you can. If you don't have any remnant cloth, use something simple such as a cloth napkin or white undershirt, or a pillowcase. Light it so as to bring out value patterns and beauty.

Drawing

2. Pick the method best suited for transferring your work to the surface you've chosen. Emphasize contours of folds and shadow value structure. Put in accents; create cast shadow if the fabric is on a wall. Add vertical value strokes within the cast shadow to define the wall surface. Use yellow oxide to make your drawing permanent, if needed. Let dry.

Blocking In

3. Mix the shadow color of the fabric. Paint in the shadow value structure and fabric accents thinly. Include the cast shadow on the wall if you see one. Add some gesso underpainting in brightest areas.

Development

4. When the previous layer is dry, apply the local color in thin medium-consistency paint over the entire surface of the fabric. Underpainting should show.

5. When this is dry, fill in wall and cast shadow colors, using negative space painting to define the fabric shape.

6. Build up paint in the lighter areas of the fabric and on other surfaces that need it. Deepen shadows where needed. Overlap the wall surface slightly with the fabric color at the contour edges. This defines the forward position of the fabric relative to the wall.

Finishing Touches

7. Add accents and highlights. Drybrush is especially effective for highlights on fabric.

DEMONSTRATION: PAINTING FABRIC

I arranged numerous fabrics in many colors, on doorknobs, walls, and chair arms. Nothing sparked my interest until finally I pulled out a big piece of cardboard I'd been using to divide my large canvases and threw a supple, green fabric over the edge of it. Beauty and the beast! And in the light, they worked even better together.

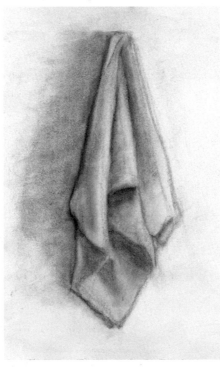

FABRIC (left), FABRIC AFTERTHOUGHT (right), *by Liz Finkelstein, student*
"I used a pillowcase as my subject. I wasn't looking forward to focusing on fabric because my fabric comes out looking stiff—so I just said 'not fabric, just shapes, and shadows' and I actually enjoyed it once I got past that. I actually prefer the 'afterthought' version I did to the one that took more time."

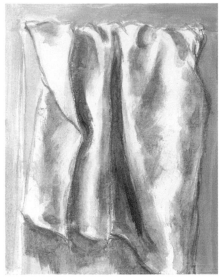

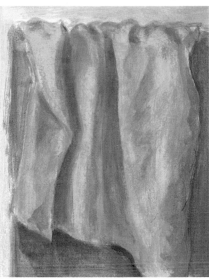

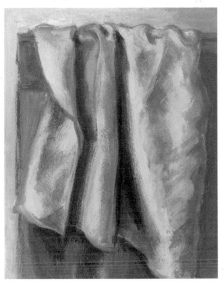

1. I made a charcoal drawing, then transferred a photocopy carbon to gessoed paper taped to box cardboard. After making lines and shadow areas permanent with yellow oxide, I blocked in shadow areas with a mixture of ultramarine blue and yellow oxide. I underpainted the brightest light areas of fabric with opaque white, the white wall with gray, and the cardboard with yellow oxide. Finally, I added two dark accents to fabric with warm faux black.

2. Using a medium bristle brush I applied green (white, green, with some red to neutralize) in a thin medium consistency over the entire fabric. This colored the dry underpainting, which remained visible as a guide. Then I painted an orange mixture onto the cardboard. Mixtures were created from a palette based on red/green complements— phthalo green, naphthol crimson, ultramarine blue, burnt umber, white, yellow oxide, and cadmium yellow medium.

3. Push/pull begins: I applied thicker medium-consistency mixtures of white and yellow oxide to the lightest areas on the fabric to pull them forward, and deepened shadow areas on the same surfaces to push those areas back. Cutting in with thicker gray background color I defined cardboard and cloth edges. Shadows were added to cardboard and deepened on cloth, and I defined select edges with line or contrasting values applied crisply along their contours; others were left softer (lost and found edges!)

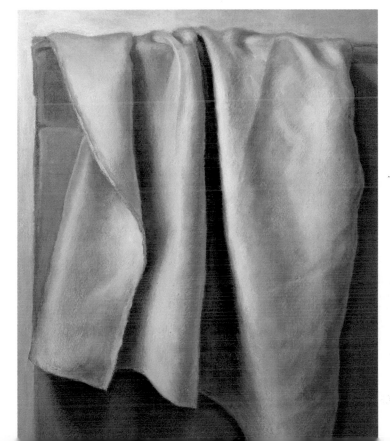

4. Next, I worked in smaller areas with a variety of color values in medium-consistency paint using dry-brush technique. Lighter middle value color was applied on surfaces throughout to soften transitions between values where needed and create the impression of solidity. Then I applied mixtures of white and cadmium yellow to the lightest-value areas to make them pop out. Finishing touches included deeper accents, creating crisp edges, and adding detail along fabric edges.

FABRIC STUDY, *by the author*

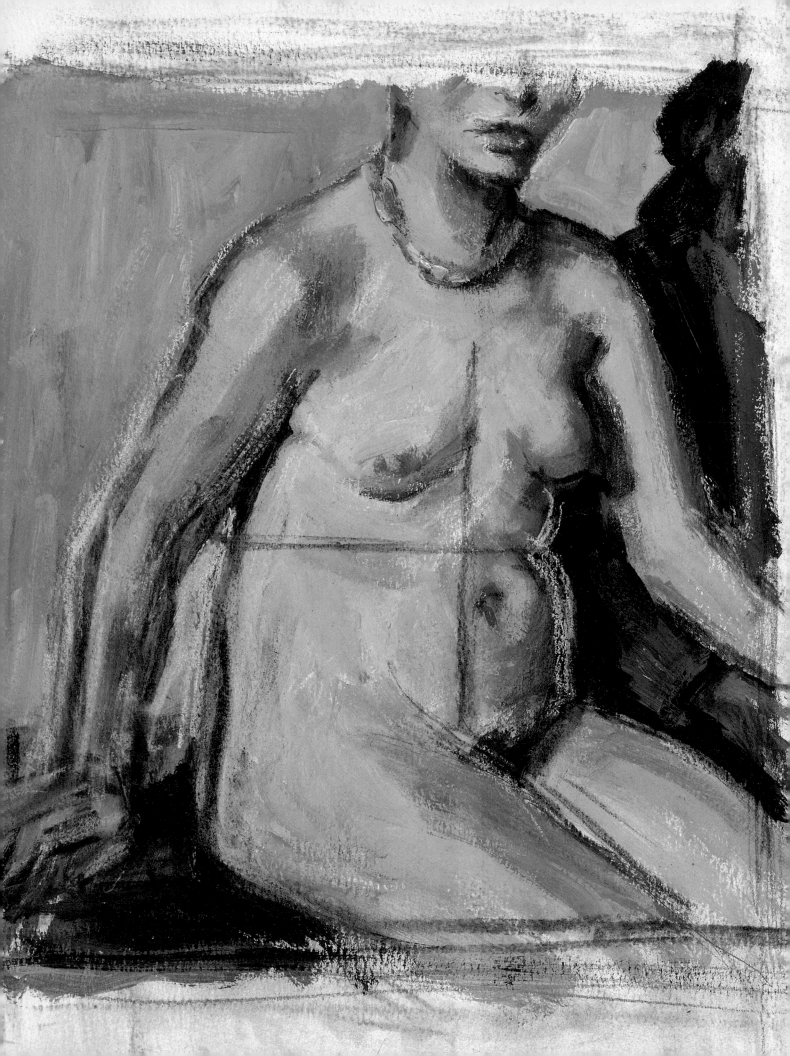

The Human Figure: Painting the Nude

"What spirit is so empty . . . that it cannot recognize that the foot is more noble than the shoe and the skin more beautiful than the garment?"

MICHELANGELO

Beginning painters enjoy painting the nude, and usually find it more accessible than a portrait. Students find the face to be a more challenging subject than the figure because surface areas of the face are smaller and skin color variations more subtle. There is also the challenge of painting individual features of the face, as well as trying to capture the expression or mood of the sitter. And when it comes to choosing between a clothed or nude model, beginning students again choose the nude. Less complicated!

Once you've learned to create a variety of skin tones in this chapter, you can decide to paint the figure or move ahead to paint the face first.

Opposite: **STUDY OF A PORTION OF ROBERT HENRI'S OLD MODEL WITH HER DAUGHTER,** *by the author*

Right: **HAND,** *by Julie S. Swearingen, student*

Skin Tones

The people represented in masterpieces of Western European art reflect a small percentage of the world's population. The dominant skin color in those paintings is light: Caucasian. But that color isn't skin color.

Since there are a great number of skin colors in the world, your focus can't be on identifying a generalized ethnicity, then matching skin tones to that. In fact, I had to smile when I found a tube of paint the other day in a garish pink color labeled "skin color." I wondered what ethnic group Miss Piggy belongs to!

Luckily, the skin color palette is limited. Nobody has green or blue skin yet! A basic palette for every skin color contains just a few colors from which you can create mixtures for skin in the light, as well as color for shadows. By changing the proportion of these few colors in a mixture you can create the color you want. Let's get an overview of the several skin tone bases and how to create different skin variations from them.

Light-Base Skin Tones

Skin color with a light base is mixed with a large proportion of white color compared to the colors used to tint it. To create light skin color, white is colored with small amounts of a yellow and a red (standard colors for this are, respectively, yellow oxide and crimson). These colors are used in differing proportions to create a more rose, peach, or yellowish color. Cadmium red light, as well as cadmium yellow medium, are useful to further brighten skin tones.

Shadows for Light-Base Skin Tones

Use complements to create shadow color: small amounts of ultramarine blue for peach and phthalo green for rosy skin.

Effective Shadows for All Skin Tones

In all skin tones, a warm mixture of burnt sienna and ultramarine blue, either applied as a mix or a wash, makes an effective shadow alternative to using complements. Burnt sienna and cadmium red light can be added to shadow areas to warm them up. Faux black in a wash creates a light shadow, and in any consistency can be used to deepen shadows as well. The darker the shadow the less white will be in it.

If you can identify the category of your own skin, try to match it, then paint your results on scrap paper and hold it up to your skin in front of a mirror. See if the color you've mixed isn't too dark or too intense a hue.

ALEX'S PORTRAIT, *by Katharine H. Welling, student*
In this portrait the artist creates the boy's light skin tone by tinting white with a small amount of crimson and yellow oxide.

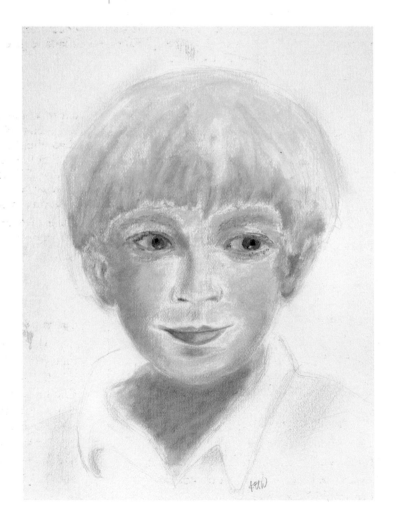

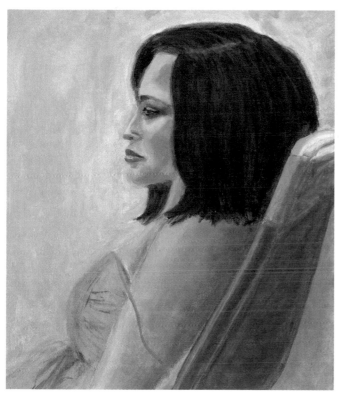

NAOMI, *by Anne Smith, student*
This student was able to give dimension to her painting of the model by successfully creating both light and shadow versions of skin colors in the medium range.

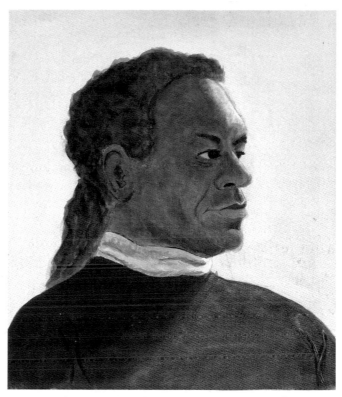

WENDELL, *by Liz Finkelstein, student*
This artist's ability to capture the warm color contrast between dark tones in the light and in the shadows gives this face dramatic impact.

Medium-Base Skin Tones

For this range, tint white with red/yellow colors ranging from cadmium yellow medium, yellow oxide, cadmium red light, burnt sienna, and/or crimson. Your choices will depend on whether the base color you're looking at seems to have more red, brown, yellow, or orange in it. You'll have less white in the mixture than in the previous category, because the medium skin tone is of a darker value.

Shadows for Medium-Base Skin Tones
Add complements, as you did for light skin, to create shadow colors for medium skin tones: blue in peach and tawny brown skin, and green in rosy skin.

Dark-Base Skin Tones

Dark skin tones are based on brown, usually burnt umber. Small amounts of white, cadmium red light, or yellow oxide, cadmium yellow medium, phthalo green, or ultramarine blue are added to create color variations and to soften pure burnt umber. Dark skin in the light can have light values requiring use of the light medium base ranges. For the darkest, almost black skin color, use burnt umber and ultramarine blue with a little bit of white to keep the color rich. Purplish color can show in this skin color range. For a more natural look, mix your purple, rather than use dioxazine. Add yellow oxide to tone down the mix.

Cadmium yellow medium, yellow oxide, burnt sienna, and cadmium red light can play important roles in brightening and warming up a range of dark skin tone values.

Shadows for Dark-Base Skin Tones
Complements can be used to create shadows. For more orange-brown skin tones use blue, and for more reddish-brown skin use green.

"I added a little blue to the skin color and got the shadow for under the nose. I said yes!! That's what I've been trying to do!"
Donna Farber, student

TIP The local color you mix will generally be too intense the first time you mix it. Test a little on the painting surface, then step back to evaluate before you add a lot of paint. If it's too strong, use that mixture to tint it more white.

Reading the Chart

On the skin tone chart, pure color sources line up horizontally in the middle. For light skin, pure color sources from left to right are: crimson, yellow oxide, cadmium red light, and cadmium yellow medium. For medium skin: burnt sienna; and for dark skin: cadmium yellow medium, yellow oxide, burnt sienna, burnt umber, cadmium red light, and crimson. Source colors mixed together form a base color, pictured below them. Colors used to create each mixture are indicated with small color lines. White is added to the base color to create lighter versions, in verticals below. Source colors mixed together with a complement create shadow bases, which appear above them. White is added to create lighter shadows, vertically above. Mixtures that appear directly above or beneath a source color have more of that source color in them.

In darker skin tone mixtures brown in general will form the largest proportion of color, while in light to medium skin color values, white will generally comprise a larger proportion of color. The colors pictured on the chart are more intense than what you'd use on a body or a face, and were used in intense form so that you see the nature of the color mixture more clearly.

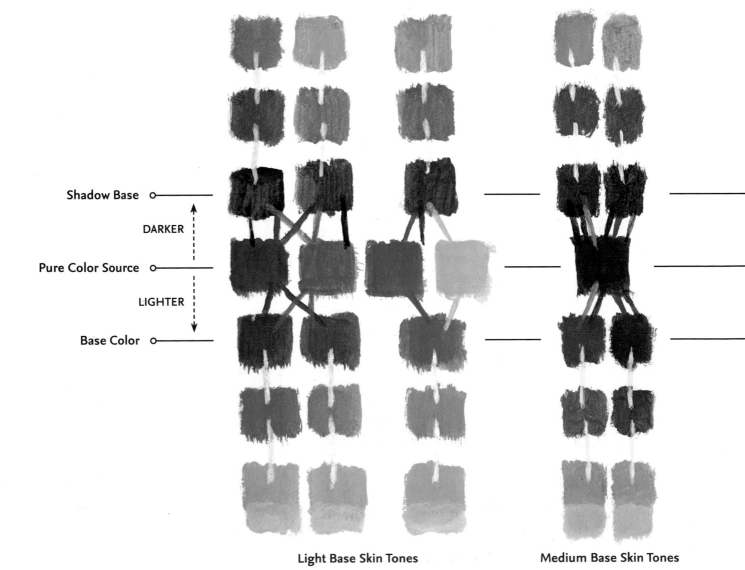

Light Base Skin Tones **Medium Base Skin Tones**

Practice mixing a variety of skin colors to prepare for painting the nude and the face. Explore making some mixtures in the three different categories.

Summary

To mix a particular skin color base, identify whether your model has light, medium, or dark skin. Then, look for the dominant shade of the skin. Is it yellowish, tawny, reddish, rosy, or peach? For light and medium skin, mix the appropriate base, then use that to tint white. More tint, less white for medium skin. For dark skin, add the distinguishing color to tint the brown, and then add a bit of white to soften the result. In all skin tones, white is added to create a lighter version of the color.

To create the base shadows in light and medium colors, add complements—blue (to orangey base tint) or green (to a reddish one). For darker skin colors, add some blue or green to a mixture of brown and the selected tint, with no white in the mix. Or substitute a warm brown/blue mixture (such as burnt sienna and ultramarine blue) for shadow color. Lighten the resulting base shadow with white to obtain lighter variations.

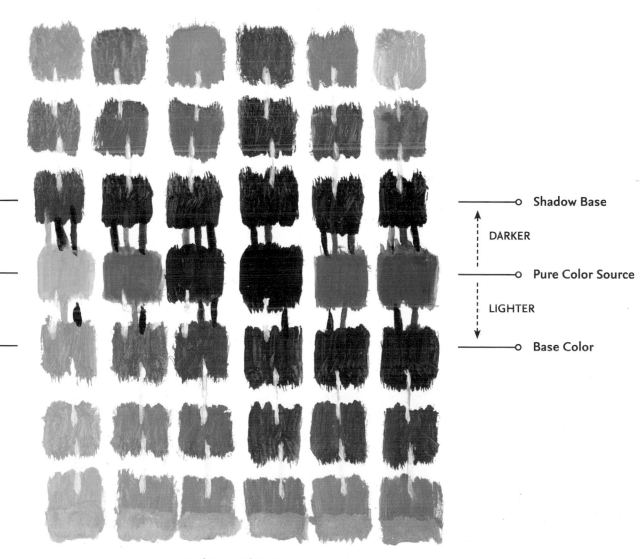

Shadow Base

DARKER

Pure Color Source

LIGHTER

Base Color

Dark Base Skin Tones

The Nude

In class we have instruction in painting the face first, because we use a live model, and painting the figure without prior preparation on the face would be confusing for students. However, at home you have a choice as to which to do first. It's likely you'll be using books as sources. If you use a mentor source for the figure, make the torso your focus, cropping out the head and/or the hands. Beginners from the painting class do this for homework. They find that the mentor paintings help them paint the live model.

You'll continue to educate yourself about art history in the process of searching for your model in art books. For mentor practice with dark skin tones, look for paintings by Gauguin, Delacroix, Romaire Bearden, and Winslow Homer.

In trying to avoid painting the head, beginners sometimes place a headless figure too low on the canvas, or simply leave the face as a blank, which doesn't work either. Use thumbnails to help you crop out areas you don't want to paint. Avoid the "headless horse (wo)man" look by softening the neck near the edge of a painting on canvas. Plan to leave enough paper around the figure to crop later.

Drawing the Nude

In class we begin with drawings in charcoal on newsprint to warm up. If you draw but haven't drawn the nude figure, an extended course in human anatomy isn't necessary before you draw and paint one. Start drawing nudes from painting or figure-drawing books. If you haven't drawn the figure before, this is not only a good idea, but a fun one as well.

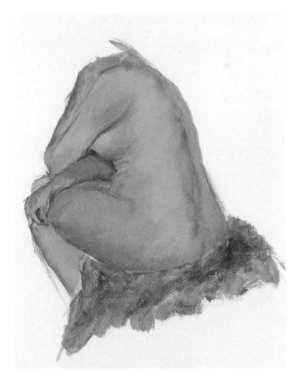

STUDY OF RENOIR'S *NUDE WOMAN SITTING*, *by Mary E. Tangney, student*

"'My' Renoir did not reflect the true colors of the painting well, but I liked attempting the various shadows to show the shape of the thigh, and where the backbone and shoulder blades were with the application of darker or light values."

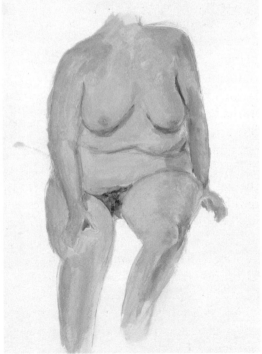

STUDIO NUDE, *by Mary E. Tangney, student*

"In the painting of Susan in class I could see better where to darken and lighten in order to reproduce her body, thanks to the Renoir mentor painting I did for homework."

Observing the following from your source can help you:

1. The body is composed of big and small containers. The pelvis and chest can be compared to tapered basket shapes; the chest has a wider opening at the top, the pelvis at the bottom.

2. Cylindrical-shaped limbs articulate at specific junctures: neck, shoulders, wrists, knees, ankles, hips, etc. Watch for angles here.

3. Calves and forearms taper respectively to ankles and wrists.

4. Buttocks, breasts, and stomach are oval-shaped.

5. In a three-quarter view of the body, just as with the head, features of the body closer to the viewer will appear larger.

6. Flesh is comparable to fabric draped over an angular structure—the skeletal system—and catches light similarly.

Find Reference Points

Make two photocopies—a color and a black-and-white—of your source painting. Hold a ruler parallel to the sides of the photocopy page (a vertical); move it across the page, noticing which features in the top and bottom of the body will line up along the vertical. For instance, does the inside of the ankle or knee fall along the same vertical edge as an area in the neck, breast, ear, etc.? Use the ruler to find horizontal and diagonal references as well. Mark them on your photocopy.

Use the head as a measuring unit to keep parts in proportion to each other. This works even if you don't include the head in your final image.

You can work with the source upside down to help you focus, and then turn the drawing around to make some corrections. Block in the overall shape just as with a still life object, using short directional strokes to generalize the shape. Sketch to generalize an overall shape, break larger sections into smaller components, and then add detail. Use negative space shapes created between legs and arms with the side of the body to help you draw the positive shapes. Squint, add shadows. Stand back to compare drawing and source together on a vertical surface.

I see people I've taught to draw making the same mistakes over and over again when they're doing preparatory figure drawing in painting class.

While drawing a sitting model even experienced beginners make the thighs too short, for example. You'd think this would make them feel discouraged, but not at all. They're used to the fact that they—and in fact all artists—always make mistakes and make corrections. But they feel they can fix it, and also that "I can draw." Gradually, with experience, the same attitude will apply to correcting your painting errors.

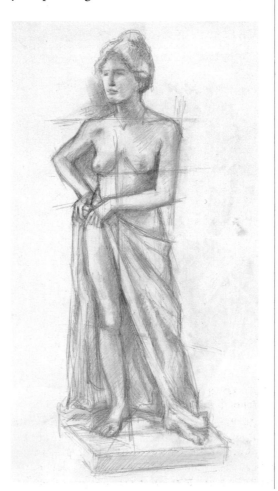

STUDY OF W. H. WATSON JR.'S, WOMAN WITH A DRAPERY, *by the author*

Notice the use of straight lines to find reference points in the blocking stage in this drawing of a plaster sculpture. These lines can be erased later.

Painting the Nude

Once the studio is quiet and I've finished lighting the model, most beginners are stunned to discover how truly beautiful the emerging forms are. And they understand why so many artists over the centuries have been captivated by the nude as a subject.

Of course it would be unrealistic to suggest that there aren't other reasons people are intrigued by nudes, personified by the adolescent bike riders who arrived one day when the nude model was posing near the studio windows with the curtains open to capture natural light. After passing by the window, they rode past again two minutes later, this time traveling slowly in the direction from which they'd come! A few minutes passed, and then they appeared again. We got the message, and closed the curtain. So much for natural light on that day!

When you paint the nude, the experience isn't as personal as you might imagine. You *study* the nude model, as an artist must in order to translate the shapes and colors you see into visual equivalents on the canvas. This challenge fills your mind and directs your thoughts; your approach to the nude is transformed into an artistic one.

Painted Nude Value Study

Make a pencil drawing from a mentor source. Squint to isolate shadow areas. Using a medium soft-hair round brush, apply thin warm washes of burnt sienna or orange, and ultramarine blue into those areas, paying attention to crisp and soft edges. Keep washes light in value to start, building the darker shadows and accents within shadows by adding more wash layers, either when the wash is receptive to additions or after the underpainting is dry. Leave the original color of the paper unpainted to represent the light skin areas.

Look at your drawing and source together vertically from a distance. Bring your shadow patterns into alignment with the patterns in the source. If you made a shadow that's too dark you can put a white wash over it to make it lighter, or correct with thicker white paint. Sharpen contours here and there with your smallest soft round brush or a pencil.

Develop this until you have the equivalent of a value painting in white and warm brownish grays. Let dry. You can wash a local skin color over this, or leave it as is, if you like. You can also use your value painting as the basis for a more developed work with opaque color, as we'll see next.

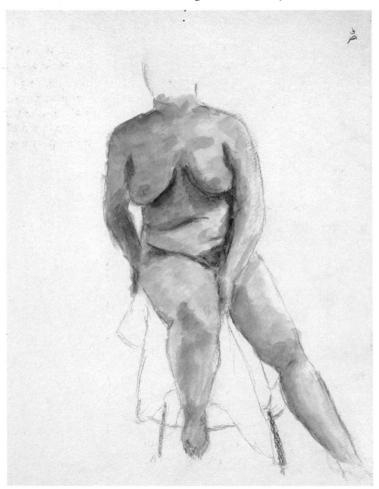

PAINTED NUDE VALUE STUDY,
by Debbie Gehrlein, student
This value study, created with washes, stands on its own as a piece of art.

Painting the Nude: Full Color

Select a mentor nude painting, follow these basic steps, and refer to my demo on the next page to help you visualize how the painting of the nude develops. I recommend using thumbnails, color sketches, and color tryouts to help you when working on a more complex composition.

Drawing

1. Draw the nude. Choose the method of direct drawing or transfer that suits you best, and the painting surface you prefer.

Blocking In

2. Create the shadow value structure. Use a mixture of complementary colors based on the model's skin color, or burnt sienna or cadmium red light with ultramarine blue wash, just as you did in the study. If you intend to move ahead with full color and thicker paint, spend less time on nuances here, which will be lost when painted over. Block in background and surrounding objects. Notice if the background color appears reflected subtly in the skin tones. Let dry.

3. Mix the overall color of the skin. Test this on a small area; step back to check in context. Paint here should be slightly thicker than a wash. Brush on over the figure, including the shadow structure. Add some color variations wet-into-wet if you like. Shadows on the body vary relative to the base color. What looks like dark shadow on light skin may not be dark enough for darker skin.

Development

4. Step back and look at what you have. If you're good to go, work with medium-consistency paint throughout the painting, adding color variations within large areas. Further develop shadow areas and light skin areas, creating more contrast and building layers of paint, especially in light areas. Use your small brush to correct and define contours. Within shadow values, you may see a variety of color values, some of them warm, some of them reflected light. None of the values within a shadow should be as light as the local base color in the light.

> **TIP** If color contrasts are too high on the nude or paint too vivid, remix, adding more base color.

Finishing Touches

5. When dry, use small brushes to sharpen features and add subtle value changes. Use glazes or dry-brush to add additional color changes, etc.

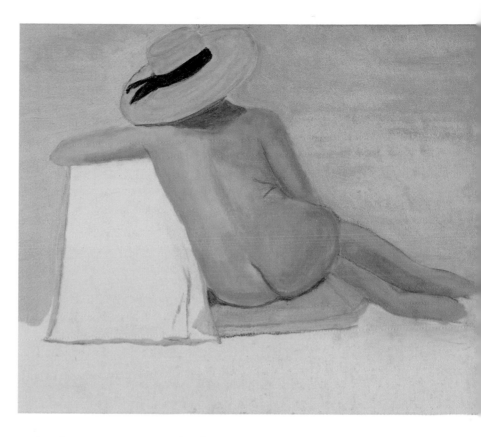

NUDE IN A SUNHAT, *by Pat Glass, student*
This painting in progress gives us a glimpse of the development of a figure painting.

DEMONSTRATION: PAINTING THE NUDE

I've approached the nude as you would at home, choosing William J. Glackens as my mentor rather than painting from a live model, an opportunity you may not have until you take a class. It was clear in studying him that our mentors have mentors! An American Impressionist, Glackens combines classic representational technique with lessons learned from the French Impressionists, especially in his use of broken brushstrokes on the hat and wall to the left of the model, and a palette based on complementary opposites—cool green and crimson red. *Nude with an Apple* is thought to be Glackens's tribute to Renoir.

2. I used a color sketch to help me explore Glackens's palette—cool green/red complements, white, yellow oxide, cadmium yellow medium, burnt umber, and ultramarine blue— and figure out how to balance color in the altered composition.

1. Charcoal thumbnails helped me crop out head and legs from a much more rectangular source. I moved hat and fruit bowl closer to the figure to balance the newly cropped composition.

3. After drawing directly with charcoal on canvas, I applied yellow oxide over lines and shadows. I underpainted a pure red on flowers, fabric, fruit, etc., to add vibrancy to the next layers. Dark accents in thin wash were added to the hat, arm of chair, and background. When yellow oxide shadows were dry, I blocked in over them with a cool shadow mixture.

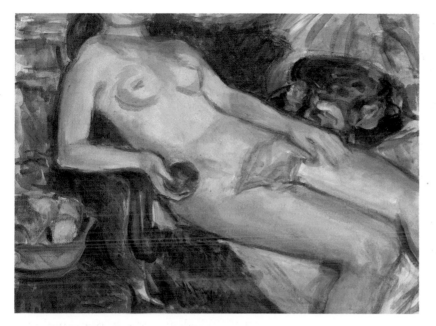

4. I applied local color in medium-consistency paint to the figure, sofa, hat, and wall, and left it thin around the painting's edges. Using grays I underpainted the white cloth and bowl. I used a small brush to redraw/correct shapes more accurately, and added color and detail to the fruit, hat, and nude (where I accentuated her shape by deepening shadows around her).

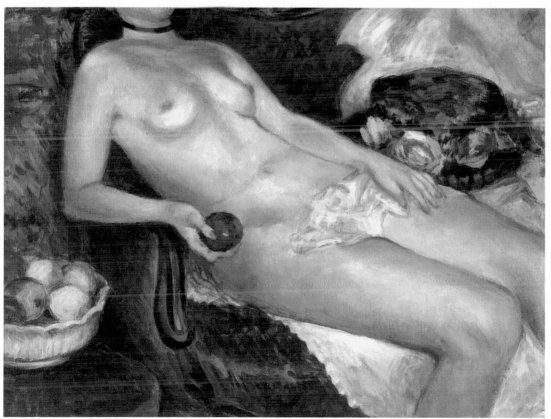

STUDY OF GLACKENS'S
NUDE WITH APPLE,
by the author

5. To give a more substantial dimension to the painting, I used a bristle brush and medium-consistency paint to apply warmer, lighter color throughout to the nude, white cloth, fruit, and areas of the couch. Using a small brush to apply contour lines I further corrected the shapes. I added detail to the rim of the bowl, arm of the chair, fingers, and edges of the cloth. Finally, I noticed Glackens had used subtle yellow in fabric, skin, and fruit to tie these elements together. It was one of my finishing touches, along with deepening accents.

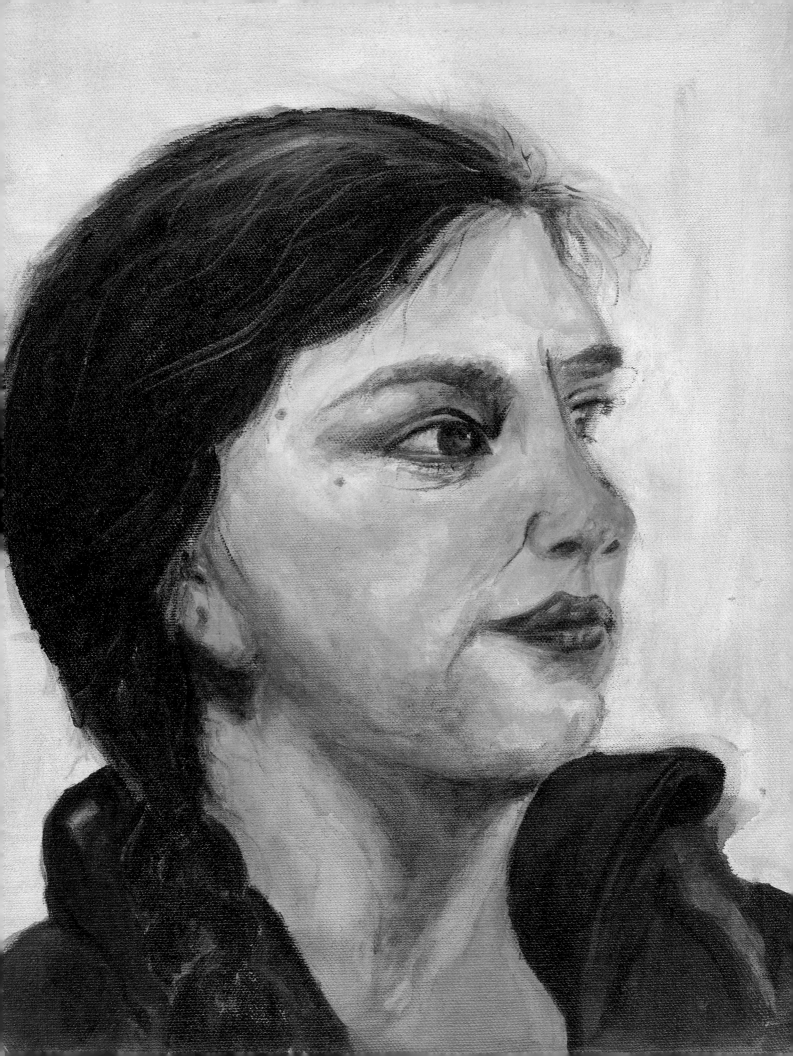

Portraiture: Painting the Face

"Faces are the most interesting things we see; other people fascinate me, and the most interesting aspect of other people— the point where we go inside them—is the face. It tells all. "

DAVID HOCKNEY

The face painting, while challenging, can also give the beginner the greatest sense of satisfaction. It's another step up the mountain! Start looking for a face that captivates you and will keep your interest. It's got to be "the beloved" for a time. Find a face you can tell the truth about, and hang in with for a while, rather than one you feel the need to flatter. Then, focus in on the elements of color, value, and shape that make up the image, more than on the identity of the individual person.

You'll focus first on acquiring the skills you need to paint a likeness of the face. Then you can move toward creating a portrait—capturing the essence of a particular model's face.

Opposite: **PAINTING OF SUSAN,** *by Lois Nieto, student*

Right: **LIPS,** *by the author*

Getting Ready

The preparation for painting the face starts with observation. Study the faces in your life—your friends and family, your own reflection—as well as faces in print ads, on TV, and in movies—with your painting goal in mind.

Pay close attention to shadow value patterns. You'll notice that in all views of the face the same areas are usually in shadow. Here is a list:

1. Orbits of the eye, under the brow.
2. Sides of the bridge of the nose.
3. Base of the nose, under the tip.
4. Upper lip.
5. Under the lower lip.
6. Bottom of the chin; and on the neck under the chin.

Shadow values on the face vary. Shadows falling vertically on the sides of the face will have slightly lighter value than the value areas mentioned, though high-contrast lighting can reduce all shadows to one dark pattern. The basic shape and location of these shadows varies only slightly from person to person because they're based on the universal shape of the underlying skull, and the effect of prominent features such as the nose or the brow casting shadows on the face. However, small shape variations are enough to create the impression of a specific person. Depending on how recessed the bony orbit of the eye is will determine whether it's deep or only slightly in shadow.

Among the shadows are darker accents at the nostril openings, lip line, brow, and upper lash line. The lightest values of the face are found on protruding areas of the brow, tip of the nose, lips, cheekbones, jaw, and chin, which are closest to the light.

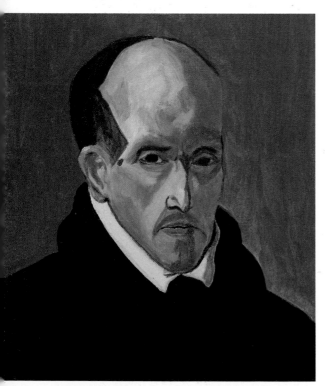

STUDY OF DIEGO VELÁZQUEZ'S *LUIS DE GONGORA Y ARGOTE*, *by Renee Hansen Goddu, student*
Squint while looking to see the interlocking pattern of light and dark in this beginner's mentor painting.

PHOTO OF LAURA, *by Pam Booth, student*
"Despite some technical problems I had taking the photo of our model—the photo ended up paint worthy. Her lovely face helped a lot!"

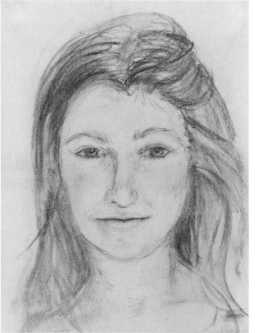

DRAWING OF LAURA, *by Pam Booth, student*
"It seemed that I had to attend to every little detail to make her 'real.' So I did a detailed same-size drawing. In doing so I accomplished a portrait that pleased me so much so that I didn't want to paint it and ruin the feeling of success."

Choose Your Model

A friend may be willing to pose for you. This will work if he or she has enough time available for you to complete the painting and drawing. Some artists prefer the photo source, others the real person; you can also combine both approaches.

Or you can do a self-portrait from a photograph or from life (a slightly more challenging project), or you can combine the two. You can count on your model that way! Some people choose to do a mentor portrait, and others are motivated to paint a family member.

Photographing Your Model

I recommend a frontal view for your first face painting. In any view, don't include too much of the torso; a little of the shoulder area is fine. I'd also recommend avoiding an open toothy smile, which is hard to paint and difficult to capture with a natural expression.

"Even in the case of friends who will come and pose, I've had photographs taken for portraits because I very much prefer working from the photographs than from them—I find it less inhibiting."

FRANCIS BACON

PORTRAIT OF BRIAN SMITH, *by Anne Smith, student*

This student was motivated to create two successful portraits by the faces of her two sons (see the other on page 157).

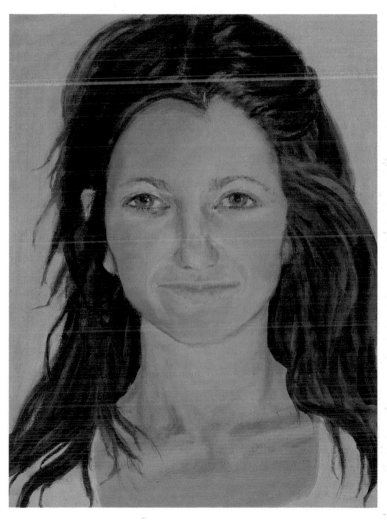

PORTRAIT OF LAURA, *by Pam Booth, student*

"After finally getting to a place where I was happy with the face I still felt daunted by the hair. At first I wanted to stop there and just ignore it! But then I realized I could apply what I'd learned while painting the face to the hair: apply local color; add the shades of color in the shapes that appeared in the photo. Look at shapes and color as just that; look at the relationship of one to another."

Drawing the Face

Now that you have chosen your model, the next step is to draw him or her. If you haven't drawn a frontal face, *Drawing for the Absolute and Utter Beginner* gives you a complete look at how to do so. For those inexperienced with drawing, use a photocopy carbon of a photo source, and transfer. Those with drawing experience will get a more personal result by drawing a face source freehand. Though a frontal view is the best and easiest one for your first face painting, I've included a step-by-step demo of a three-quarter view painting (on pages 152–153), because it is the most commonly seen view in life and art. It does provide the painter with interesting asymmetrical positive and negative space shapes. However, it's also the most challenging to draw. I've included tips for drawing in a three-quarter view at the end of this chapter, for those who are interested (see page 156).

Thumbnails

Continue to use thumbnails to help you make compositional decisions before you make your same-size drawing and color sketches to explore color relationships.

Same-Size Drawing

I recommend a same-size drawing for this project since attaining a likeness depends on specifics. An accurate drawing is key to a successful painting experience. Revise when you need to do so, at any time in the process, erasing and redrawing to get the desired effect. The step-by-step painting instructions apply to any view you choose to paint.

"I was able to zero in on the part of the whole that was most interesting to me. The thumbnails were a great help. I actually plan on doing some more thumbnails of the model's head next week so I can get the angles and proportions more to my liking."

Barbara Bosill, student

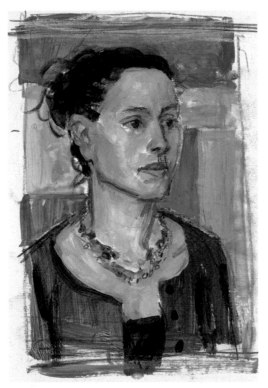
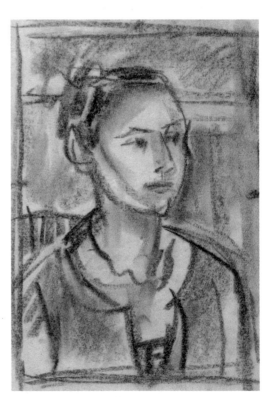

STUDIES FOR PORTRAIT OF JESSICA, *by the author*
Even though thumbnails and preliminary sketches are tools to help you paint a larger piece, they can be really enjoyable to make, and sometimes may stand on their own.

Painting the Face

The overall local or base color value of the face forms a middle ground, or plane. You'll see lighter and darker values of the face in contrast to it. Individual features will protrude from this surface, each one with its own unique sculptural identity. To give the features an illusion of sculptural dimension you will use the techniques you're familiar with: applying shadow values and light values specific to the shape of each feature with transitional values between the two. You'll start with a base color skin color and then add varying amounts of light, medium, and dark paint color to create the desired value you need. Darkest accent values need little if any base skin color.

Setup

1. Set up your palette to create the light color of the face, shadow colors of the face, background, hair color, and clothing.

Transfer

2. Transfer your same-size image onto the support. Then use yellow oxide to make the value structure and contours permanent.

Blocking In

3. Apply the shadow color you observe over the yellow oxide pattern to create the shadow value structure. A thin warm mix of burnt sienna and ultramarine blue are a nice alternative for the shadows if you don't want to use a complementary color mixture.

4. Using a medium brush, brush in the local skin color, painting over the dry shadow values. Add some local skin color to the eyebrows, eyes, and lips to avoid harsh value contrasts. Cover all areas of the painting. Then step back to see the color values in context.

Stand back frequently to check your painting and source together at a distance. This is not a rush job. Painting

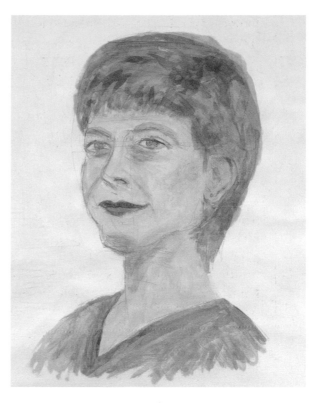

PORTRAIT OF MARY COLLINS, *by Kristen Nimr, student*
Adding washes to this drawing was all that was necessary to make an effective portrait study.

a face often takes a while—days, weeks, even months. Keep taking breaks from the painting to gain a fresh perspective.

Development

5. Correct color and develop values once the previous layer is dry, working with medium-consistency paint. Pull out light areas with light paint, then deepen shadow areas where needed. Color variations can once again be added in the larger areas of color and shadow. Correct shadows that are too cool by adding more warm color. Now that you have some painting experience, seize the moment to alter a paint passage while it's wet. Or if you need to wait, do so.

Finishing Touches

6. Glazes, dry-brush, and small lines can be used now with small brushes to correct small areas. Finishing can take a while. Even though less painting is going on, you're asking yourself, "Is it done?" Live with the painting, walk by it and, in passing, observe it.

"It's not about being the best at something—it's about how I feel doing it. And not about having the best representation but the process. And that's something I had forgotten, to keep doing it for the love of it."

Kristen Nimr, student

DEMONSTRATION: PAINTING THE FACE

I kept my camera with me every day, looking for a model. When I saw Jessica, who works in the Silvermine school office, I knew I'd found her!

The sculptural shapes of her face, the high contrast of hair and skin color, and the quiet dignity of her expression reminded me of Renaissance paintings I admired. She let me take some photographs of her at her desk, which I used to make this painting.

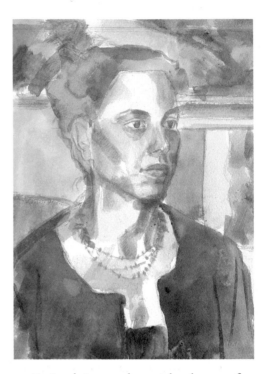

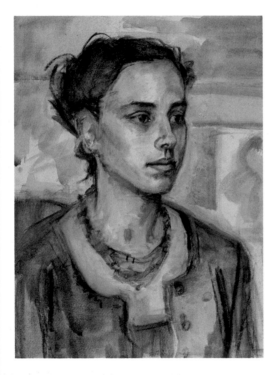

1. I transferred a photocopy enlargement of my color sketch, and then made corrections to create a better likeness of the model. I redrew with charcoal and white chalk first, then filled in with yellow oxide, white, ultramarine blue, and burnt umber paint mixtures. The results are more developed than an ordinary first step due to corrections.

2. Applying washes with a large soft round brush, I blocked in large color areas over the first step, including white wash over features to soften dark lines. Based on the red/green complementary palette explored in my color study, I used mixtures of crimson, phthalo green, cadmium yellow medium, cadmium red light, titanium white, ultramarine blue, and burnt umber. I underpainted areas where skin and hair had greenish undertones (such as the neck).

"There is no symmetry in nature. One eye is never exactly the same as the other, there's always a difference. We all have more or less a crooked nose and an irregular mouth."

EDOUARD MANET

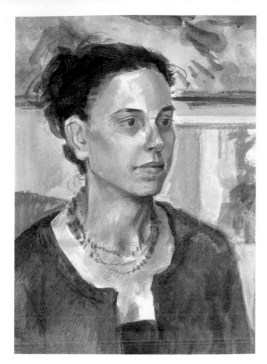

3. Using a soft round brush and washes, I developed contrast areas, adding faux black to darken values and small accents to the sweater, background, features, and hair. Shadows on the face and neck were deepened with washes. I applied light middle value, opaque skin color to the forehead, neck, cheek, nose, chin, lower lip, and earlobes with a medium bristle brush.

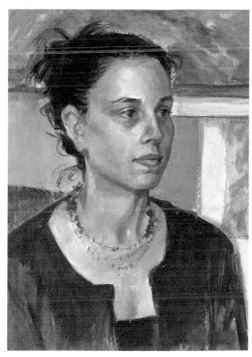

4. I painted warm light-value skin color over high contrasts on the model's skin to unify surfaces. Underlying contrast remains visible through the new layer. Then I deepened smaller areas within large dark-value areas on sweater, the hair, far side of the face, and background. Finally, I focused on developing features with my smallest brushes.

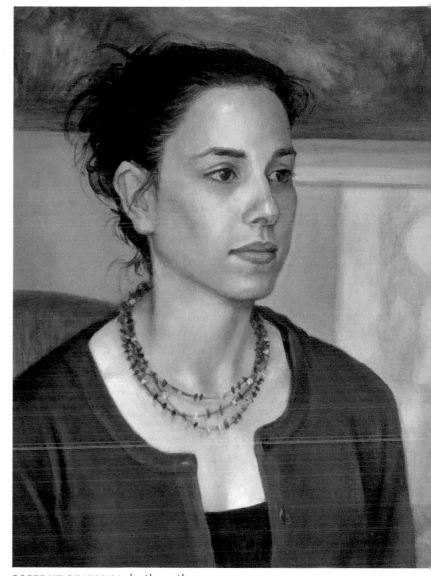

PORTRAIT OF JESSICA, *by the author*

5. I applied variations of warm skin color within larger areas to even out and brighten skin, using medium-consistency paint to give solidity to the model. I finalized the features, correcting shapes, developing color and sharp detail to capture my model's specific expression. In contrast, I neutralized color and softened contrast in the background to make her stand out more. Then I added the finishing touches: dry-brushed rosy color on cheeks, completed the necklace and its shadows, and painted tendrils of hair over the background.

Tips on Creating Features

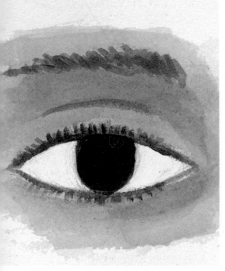

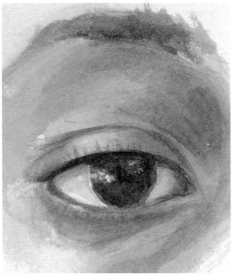

Problem

Solution

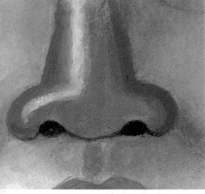

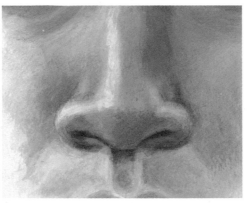

Problem

Solution

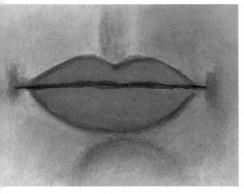

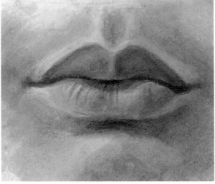

Problem

Solution

"I repainted the lips a
thousand times!"
*Renee Hansen Goddu,
student*

These illustrations will help you in drawing
and painting more natural-looking
features of the frontal face. I've painted
some common pitfalls for beginners (at
left), and next to them are tips on how
to avoid or fix them (at right). Though
the level of detail created at right isn't
necessary for a convincing painting of the
face, it's helpful to know what's there.

Eyes

Draw the lower lid onto the eye oval to
avoid making the iris too big. Angle the
lower lid down at both corners to avoid
the sausage-shaped eye. White of the
eye isn't white; it's a light gray-blue that
allows white highlights to show. Avoid an
unnatural-colored iris by neutralizing the
pure color. Brows are more value shape
than individual hairs; lash lines more
line than fringy lashes. Lashes are less
pronounced on the lower lid, where skin
and not lash lies against the eye. This area
should be light-flesh colored, or in darker
skin colors, darker than skin color.

Nose

To bring out dimension, build up lighter
paint on the length and tip of the nose.
Contrast with shadow under the tip and
on the sides of the nose (apply wash for
this). Uniform shadow around the nose
makes it cartoon-like: look for value
changes. The greater the contrast in these
areas the more the nose protrudes from
the face. Some noses are flatter than
others, so watch this.

Lips

Flat lips result from a uniform outline
and no value contrast on top and bottom.
The upper lip is often in shadow; the
lower lip catches the light. A shadow
shape under the lower lip defines volume
and makes prominent the lower lip.
Avoid an emphatic continuous contour
around the lower lip. Notice the contour
break on the lower lip right and left.

Hair

Beginners obsess over it! Hair needs to take backstage to the face, or to the body, so don't give it more detail than necessary. Approach it as a dimensional shape and forget about all those individual hairs. This means you'll block in the local color of the hair. Add dark-value areas around temples, crown, ears, and forehead. Develop the hair by thickening paint and correcting local color. Deepen shadows. Add color variations within broad areas while wet, or wait until dry to dry-brush in. Finally, create the texture of the hair—curly, straight, or wavy—with a smaller brush; add some highlights. If the outside or inside contour of the hair around the forehead looks cut from metal, soften it with dry-brush, or repaint the edge with looser strokes.

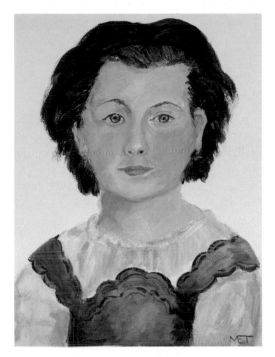

MENTORED STUDY OF RENOIR'S *ROMAIN LASCAUX,* *by Mary E. Tangney, student*
You have time to study one fleeting expression for as long as you want when working with a mentor's painting.

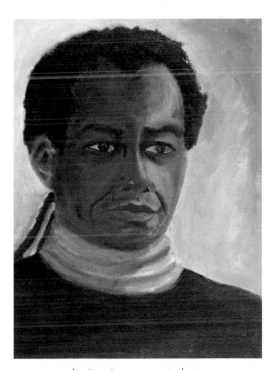

WENDELL, *by Eva Bergman, student*
This beginning painter has softened the back of the model's hair so it appears to recede, while giving the impression of curly hair.

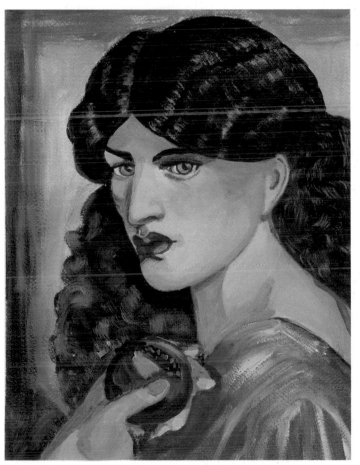

STUDY OF ROSSETTI'S *PERSEPHONE,* *by Renee Hansen Goddu, student*
"I used mostly burnt umber and black for the basic color, added cadmium red light and crimson on top for the light areas with dry-brush loaded haphazardly with those two colors, then added highlights."

Drawing a Three-Quarter View of the Face

Now that you've painted a frontal view, here are some instructions to help you with a three-quarter view, in case you'd like to try that next. The face in three-quarter view is subject to visual distortion, like a building when one surface is turned away from the viewer. Facial features, which are positioned on vertical and horizontal lines on the skull, will look slightly tilted to our eye in three-quarter view. Features farther away look smaller than closer ones, and often will be partially hidden by another feature, such as the nose. The closer eye will appear larger, the farther eye smaller, though we know that's not literally the truth.

The following will help you to better "see" the three-quarter view. Draw with a straight ruler on one of your black-and-white photocopies.

1. Draw a line through the top arch of each eyebrow, then through the pupil of each eye. These lines will tilt slightly, parallel to each other. Usually the lines will be highest closer to you, the closest eye being higher. However, the whole head may be tilted toward the viewer, reversing this.

2. Draw short straight lines: under the base of the lower lip, base of the nose, middle of the lip, and bottom of the chin. These lines will parallel each other, as well as parallel the two lines from step 1.

3. Draw a vertical line that passes through the middle of the tip of the nose, the lips, the chin, and up between the eyes. It will be at right angles to lines the features lie on. The line at the bridge of the nose between the eyes will be closer to the closest eye.

4. Notice that the distance from the tear duct of the closest eye to the contour of the nose at the bridge is the length of one eye.

5. Draw lines from the sides of the nostril to the tear duct, and the sides of the lips to the pupil. These will be approximately parallel to the tilted midline.

6. To find the ear position: measure to the top of the head, or the bottom of the chin, from eye level. Place the resulting measurement along the eye level line, starting at the tear duct and ending at the back of the ear.

7. Notice that paired features aren't the same. Look for the differences.

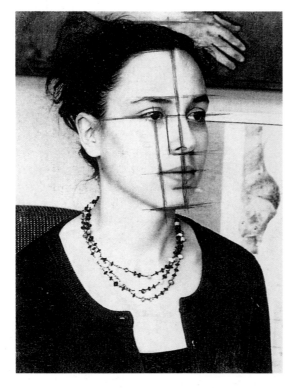

Draw a three-quarter grid on the faces you see in catalogs and magazines to get to understand it, just as I have with my model.

Common Problems and Solutions for the Face Painting

Problem: "I have a nice drawing of my niece but the painting makes her look like a much older woman. I don't know if it's salvageable. I screwed up the eyes. I don't know how to fix it other than gessoing over the whole thing."
—Pam Booth, student

Solution: Harsh contrasts age a face, as well as make it look unnatural. The problem begins when you're developing the painting and paint becomes layered, therefore darker, resulting in higher contrast than needed. Mix a little skin color into the dark paint you choose for these areas. Remember there are alternatives to burnt umber or black for shadows, which can look dirty and unnatural.

Problem: Clothes that look stiff and compete for attention with the subject.

Solution: Soften edges with dry-brush or a repainted edge.

Clothes shouldn't compete with the face for attention. If clothing is patterned, paint it loosely and thinly to avoid drawing the viewer's gaze down.

Problem: Eyes that are *off* really distort a face painting, because we focus on them.

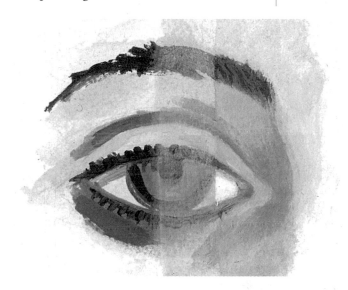

Solution: The image above shows you a correction in three vertical parts. On the left, you see contrast that's too high and color that's too intense. To correct, a wash (middle) is applied to areas needing correction. This light skin color will reduce contrast, and is thin enough to allow the image underneath to show through. To the right, once this wash dried, I repainted color and values to correct them.

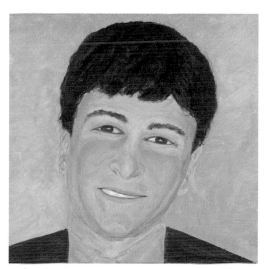

Before

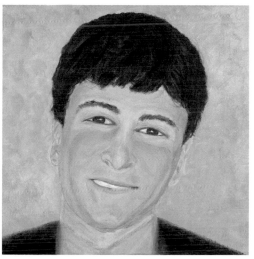

After

PORTRAIT OF GREG SMITH, *by Anne Smith, student*

High contrast in the suit shoulder area pulls eyes away from this young man's expressive face (before). The artist has softened the edges of the clothing so that it looks more subtle and natural (after).

Face and Body Together Again!

Once you've studied both face and figure, you'll feel comfortable with a project calling for both.

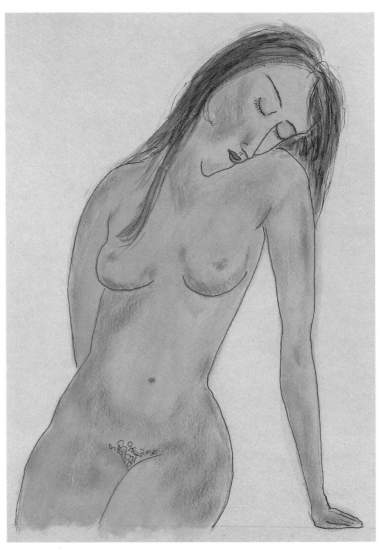

STUDY OF MODIGLIANI'S *NUDE,* by Nancy Brown Condon, *student*
You don't have to choose a classic nude painting to study the genre. Feel free to add your own touches as this beginning painter did by adding pen to her version of this Modigliani painting.

TWO STUDIES OF MARY CASSATT'S *THE BATH,* by Junko Goto Donovan, *student*
In her black-and-white painted study (top), this beginner refines her drawing (bottom), corrects scale, and captures tender gestures in a more accurate representation of her source.

"Painting is stronger than I am. It makes me do its bidding."

PABLO PICASSO

Final Constructive Evaluation

Now that you've worked your way through the book, try this fun and instructive exercise to get some perspective on your learn-to-paint experience. Assemble all your work, sketches and sampler included. Put them out where you can see them all in sequence, if possible on or against a wall. You can start with all of it upside down to help you see past the subjects' identities. Look for signs of your inner aesthetic by searching for similarities in your choice of shape and scale, approach to color, amount of contrast, brushwork, and compositional arrangements. Does any of it look as though it came from the same sensibility? It takes study to find these aesthetic echoes.

When you look at the world for the purpose of painting, you are looking through a painter's eyes. Now that you have learned how to mix the colors you are looking at, how to replicate the contours of a shape or the texture of a particular surface with brushstrokes, you are approaching the visual world the way a painter does. Once more of your time is spent in noticing color shapes, thinking about how to mix colors you see, and considering subjects to paint, you are thinking like a painter does. And once you begin painting on a regular basis, you have become a painter. You may have developed your eye, but you also need to put brush to paint, and paint on the canvas.

There isn't perfection or a final answer to the painting story. It's like an ongoing love affair. It's personal, passionate, makes you happy, can be messy, leaves you vulnerable; there's truth in it, and it heightens your desire to be alive. You'll

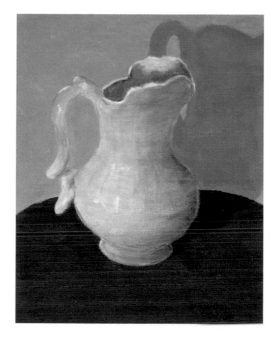

WHITE PITCHER (left), SHELL AND CUP (right), by D. Gehrlein, student
This artist's effective use of contrasting value shapes to create visual interest and balance gives her paintings a unifying element. Notice how a scalloped edge is found both on the mouth of the pitcher and the shell.

find the investigation doesn't come to an end; instead, you'll become part of a fascinating process of discovery that opens up into a deeper understanding of paintings past and present, as well as the part you play in that process.

Congratulations for making these first significant steps toward developing the gifts within you. Enjoy your art!

"The job of the artist is always to deepen the mystery."

FRANCIS BACON

Index